A Shared Heritage

A Shared Heritage
Art by Four African Americans

William E. Taylor and Harriet G. Warkel

with essays by

Margaret T. G. Burroughs

Floyd Coleman

Edmund Barry Gaither

Corrine Jennings

Indianapolis Museum of Art in cooperation with Indiana University Press

Exhibition Schedule

Indianapolis Museum of Art
 February 25-April 21, 1996
Terra Museum of American Art, Chicago
 May 11-July 6, 1996
Museum of the National Center
of Afro-American Artists, Boston
 September 23-November 30, 1996
Hunter Museum of Art, Chattanooga
 January 19-March 2, 1997

This exhibition is sponsored by NBD Bank, N.A. Additional support has been provided by the Institute of Museum Services, the Arts Council of Indianapolis and the City of Indianapolis, the Indiana Arts Commission, and the National Endowment for the Arts.

First edition

5 4 3 2 1

Library of Congress Cataloging-in-Publication Data

Taylor, William E. (William Edward), 1934-
 A shared heritage : art by four African Americans / William E. Taylor and Harriet G. Warkel ; with essays by Margaret T.G. Burroughs ... [et al.] — 1st ed.
 p. cm.
 Catalog of an exhibition held at the Indianapolis Museum of Art.
 Includes bibliographical references and index.
 ISBN 0-936260-62-9 (paper)
 1. Afro-American art—Exhibitions. 2. Art, Modern—19th century—United States—Exhibitions. 3. Art, Modern—20th century—United States—Exhibitions. I. Warkel, Harriet G. (Harriet Garcia), 1942- . II. Burroughs, Margaret Taylor, 1917- .
III. Indianapolis Museum of Art. IV. Title
 N6538.N5T37 1996
 760'.089'96073—dc20 95-45569

Clothbound edition ISBN 0-253-33079-3

Published by the Indianapolis Museum of Art, 1200 West 38th Street, Indianapolis, Indiana 46208. Distributed by Indiana University Press, 601 North Morton Street, Bloomington, Indiana 47404-3797.

Edited by Debra Edelstein, Medford, Massachusetts
Photography by John Geiser, Indianapolis Museum of Art, except for photographs listed on the last page of this book.
Designed by David Alcorn,
David Alcorn Museum Publications, Blairsden, California
Publication coordinated by Jane Graham,
Indianapolis Museum of Art
Printed by Dai Nippon Printing Company

Cover: John Wesley Hardrick. *Little Brown Girl* (detail), 1927 (dated March 25, 1929), oil on canvas, 22 x 30 inches. Indianapolis Museum of Art. Gift of a group of African-American citizens of Indianapolis, April 16, 1929.

Contents

Lenders to the Exhibition *6*

Foreword *Bret Waller* *7*

Acknowledgments *8*

Introduction *10*

The Four Artists *Margaret T. G. Burroughs* *13*

1 Image and Identity: The Art of William E. Scott, John W. Hardrick, and Hale A. Woodruff *Harriet G. Warkel* *17*

2 Hale Woodruff: African-American Metaphor, Myth, and Allegory *Corrine Jennings* *77*

3 William Majors: Aspirations and Beliefs *Harriet G. Warkel* *99*

4 The Mural Tradition *Edmund Barry Gaither* *123*

5 The Changing Same: Spiral, the Sixties, and African-American Art *Floyd Coleman* *147*

6 Echoes of the Past: Artists' Biographies *William E. Taylor* *159*

Checklist *185*

Index *191*

Lenders to the Exhibition

Amistad Research Center
Derrick Joshua Beard
Rachel Buckner
Dr. Margaret Burroughs
Dr. Stephen N. Butler
Mary Louise Clampitt
Clark Atlanta University
The Detroit Institute of Arts
DuSable Museum of African American History
Jack D. Finley
Fisk University
George and Terry Gray
Hampton University Museum
John H. and Vivian D. Hewitt
Indiana Historical Society
Indiana State Museum and Historic Sites
Indianapolis Museum of Art
Mary H. Jennings
The Harmon and Harriet Kelley Collection
Kenkeleba House
Richard and Elizabeth Kramer

Dr. Daisy Riley Lloyd
Kelley Majors
Susan Stedman Majors
Lester and Nancy McKeever
Byron and Frances Minor
Museum of the National Center
 of Afro-American Artists
National Museum of American Art
The Newark Museum
Mr. and Mrs. Richard C. Norton
David and Carol O'Connor
Betty Joan Owsley
James T. Parker
Wendell L. Parker
Georgia A. Hardrick Rhea
Schomburg Center for Research in Black Culture
Rowena Tucker
Mrs. Virginia Van Zandt
Wadsworth Atheneum
Dr. Joan Scott Wallace

Foreword

*I*n the 1920s, when the Harlem Renaissance was in full flower in New York City, Indianapolis also had a vibrant African-American cultural scene. Indiana Avenue became the center for such talented Indianapolis jazz musicians as pianist Leroy Carr, guitar player Francis "Scrapper" Blackwell, and Noble Sissle. The area became almost as famous as New Orleans for its jazz and attracted such prominent musicians as Fats Waller, the original Ink Spots, Duke Ellington, Count Basie, Cab Calloway, and Louis Armstrong.

Indiana Avenue also was the site of the Madame C. J. Walker Building and Theatre. Built in 1928, and named for the first black American woman millionaire, the theater became the most prestigious arts center in the city.

The Senate Avenue YMCA, which opened in 1913, was the home of the "Monster Meetings," a series of annual lectures that attracted such high-profile African-American speakers as the educator Booker T. Washington, actor-singer Paul Robeson, and the scholar and civil rights leader W. E. B. DuBois.

During this period the John Herron Art Institute (which combined the present Indianapolis Museum of Art and the Herron School of Art) was the artistic center of Indianapolis for both the black and the white communities. The art school fostered the talents of the four African-American artists whose work is featured in this book: William Edouard Scott, John Wesley Hardrick, Hale Aspacio Woodruff, and William Majors.

The Indianapolis Museum of Art is fortunate to have in its collection works by all four of these artists, works that became the starting point for creation of the exhibition *A Shared Heritage: Art by Four African Americans.* Additional paintings and works on paper have been generously lent by the artists' families, collectors, and national museums.

A common thread that unites the work of these four artists, despite their stylistic differences, is the deep sense of pride in their African-American cultural heritage. Collectively these paintings, drawings, and prints offer viewers a unique opportunity to follow the development of African-American art in the twentieth century as it unfolds in the work of four talented artists.

The germinal idea from which this exhibition has grown was planted some five years ago by William E. Taylor, an artist and educator who approached me with the concept shortly after my arrival in Indianapolis. Bill has devoted more than fifteen years to research into the lives of Scott, Hardrick, Woodruff, and Majors, and as guest curator has been the driving force behind the whole project. His contagious enthusiasm spread to and is now completely shared by the museum's curator and exhibition organizer Harriet G. Warkel. Bill and Harriet have made a marvelous team, and I am grateful to them both for their zeal, dedication, and hard work.

This is the first comprehensive publication devoted to the work of the four artists in this exhibition. As such, it is a major addition to art historical scholarship. Ms. Warkel, Mr. Taylor, and I want to thank the contributors to this catalogue. We are grateful to them and to the lenders, donors, and members of the artists' families who have made the exhibition possible, as well as to the individuals, corporations, and government agencies who have provided financial support.

The works in the exhibition testify to the pride, talent, and imagination of their creators. So confident and accomplished is the art of these four men that viewers unfamiliar with the conditions under which it was produced might not fully appreciate the struggle required to bring it into being. Hale Woodruff placed the art in context:

Everything the Afro-American artist does has to do with his image of himself and his aspirations. It involves human as well as racial fulfillment. The Afro-American artist faces all the artistic, hence economic and cultural problems all artists face. But for the Afro-American artist these problems are aggravated by the fact that the power structure of the art world is not altogether prepared to accept him as "just another artist" particularly in the visual arts.

Bret Waller
Director
Indianapolis Museum of Art

Acknowledgments

Almost five years have passed since William E. Taylor, consulting curator for *A Shared Heritage: Art by Four African Americans*, suggested this exhibition of the work of four black artists trained in Indianapolis to Bret Waller, director of the Indianapolis Museum of Art. The long process of researching the artists' lives and locating their work has been rewarded by exciting discoveries and the development of new friendships.

The exhibition would not have been possible without the cooperation of the artists' families. A special thanks to John Wesley Hardrick's daughter, Rachel Buckner, who assisted in verifying facts about her father's life and always graciously responded to our many questions over the years. Thanks also to her sisters, Rowena Tucker, Georgia Rhea, and Ruth Reed, for sharing their memories. A debt of gratitude is extended to William Edouard Scott's daughter, Dr. Joan Wallace, for sharing her recollections and the wealth of documents and personal papers that yielded valuable information on her father. Our sincere thanks to Susan Stedman Majors, wife of William Majors, who allowed us to examine her extensive collection of prints and drawings executed by her husband and supplied important details about his working methods.

The success of the exhibition is due to the efforts of the staff of the Indianapolis Museum of Art, especially Bret Waller and the museum's chief curator, Ellen Lee. Ms. Lee's encouragement and constructive assistance are sincerely appreciated.

The expertise and support of the museum staff were essential in bringing the exhibition to its completion. I am particularly grateful for the friendship and advice of Barry Shifman, curator of decorative arts. Sincere thanks are also extended to Martin Krause, curator of prints, drawings, and photographs, whose expertise was a valuable resource.

Because many of the works in the exhibition have never before been displayed, there was a need for expert conservation. We have been very fortunate to be able to rely on the expertise of Linda Witkowski, conservator of paintings, and Claire Hoevel, conservator of paper. Our gratitude is also extended to Martin J. Radecki, chief conservator and director of curatorial services, for his advice and assistance.

Our thanks to the Registration Department and especially to Vanessa Burkhart, registrar, who made certain the works arrived safely and on time. Also appreciated is the assistance of Rose Wood, former registration intern, and Sherry Peglow, assistant registrar of exhibitions. We are indebted to the staff of the Exhibits Department, particularly Laura B. Jennings for her excellent sense of design and her creative installation of the exhibition. Susan Longhenry, director of education, and her staff produced programs that greatly enhanced appreciation of the exhibition. The interest, assistance, and proficiency of Virginia Hamm, Brian Hogarth, Alan Davis, and Carol White are especially appreciated. We would like to thank Mary Bergerson, director of marketing and communications, and her staff, particularly Mona Slaton, assistant director of marketing and communications, for taking a personal interest in the exhibition.

Debra Edelstein edited the catalogue with her usual insightful approach and talent for organization. The splendid book design was the work of David Alcorn, who combined the text and illustrations in perfect harmony. The catalogue would not have been successful without the expert photography of John A. Geiser, who spent months photographing the works in the exhibition. We also would like to thank Ruth Roberts, photographer's assistant and coordinator of rights and reproductions, and Hadley W. Fruits, NEA photography intern, for their help.

A special thanks and our sincere appreciation to Jane Graham, publications manager, for coordinating publication details. Her constant vigilance made timely publication of this book possible. Russ Wadler, design manager, was extremely helpful in assisting with decisions relating to the catalogue and the production of posters for the exhibition.

Without the expertise of our writers, this catalogue could not have been brought to fruition. Thanks are due to Dr. Margaret Burroughs, artist and founder and direc-

tor emeritus of the DuSable Museum of African American History, Chicago; Corrine Jennings, director, Kenkeleba House, New York; Dr. Floyd Coleman, chairman of the department of art, Howard University, and Dr. Edmund Barry Gaither, director, National Center of Afro-American Artists, Inc., Boston.

We extend thanks for their help with research to B. J. Irvine, Fine Arts Library, Indiana University; Joan Stahl, National Museum of American Art, Washington, D.C.; Eric Pumroy and staff, IUPUI Archives, John Herron Art Library; Ursula Kolmstetter and staff, Indianapolis Museum of Art; Theresa Leininger-Miller, University of Cincinnati; and Beryl Smith, Rutgers University. A special thanks to retired Professor Earl Floyd, Indiana University; John H. and Vivian D. Hewitt, Charles Wharton, Kelley Majors, Patricia Hurd, Clara Martin, and Rebecca Higgins. A National Endowment for the Arts planning grant enabled us to complete our research for this project.

For their friendship and for sharing their knowledge, we would like to thank James East, dean, Indiana University-Purdue University, Indianapolis (IUPUI) Credit Programs; Monroe Little, director of Afro-American studies, IUPUI; Joseph Taylor, dean emeritus, liberal arts, IUPUI; Bee Shepard, and Jane Wilcoxon. Finally, we extend our appreciation to Ray Warkel and Joyce Taylor for their patience and understanding and for the constant encouragement and support they provided.

Harriet G. Warkel
William E. Taylor

Introduction

American art depicting African Americans, especially from the eighteenth and nineteenth centuries, is replete with stereotypical images of slaves, minstrel performers, and servants. These depictions led the expatriate Henry Ossawa Tanner, in 1893, to become the first African-American artist to paint sympathetic genre scenes focusing on black subjects. Tanner abandoned this theme in favor of religious imagery in 1895, after realizing that the European community could not be expected to understand or appreciate a theme that was distinctly American in nature. It would be up to the African-American artists who followed Tanner to set the tone for a new approach to African-American subjects.

One of the most outspoken promoters of "a school of racial art" was Alain Locke.[1] The first African-American Rhodes Scholar and a professor of philosophy at Howard University, Locke was the impetus behind the New Negro movement, the flowering of black culture in the mid-1920s, often referred to as the Harlem Renaissance. Locke encouraged African-American artists to look to their African heritage for inspiration and to their own environment for black themes. He noted the example set by such prominent American artists as Thomas Eakins, Winslow Homer, Wayman Adams, Robert Henri, George Luks, and George Bellows, who "were raising the Negro subject from the level of trivial or sentimental genre to that of serious type study and socially sympathetic portrayal."[2] Because he felt the black artist could "furnish the fullest and most revealing portrayal of Negro life," Locke saw an opportunity for "the American Negro…to make as distinct a contribution to the visual arts as he has made in music."[3]

In this environment black artists saw themselves as leaders of change, who could give visibility and identity to the African-American community by translating the black experience into works of art. They hoped a commitment to black subject matter would reverse the stereotypical perceptions of African Americans and eventually foster an understanding among the races. William Edouard Scott, John Wesley Hardrick, and Hale Aspacio Woodruff

were among the artists of the New Negro movement who tried to achieve this goal through historical painting, portraiture, and sensitive portrayals of the black experience. They were part of what Locke perceived as "the growing maturity of the young Negro artist, the advent of a representatively racial school of expression, and an important new contribution, therefore, to the whole body of American art."[4]

In the 1960s, at the height of the civil rights movement, black artists, writers, and musicians joined together, as they had during the Harlem Renaissance, "to formulate new ideological directions."[5] Woodruff and William Majors, whose artistic career developed during this period, created an abstract style that expresses the contemporary role of the African-American artist. These artists were no longer satisfied with the traditional methods of painting or the unity of presentation advocated during the Harlem Renaissance. The contemporary African-American artist sought the freedom to use diverse means of self-expression. Artist and art historian Samella Lewis notes, "The result of this new consciousness is an art in the process of realization, a process in which the most important aesthetic principle to emerge is that differences are valid."[6]

Scott, Hardrick, Woodruff, and Majors began their artistic careers in Indianapolis. The black population of Indianapolis, like that of many American cities, has endured racism, and the existence of a thriving black community in the city testifies to the tenacity of people faced with prejudice in housing, education, and politics. When Crispus Attucks High School was dedicated in Indianapolis on October 27, 1927, a separate but equal doctrine was on its way to becoming the norm and segregation the dominant practice.[7] The opening of the high school laid the foundation for a discriminatory policy that would follow members of the Indianapolis black community from cradle to grave.

An 1877 statute had sanctioned the establishment of separate elementary schools for black children.[8] From 1900

to 1950 elementary schools in Indianapolis adhered to this segregation policy. With the opening of Crispus Attucks High School in 1927, the policy was extended to high schools, as black students were withdrawn from all other Indianapolis high schools and enrolled in this new facility. Invisible lines were soon drawn throughout Indianapolis, separating blacks into designated areas and creating psychological barriers—barriers that were, for the city's African-American community, a way of "knowing your place and staying in it."

The black population of Indianapolis increased from 16,000 in 1900 to almost 44,000 by 1930. Blacks originally came to Indiana as farmers; later they sought jobs in manufacturing and industry. Housing quickly became a problem. The white community's fear of fewer jobs, decreased property values, and integrated schools was reflected in the political mood. In 1925 Ed Jackson was elected governor on the Republican ticket controlled by D. C. Stephenson, grand dragon of the Ku Klux Klan. During the same year Stephenson's backing was also sought by John Duvall, who was running for mayor of Indianapolis.[9] It was in this segregated atmosphere that Scott, Hardrick, and Woodruff sought careers as visual artists. Even in the 1950s, when Majors began his artistic training, the environment had changed very little.

The foundation for blacks to pursue artistic endeavors had already been laid by successful black musicians. The relaxation of racial barriers in the field of music may have helped open the door for blacks pursuing careers in the visual arts.[10] The art school in Indianapolis, John Herron Art Institute, had no reservations about accepting black students. The Indiana State Fair and the Pettis Gallery, showplaces for the work of white artists, did not deny the black artist the opportunity to participate in exhibitions.

For the most part, the art community praised the skill and perseverance of black artists and treated them with the respect their talent deserved. The critics regularly featured Scott, Hardrick, Woodruff, and Majors, although they sometimes described their use of color and rhythmic

line as innate traits derived from their African heritage. In 1913 the John Herron Art Institute (now the Indianapolis Museum of Art) received its first work by a black artist, Scott's *Rainy Night, Etaples*, 1912 (fig. 3), presented as a gift from the African-American community of Indianapolis. In 1929 another group of African Americans gave the art institute a painting by Hardrick entitled *Little Brown Girl*, 1927 (fig. 31). The Harmon Foundation, established in New York in 1922 and remembered today for its pioneering national exhibitions of African-American art, was supportive of Indianapolis's black artists. Woodruff was given the Harmon Foundation bronze award by Governor Jackson in 1927. The following year the Harmon Foundation's bronze award was presented to Hardrick by Mayor L. Ert Slack.

In an environment filled with racism and intolerance, the arts in Indianapolis seemed to transcend fear and ignorance, allowing a group of talented African Americans to fulfill their dreams and take their rightful place in the history of American art.

Harriet G. Warkel
William E. Taylor

1. Alain Locke, ed., *The New Negro* (New York: Albert and Charles Boni, 1925; reprint, New York: Atheneum, 1968), 254.

2. Alain Locke, "Up Till Now," in *The Negro Artist Comes of Age* (Albany: Albany Institute of History and Art, 1945), IV.

3. Alain Locke, ed., *The Negro in Art: A Pictorial Record of the Negro Artist and of the Negro Theme in Art* (Washington, D.C.: Associated in Negro Folk Education, 1940), 10.

4. Alain Locke, "The American Negro as Artist," *American Magazine of Art* 23 (September 1931): 220.

5. Samella Lewis, *African American Art and Artists* (Los Angeles: University of California Press, 1990), 143.

6. Ibid., 144.

7. Stanley Warren, "The Evolution of Secondary Schooling for Blacks in Indianapolis, 1869–1930," in *Indiana's African-American Heritage*, ed. Wilma Gibbs (Indianapolis: Indiana Historical Society, 1993), 44.

8. Ibid., 29.

9. M. William Lutholtz, *Grand Dragon* (West Lafayette: Purdue University, 1991), 150.

10. Interview with Jerry Daniels, one of the original Ink Spots, 29 October 1994.

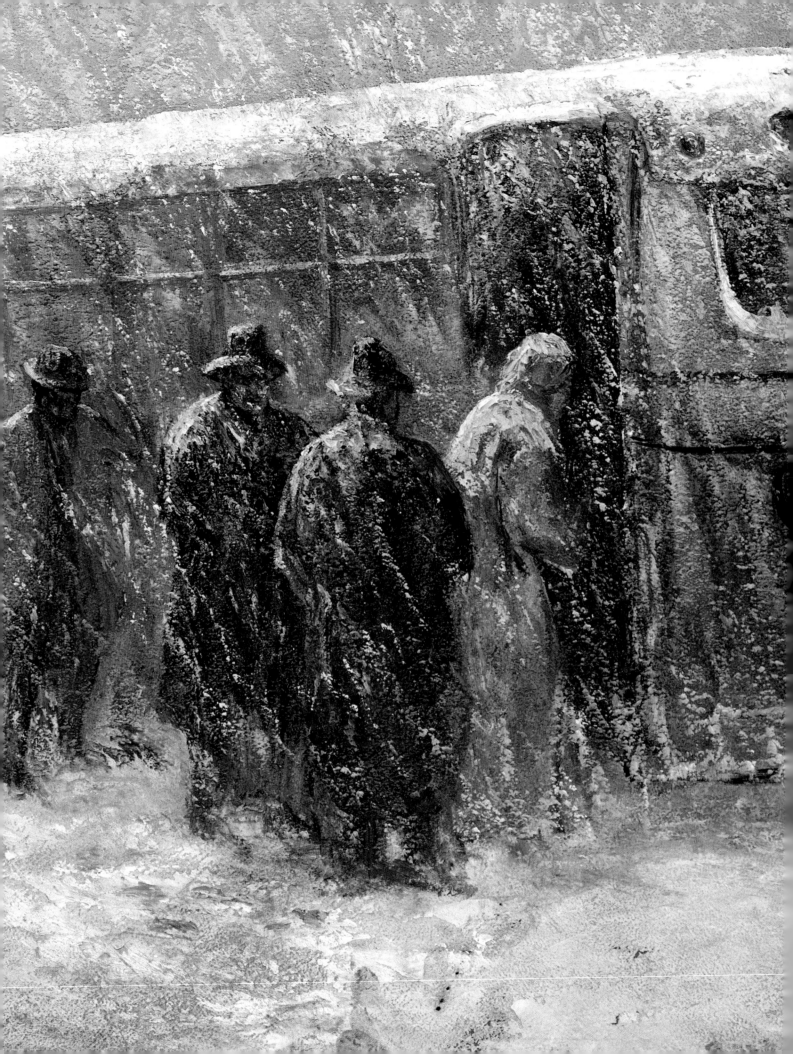

The Four Artists

Margaret T. G. Burroughs

*A*frican-American artists have persevered in their chosen profession despite being refused entry into many academies, exhibitions, museums, and schools. They have often been ignored by critics and shunned by a public that does not take them seriously as artists. Except for special events labeled "black," African-American artists usually have no place to exhibit their work. Despite this restricting atmosphere, many of these artists remain undaunted. Among the pioneers who met the challenge and succeeded were William Edouard Scott, John Wesley Hardrick, Hale Aspacio Woodruff, and William Majors.

As a young artist in my twenties, I had the honor of knowing the distinguished, goatee-wearing **William Edouard Scott**, the dean of Chicago's African-American artists. During his early years as an aspiring artist in Indiana, Scott supported himself as an assistant high school art teacher, and was the first African American to teach in the Indianapolis high schools. He moved to Chicago in 1904 to continue his art education at the School of the Art Institute of Chicago, and during his tenure won several prizes and scholarships. In 1909, after graduation and some advanced training, Scott traveled to France, where he studied with the expatriate African-American painter Henry Ossawa Tanner, who impressed him as a painstaking worker and a real genius. He also enrolled at the Julian and Colarossi academies and the Ecole des Beaux-Arts in Paris. Scott made three trips to Europe between 1909 and 1913. Upon settling in Chicago he executed works that utilized his academic training but moved beyond imitating European subject matter to treating racial types and themes.

Scott became a prolific mural, portrait, and genre artist, whose works are not only represented in important national collections, but can also be found in Haiti and Argentina. His numerous portraits include likenesses of such historic figures as Frederick Douglass, George Washington Carver, Booker T. Washington, and Toussaint L'Ouverture, to name only a few of his paintings of notable African Americans. Scott's murals, many containing historic and religious subjects, were executed for schools, churches, and public buildings in Illinois, Indiana, West Virginia, Washington, D.C., and New York.

In 1931 Scott won a Julius Rosenwald Fellowship to study and paint in Port-au-Prince, Haiti, where he spent over a year recording peasant life. He is credited with stimulating the interest of Haitian artists in painting and portraying local scenes. His success in Haiti was a catalyst for the establishment of the Centre d'Art in Port-au-Prince, which eventually led to an explosion of interest in Haitian art in the 1950s and 1960s. Scott's stated goal as an artist was to stimulate racial pride in the hope of bringing about a better understanding between the races.

During his entire career, **John Wesley Hardrick** made his home in Indianapolis. He came to prominence as an artist at the age of thirteen, while a student of the Indiana painter Otto Stark. Hardrick won praise and admiration for his youthful endeavors. Encouraged by a local art store owner, Herman Lieber, he entered the John Herron School of Art in Indianapolis. Hardrick managed to achieve national stature while painting only in his spare time: to fund his studies he worked in a foundry and later hauled coal and drove a cab to support his growing family. Although he aspired to studying in Europe, he was too occupied with family obligations to accept offers supporting his study abroad.

By the 1930s Hardrick had established himself as a masterful portrait painter, gaining prestige for his portraits of children as well as prominent people. Almost every well-to-do black family in Indianapolis owned paintings by Hardrick, and many residents had their portraits painted by him. Although portraiture occupied much of his time, he was also a prolific landscape painter and won accolades and prizes in both genres.

Hale Aspacio Woodruff was a respected artist and notable educator who sought to awaken the inner aesthetic man in his students. He likened man to an iceberg: The small portion of the ice appearing above the water is man's intellectual and analytical mind, while the major portion

below the surface is the aesthetic man capable of sensing and appreciating the beauty of the world. Woodruff felt an appreciation of this kind could be acquired only through active creativity, not by merely attending exhibits or gatherings with artistic people.

Woodruff exhibited frequently at local shows during his student days. Although he entered the Herron school in 1920, he was anxious to further his studies in Europe and introduce himself to the modern movements. In fall 1927 he sailed for France, where he spent four years studying and painting. During his European sojourn, Woodruff had the opportunity to show his work to Henry O. Tanner and discuss his artistic goals with the master.

In 1931 Woodruff accepted a teaching position at Spelman College in Atlanta. He spent fifteen years as the college's leading art educator, while continuing to pursue his own career as an artist. A major accomplishment of Woodruff's Atlanta years was his founding and directing of the annual Atlanta University art exhibitions, which became pivotal to the advancement of African-American artists in this country.

Woodruff's return from Paris and move to Atlanta coincided with, and perhaps encouraged, a major change in his style from provincial landscapes and figure studies to social realist scenes and stylized landscapes. In 1936 the artist received a grant offering him an opportunity to assist the eminent Mexican muralist Diego Rivera. The time with Rivera and support from the Federal Arts Project spurred Woodruff to undertake his famous Amistad murals for Talladega College in Alabama, which were installed in 1939.

During this period Woodruff was influenced by the Mexican muralists and American scene painters, such as Thomas Hart Benton and Grant Wood. With the demise of the WPA art programs and the advent of World War II, much of the impetus for American scene painting disappeared, and in the 1940s new forces began to emerge. Woodruff left Atlanta to take a position at New York University in 1946, where he came under the influence of the developing school of abstract expressionism.

Stimulated by his personal collection of African sculpture, Woodruff purposely and consciously included the aesthetics of African art in his charcoal drawings and oil paintings, which over the years became increasingly more abstract. He never attempted to render African forms directly but used them as the basis for distilling and creating new forms emphasizing the frontality, the unity, the gesture, the sense of dignity and presence that exist in African art. He did this without references to the historical, religious, or functional role that art plays in African culture. His aim was to interpret, through his knowledge of African sculpture, the African artist's view of life and the nature of man.

Woodruff felt art was an intricate part of life and an important force in society. He wanted to see a balance between science and art that placed an emphasis on the aesthetic sense. In his own art, Woodruff sought to make society aware of the black experience, the contributions African Americans made to America's growth and development, and the importance of their African heritage. He accomplished this through his murals exhibiting African-American history, his social realist paintings of southern life, and his abstract expressionist compositions incorporating African imagery.

William Majors was thirty years old when he received his Bachelor of Fine Arts degree in 1960. His late start as an artist was due to his hospitalization in a tuberculosis sanitorium for six years beginning at age sixteen. Illness did not dampen Majors's enthusiasm nor stand in the way of his progress. Following his recovery, Majors enrolled at the Herron school. In his senior year he won a John Hay Whitney Foundation Fellowship for the study of religious art and painting in Florence, Italy. Majors returned to Indianapolis in 1961 and settled in New York a year later, taking a job as a guard at the Museum of Modern Art and as an art instructor in the evening at the museum's Institute of Modern Art.

Majors's work includes abstract expressionist paintings and prints. His eighteen-print portfolio, *Etchings from Ecclesiastes* (figs. 66-68), won the grand prize at the First

World Festival of Negro Arts in Dakar, Senegal, in 1966. The folio, published by the Junior Council of the Museum of Modern Art in 1965, is now in the collections of museums across the country, including the Indianapolis Museum of Art.

Majors was also a teacher. While still a student he taught children's classes at the Herron school and later held such positions as art department chair at Orange County Community College in Middletown, New York; chairman of the graphic arts division at California State University; and director of the Third World Program at the Rhode Island School of Design.

Majors's ideology was inspired by his religious upbringing and by his acute awareness of the world around him. Late in life he recalled: "Through the years, the major underlying themes in my work have derived from my personal experience and the practice of making pictures. I have been inspired by themes from the Old Testament, moved by the course of events in the life of the streets and the world at large and stimulated by nature, both seen and unseen."[1]

The exhibition *A Shared Heritage: Art by Four African Americans* focuses on the work of Scott, Hardrick, Woodruff, and Majors, whose careers were launched in Indianapolis. With this exhibition and accompanying catalogue, the Indianapolis Museum of Art recognizes the significant contributions made by the four artists to the history of American and African-American art. Ranging from realism and impressionism to expressionism and abstraction, their styles span the trends in twentieth-century American art. Through analysis that begins at the turn of the century, when Scott and Hardrick were painting their earliest canvases, and culminates in the abstract art of Woodruff and Majors in the late 1970s, the essays in this book offer an enlightening view of the artists and the environments in which they lived.

The New York Store, Indianapolis, 1914. Reproduced from the archives of the Indiana Historical Society Library. This building housed the Pettis Gallery, one of the local galleries where William E. Scott, John W. Hardrick, and Hale A. Woodruff exhibited their work.

Frontispiece:
John Wesley Hardrick. *Bus in a Snowstorm* (detail), oil on board, 20 x 24 inches. Collection of George and Terry Gray.

1. *Majors: Graphics*. An exhibition of the winter artist-in-residence, Dartmouth College, Beaumont-May Gallery Hopkins Center, 28 January-6 March 1977, n.p.

1

Image and Identity: The Art of William E. Scott, John W. Hardrick, and Hale A. Woodruff

Harriet G. Warkel

Image and Identity: The Art of William E. Scott, John W. Hardrick, and Hale A. Woodruff

Harriet G. Warkel

William Edouard Scott

*I*n 1915, almost ten years before the scholar and philosopher Alain Locke called for "a school of racial art" focusing on African-American subjects, William Edouard Scott was preparing to leave for Tuskegee, Alabama, to study southern life among his people.[1] Scott's interest in African-American subject matter was enhanced by his association with Henry O. Tanner, whose formidable reputation made him a mentor to many African Americans studying in France. Scott met Tanner on his first trip to France in 1909, and the two developed a close friendship.

The work Scott produced abroad focused on French genre scenes, with a particular emphasis on peasant life. There is a poignancy to his images, a reflection of the artist's empathy with his subject. *La Pauvre Voisine (The Poor Neighbor)* (fig. 1), executed in 1912 while Scott was a student at the Académie Julian and accepted in the Paris Salon the same year, is reminiscent of Tanner's *The Thankful Poor*, 1894.[2] His mentor's influence is again apparent in *Breton Smithy*, about 1913 (fig. 2), which has its roots in Tanner's *The Young Sabot Maker*, 1895. Scott was inspired by Tanner's subject matter, palette, modified impressionist technique, subdued tonalities, and dramatic lighting.

Rainy Night, Etaples, 1912 (fig. 3), and *La Misère*, 1913 (fig. 4), depict the area around Tanner's summer home near Etaples in Normandy. Tanner's influence is evident in the style and tone of *Rainy Night*, a loosely brushed and spontaneous composition demonstrating the restrained impressionist technique that dominated Scott's European paintings. Here the scene is almost completely shrouded in darkness, except for rays of light emanating from two street lamps and an occasional window. The shadowy figures in the foreground are set against an incandescent illumination and a glistening wet pavement. Scott skillfully draws the viewer's eye into the composition by placing a horse-drawn carriage in the distance. This carriage, a symbol of wealth, forms the apex of a triangle whose base joins the two groups of figures clutching umbrellas on either side of the composition. The artist structures this work in a classical manner, then loosens his brush strokes to give the scene an elusive quality.

The style of *La Misère* contrasts with the freely brushed technique of *Rainy Night*. The buildings are solid, sturdy structures lit by bright sunlight. Even the shadows cut across the scene with a crisp angularity. Set against this rigidity are figures of a mother and child in the street and a man sprawled in the doorway. These images serve as symbols of the poverty of French peasant life. The horse-drawn carriage in the background again alludes to a more affluent society just beyond the reach of the foreground figures.

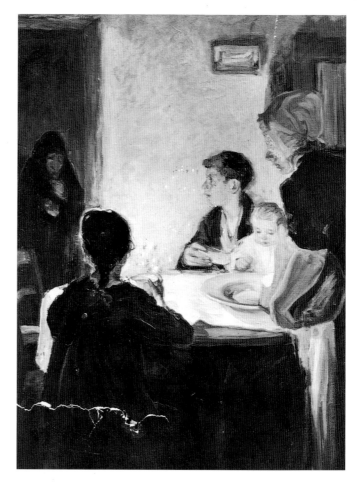

Figure 1. William Edouard Scott. *La Pauvre Voisine (The Poor Neighbor)*, 1912, photograph. Courtesy of Eric Wallace.

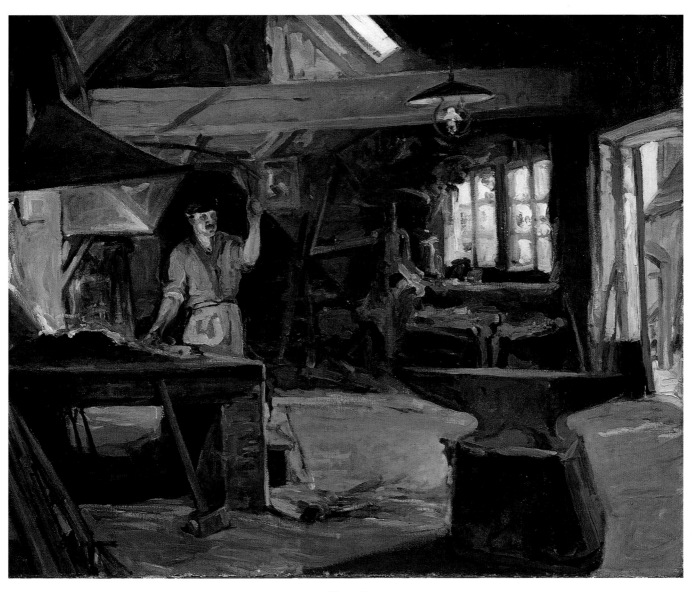

Figure 2.
William Edouard Scott. *Breton Smithy*, about 1913, oil on canvas, 25 1/2 x 32 inches.
From the collection of the Indiana State Museum and Historic Sites.

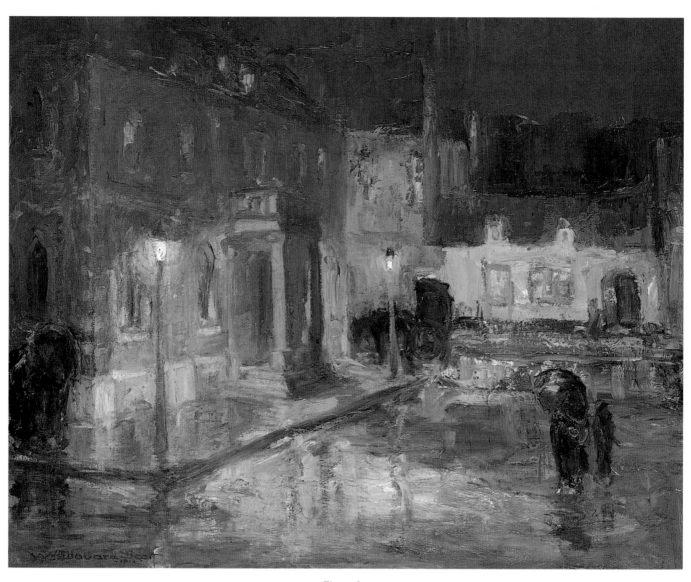

Figure 3.
William Edouard Scott. *Rainy Night, Etaples*, 1912, oil on canvas, 25 1/2 x 31 inches.
Indianapolis Museum of Art.
Gift of a group of African-American citizens of Indianapolis.

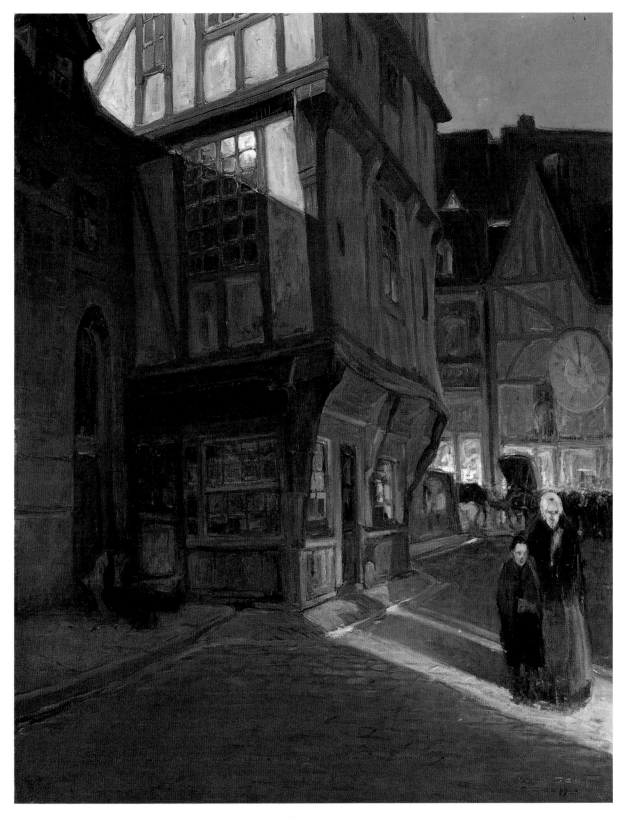

Figure 4.
William Edouard Scott. *La Misère*, 1913, oil on canvas, 58 x 45 1/4 inches.
From the collection of the Indiana State Museum and Historic Sites.

When Scott returned to America in 1914, he was solidly grounded in the French academic tradition. He had joined the legions of American artists who studied in the French academies and sought advanced training in the ateliers of Parisian artists. For the African-American artist, Paris meant a freedom and acceptance not found at home, an opportunity to study and exhibit freely with other painters. Scott had become an internationally recognized artist whose works were shown at the Paris Salon and the Royal Academy in London.[3] He was trained not only in the European academies, but also by the most respected African-American artist of his day. This combined influence was to manifest itself in Scott's pursuit of black subject matter and would remain a constant force in his art.

By 1915 Scott had attained a formidable reputation as a talented African-American artist. When he set out for his trip to Tuskegee, Alabama, the distinguished educator and founder of Tuskegee Institute, Booker T. Washington, invited him to be his guest.[4] Washington was a strong advocate of utilitarian education and manual training as a means of advancement for African Americans. His views were supported by white sponsors, and he was often accused of preaching accommodation as a solution to the problems facing blacks in America. Although his system of achieving equality for African Americans is sometimes questioned, he had an indisputable vision of a "free and united country."[5] During his stay at Tuskegee, Scott took the opportunity to paint a portrait of his host.[6] It was the first of several portraits of Washington he painted, but the only one executed from direct observation. Washington died less than a year after the artist's arrival in Tuskegee. In the first portrait, Washington faces the viewer. His strongly delineated features, emphasized by the white collar of his shirt and the nondescript, dark background, reflect the artist's academic training. A clarity and attention to detail are combined with a focus on the contrast of light and dark. Scott succeeded in presenting a sensitive depiction of Washington, one of the most influential black leaders of his time.

Scott later rendered a double portrait of Booker T. Washington and the Tuskegee scientist George Washington Carver using Carver's laboratory as the setting (fig. 5). Washington brought Carver to the Institute as the school's director of agricultural research.[7] During his tenure at Tuskegee, Carver revolutionized the southern agricultural economy by deriving hundreds of products from the peanut and the sweet potato, thus liberating the South from an excessive dependence on cotton. By placing these two prominent African Americans in the same portrait, Scott emphasized the importance of working together for the betterment of the black population.

It's Going to Come (fig. 6), painted in 1916, was probably conceived during Scott's trip to Tuskegee. The wooden shack and barren landscape are typical of the conditions under which poor southern black families lived. A woman, dressed in a white apron and scarf, stands with hands on hips looking out into the distance. Her expression is one of sadness, but her stance is defiant. The woman appears to be searching for a solution to her family's poverty and their constant struggle to survive. The subject is similar to Scott's Parisian genre scenes, but here the artist expresses a very personal response to his firsthand observation of the plight of African Americans.

During one of his trips south in the 1920s, Scott painted *The Maker of Goblins,* also known as *High-powered Salesman, Hallowe'en* (fig. 7). Here a young boy is seated on the steps of his cabin home carving pumpkins into jack-o'-lanterns to sell for Halloween. Scott takes an optimistic view of southern life in this painting. Although the boy is dressed in torn clothing and worn shoes, he seems content with his task and anxious to turn his work into profits. Scott's positive view of life permeates his canvases. He saw a bright future for his race and sought to capture this positive attitude in his work. It was never the artist's intention, however, to ignore the problems faced by his people. When the opportunity arose to take a serious look at these problems, he approached them with an intensity befitting the subject.

Scott was asked to illustrate several covers for *The Crisis,* the magazine of the National Association for the Advancement of Colored People (NAACP). William E. B. Dubois, who was the editor of *The Crisis* and the founder of the NAACP in 1909, commissioned a painting from Scott for the Easter 1918 issue of the magazine. *Traveling* (fig. 8), also known as *Lead Kindly Light* (fig. 9), is one of Scott's most poignant images.[8] The inspiration for this painting was the artist's grandparents, who traveled by ox cart from North Carolina to Indianapolis in 1847. Here two figures are huddled together in their wagon. The man

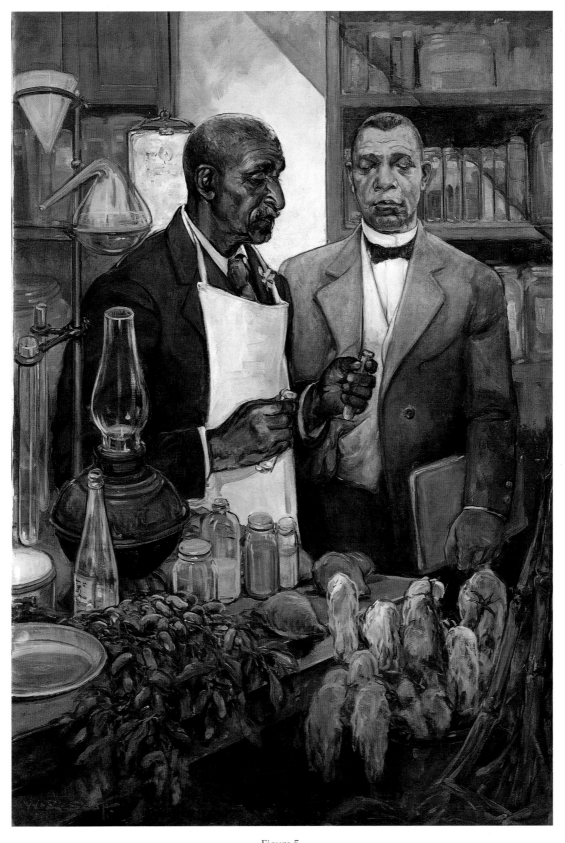

Figure 5.
William Edouard Scott. *Booker T. Washington and George Washington Carver in Carver's Laboratory*,
oil on canvas, 62 x 42 inches.
DuSable Museum of African American History, Chicago.

Figure 6.
William Edouard Scott. *It's Going to Come*, 1916, oil on canvas, 18 x 21 $7/8$ inches.
Collection of Mary Louise Clampitt.

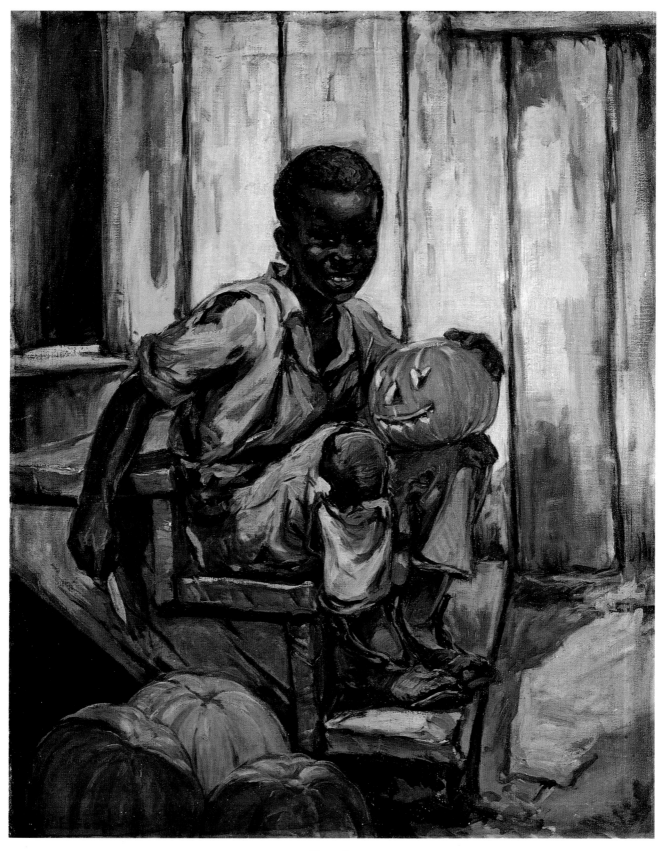

Figure 7.
William Edouard Scott. *The Maker of Goblins (High-powered Salesman, Hallowe'en)*, oil on canvas, 32 x 25 inches.
Collection of Mr. and Mrs. Richard C. Norton.

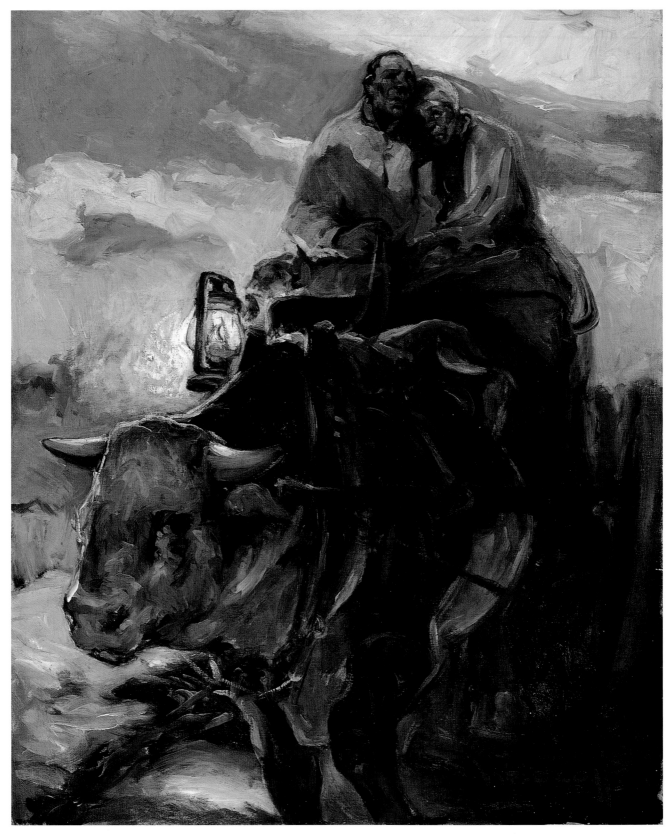

Figure 8.
William Edouard Scott. *Traveling (Lead Kindly Light)*, 1918, oil on canvas 18 x 22 inches.
Collection of Mrs. Virginia Van Zandt.

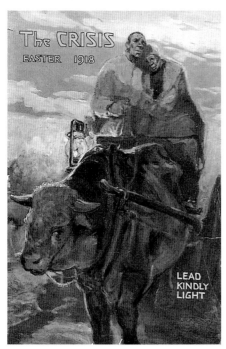

Figure 9.
William E. Scott.
Lead Kindly Light,
cover of *The Crisis*,
April 1918.

steering his oxen toward an uncertain future supports his weary wife's head on his shoulder. The light from the lantern gives the painting its title. Whether the couple were driven from their home or are moving voluntarily is left to the viewer's imagination, but desperation and apprehension are clearly evident on their faces. Scott and Dubois used the celebration of the resurrection as an opportunity to emphasize the difficult situation facing blacks in America and their constant search for a better life.[9]

Although Scott had a special interest in genre scenes portraying the black experience, portraiture and mural painting were his principal livelihood. In *The Crisis Advertiser* of 1919, Scott ran an ad offering to paint portraits from photographs, particularly of "your son or your brother who is 'over there,'" referring to the soldiers serving abroad in the years after World War I.[10]

Yet Scott's success as an artist does not lie in commissions from such advertisements. It is his more than thirty portraits of prominent African Americans, including his famous paintings of Washington and Carver, that helped to make Scott a leading black artist.[11] Among these historic portraits is a posthumous painting of abolitionist Frederick Douglass (fig. 10), shown in a pensive profile as if the burden of the world were on his shoulders. Scott depicts Douglass, with white hair and beard, in the latter part of his life, probably between 1871 and 1891. During this period Douglass served as territorial legislator of the District of Columbia, recorder of deeds, and consul general to the Republic of Haiti. Scott captures the essence of this strong-willed leader, who was instrumental in convincing President Abraham Lincoln that African Americans should be allowed to fight against slavery as soldiers in the Civil War.[12]

In 1931 Scott received a Julius Rosenwald Fellowship to study Negro types in the West Indies. The artist sailed for Port-au-Prince, Haiti, on March 13 to paint the inhabitants of the first black republic in the Americas.[13] Scott wanted to record the domestic life and customs of a people he believed lived in an unspoiled environment.[14] He felt certain the people of Haiti, who still maintained their African heritage, would be perfect subjects for his paintings.

Scott painted over 144 works while in Haiti.[15] Typically he traveled to the Haitian countryside, made sketches of people or scenery, and then returned to his studio to complete the painting.[16] The artist used a vibrant palette in his Haitian paintings, eliminating the subdued, limited tonalities and dramatic lighting of his European canvases. Haiti's local color and bright sunlight captivated the artist, who enjoyed the spirit of peasant life and his daily contact with the people. The inspiration Scott derived from painting Haitian subjects remained with him throughout his life, as he returned again and again to his Haitian experiences to express his love for his people. A Haitian critic commented on Scott's keen understanding of Haitian culture: "In our country for just eight months, Mr. Scott has analyzed and studied it thoroughly. Crossing all the island from Kenscoff to the Cape, passing by La Citadelle, the painter has taken his rich palette."[17] Scott painted numerous scenes of daily life in Haiti, concentrating mainly on the poorer classes of people. The artist felt their features, dress, customs, and directness lent to his paintings a vigor not found among the upper-class Haitians.[18]

Although almost all Haitians are baptized as Roman Catholics, the peasants practice Vodun, a religion blending African beliefs with elements of Catholicism.[19] Scott painted a series of canvases depicting Haitians going to church to attend confirmation ceremonies (fig. 11). These paintings show a young girl dressed in white seated on a donkey. A woman walking beside the animal holds a pair of shoes, probably borrowed for the occasion. In most of these depictions a man, dressed in a white suit, stands in the background. The expense of purchasing shoes and clothing plus the time required to participate in the for-

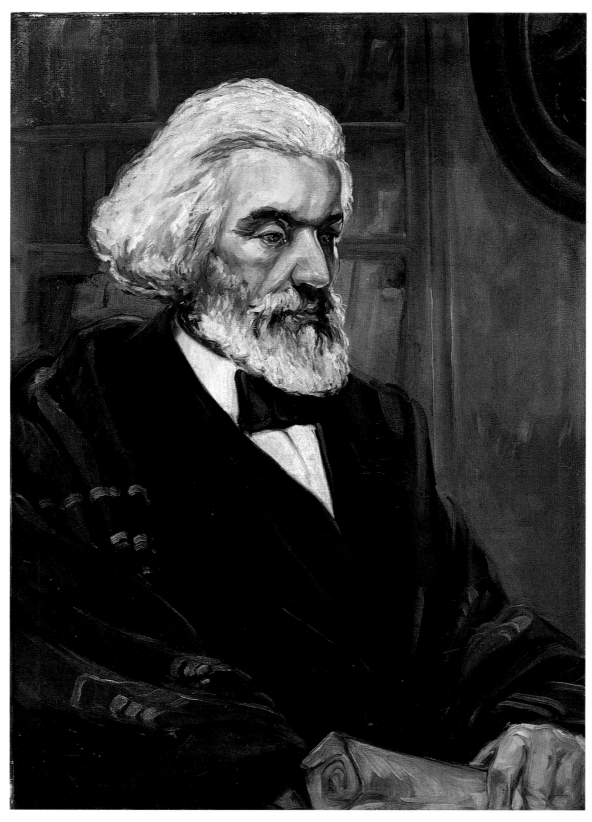

Figure 10.
William Edouard Scott. *Frederick Douglass*, oil on canvas, 40 x 30 inches.
Collection of Dr. Margaret Burroughs.

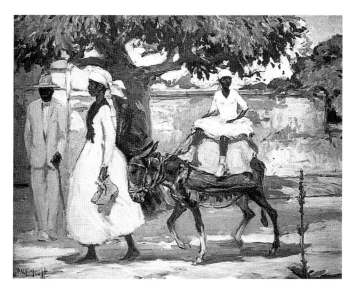

Figure 11. William Edouard Scott. *First Communion, Port-au-Prince, Haiti*, about 1931, oil on canvas, 23 1/2 x 27 1/2 inches. Gallery of Art, Howard University, Washington, D.C.

malities of religious ceremonies often deter Haitians from a full commitment to Roman Catholic ritual.[20] Most peasant families cannot afford the time away from the tasks necessary to maintain their daily existence. Scott's paintings are filled with details of the customs, conditions, and lifestyles of the Haitian people, and are valuable accounts of this black republic, recorded with an eye for truth and a taste for the exotic.

A very popular Sunday afternoon sport for Haitian men is the cockfight. The event is held under a shelter in the organizer's backyard.[21] Scott's *Cockfight* (fig. 12) focuses on the man responsible for rubbing down the birds between rounds. In the distance the spectators, with their backs toward the viewer, stand on a platform watching the match. Scott divides his canvas between anticipation and action but keeps the actual fight hidden from view behind the crowd of spectators. Here the artist's limited palette, strong contrasts of light and dark, and tightly enclosed space recall his French academic training and the work of Tanner. The scene, however, is animated by the rhythmic lines of the figures in the background and the birds positioned carefully in the foreground to lead the viewer around the canvas.

One of the most important landmarks in Haiti is the Citadel, built as a fortress by Henry Cristophe, who crowned himself king of Haiti in 1811. Designed to counter any military attacks, the Citadel was already a major tourist attraction when the artist arrived in Haiti. Scott's *The Citadel, Haiti* (fig. 13) shows the fortress looming in

the distance, a striking contrast to the foreground boat sailing on the tranquil waters and the Haitian people performing their daily chores. The calm scene is far removed from the battles Christophe was preparing to fight to keep Napoleon from reclaiming Haiti and from the splendid court life in his castle near the Citadel. The Citadel became Christophe's tomb after he fell out of favor and committed suicide in 1820.[22] At the time Scott was in Haiti, the country was under direct United States rule. American troops were withdrawn from the island in 1934, two years after the artist left the republic. In Scott's painting, the Citadel stands as a symbol of independence and a reminder of the country's past.

The Haitian markets were Scott's favorite subject. These markets, managed by Haitian women while the men worked the fields, are the spirit of Haitian life.[23] Scott's *Turkey Vendor* (fig. 14) vividly displays the local color of these busy centers. Here a woman balances two birds on her head and carries several others. Her nonchalant expression is punctuated by a pipe dangling from her mouth. *Haitian Market*, 1950 (fig. 15), also captures the crowded atmosphere and inherent exoticism of the island's markets. The classical columns in its architectural backdrop add an element of grandeur and solidity to the bustling scene. Scott's sense of harmony and organization, derived from his academic training, are essential elements in the success of his market views. The artist's tenure at the French academies taught him how to make unity out of chaos, but Scott's stay in Haiti added a richness of color and texture missing from his European scenes.

In Haiti women are often accompanied to the market by their youngest children. Haitian families are usually large, but each child is considered a gift from God.[24] In *Mother and Child* (fig. 16) the baby's head is nestled in its mother's neck. The bond between the two is enhanced by Scott's use of white for both the baby's blanket and the woman's blouse. A building and background trees halt any recession into depth, forcing the viewer to concentrate on the figures. The young mother's intense expression and her powerful presence display the energy and determination characteristic of Haitian women.

Scott's figure studies of the old men and women of Haiti demonstrate his ability to render the essential character of the Haitian people. His elderly subjects, with their deeply furrowed brows, are vividly expressive of years of

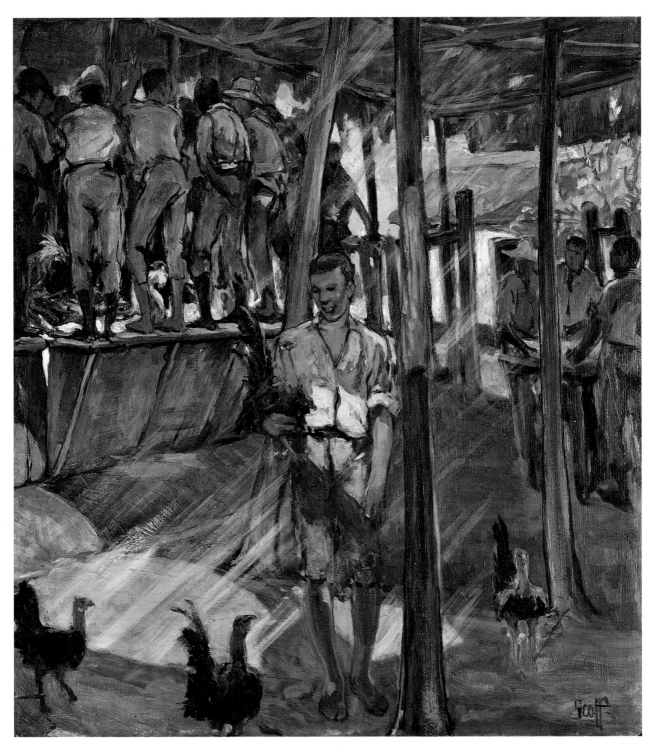

Figure 12.
William Edouard Scott. *Cockfight*, oil on wood panel, 22 x 18 inches.
Collection of Byron and Frances Minor.

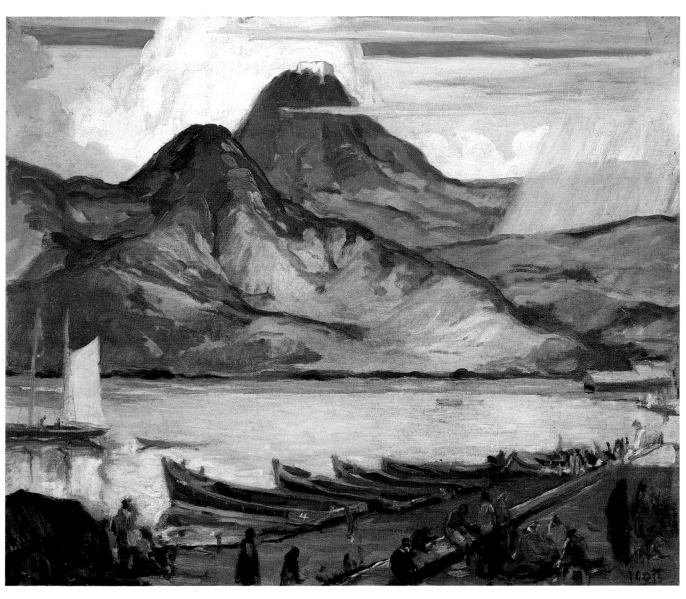

Figure 13.
William Edouard Scott. *The Citadel, Haiti*, oil on canvas, 18 ¹/₂ x 22 ¹/₂ inches.
Collection of James T. Parker.

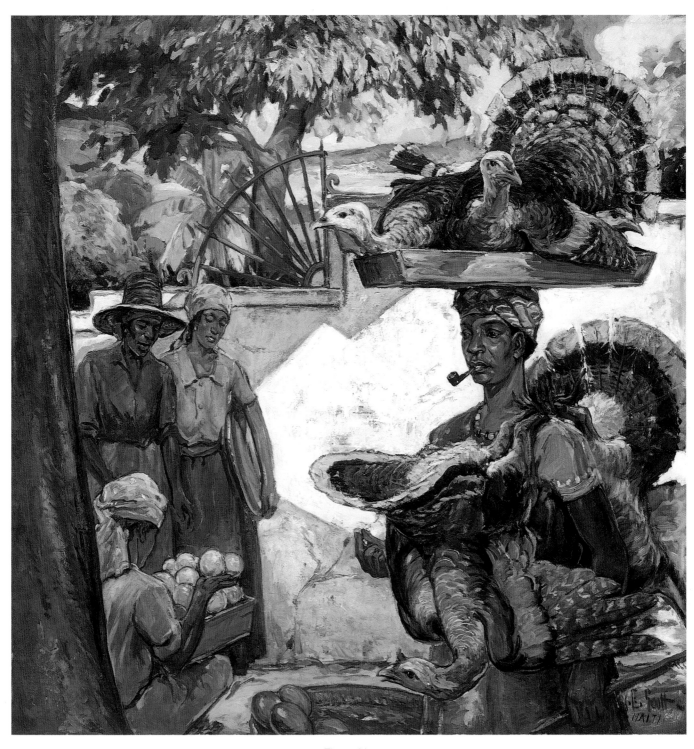

Figure 14.
William Edouard Scott. *Turkey Vendor*, oil on canvas, 37 1/2 x 36 1/4 inches.
DuSable Museum of African American History, Chicago.

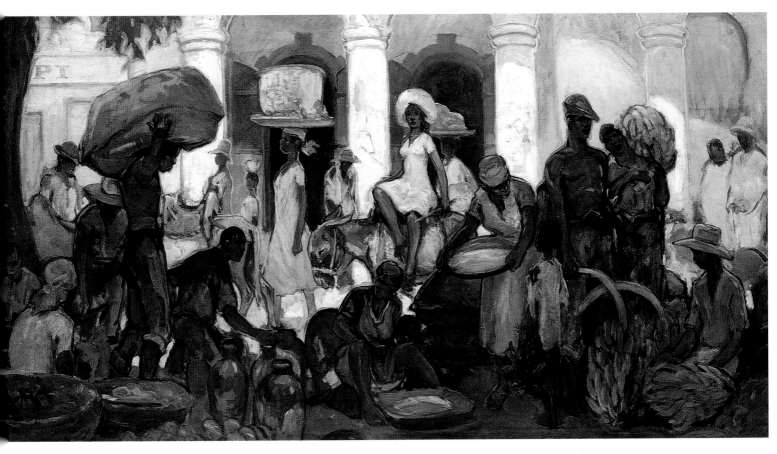

Figure 15.
William Edouard Scott. *Haitian Market*, 1950, oil on canvas, 30 x 48 inches.
Collection of Fisk University, Nashville, Tennessee.

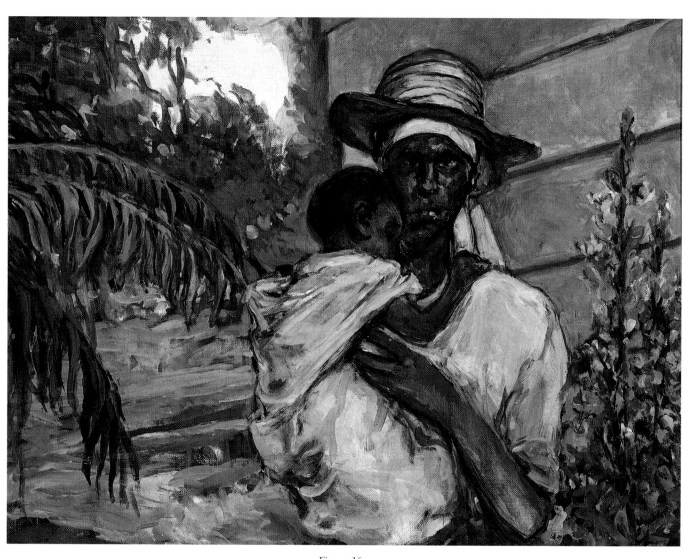

Figure 16.
William Edouard Scott. *Mother and Child*, oil on canvas, 13 x 17 inches.
Collection of Dr. Joan Scott Wallace.

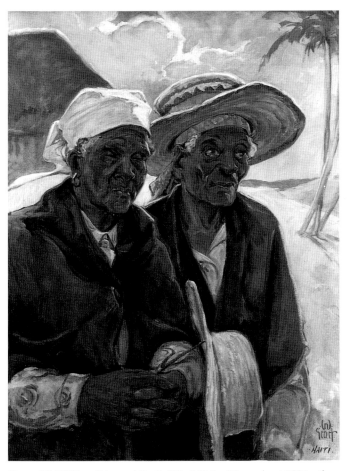

Figure 17. William Edouard Scott. **Blind Sister Mary**, about 1931, oil on canvas, 29 3/4 x 24 inches. Schomburg Center for Research in Black Culture, Art and Artifacts Division, The New York Public Library, Astor, Lenox and Tilden Foundation.

liberator, Toussaint L'Ouverture, who in 1791 led Haiti's slaves to a victory against the French. Scott's painting of this former slave (fig. 21) shows him in complete control of his small civilian army and preparing to lead the rebellion. L'Ouverture's drawn sword points in the direction of the confrontation, but his left arm is raised toward his followers, directing the viewer back to the multitude of former slaves with their crude weapons poised for battle. The work brings to mind Eugène Delacroix's *Liberty Leading the People, July 18, 1830*, (fig. 22). In both paintings the central figure is set apart from the rest of the scene. Liberty's gaze backward to the throng of people is similar to L'Ouverture's gesture toward the mass of humanity waiting to follow his lead. Scott creates his own brand of agitation, anticipation, and excitement, capturing the same sense of drama found in Delacroix's spectacle.

After Scott moved back to Chicago in 1932, he continued to paint Haitian scenes but also returned to murals and portraits. In April 1934 he executed a life-size portrait of Abraham Lincoln and his son Tad for the Cook County

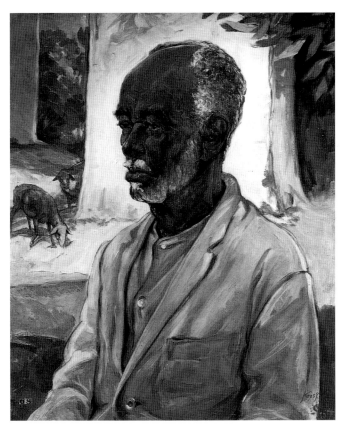

Figure 18. William Edouard Scott. **Kenskoff, Haiti**, about 1931, oil on canvas, 22 x 18 inches. Schomburg Center for Research in Black Culture, Art and Artifacts Division, The New York Public Library, Astor, Lenox and Tilden Foundation.

hard work in the hot sun under difficult conditions. The strength, resilience, and determination of the Haitian peasants is summed up in works such as *Blind Sister Mary* (fig. 17) and *Kenskoff, Haiti* (fig. 18), two of Scott's portraits of a people who endure their hardships with dignity.

Scott's *Night Turtle Fishing in Haiti*, 1931 (fig. 19), combines a Tanneresque background with a scene reminiscent of Winslow Homer's Bermuda paintings, particularly *The Turtle Pound*, 1898 (The Brooklyn Museum) and *The Gulf Stream*, 1899 (fig. 20). In *Night Turtle Fishing in Haiti* Scott achieves his most successful and dynamic composition. Here the artist returns to Tanner's blue-green palette and dramatic use of light. The richness of color beneath the hazy, sunlit sky and the diagonal thrust of the boat tilting under the force of the waves demonstrate the vitality and power that make Scott's Haitian paintings his most successful artistic accomplishments.

Any attempt at depicting the Haitian people would have been incomplete without a representation of their

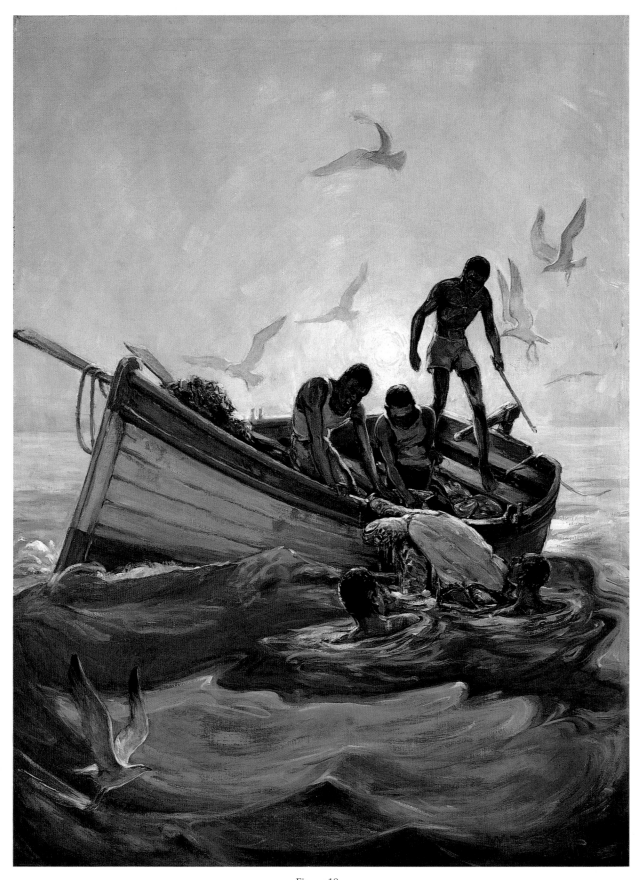

Figure 19.
William Edouard Scott. *Night Turtle Fishing in Haiti*, 1931, oil on canvas, 39 1/2 x 29 1/2 inches.
Clark Atlanta University Collection of African American Art. Gift of Judge Irvin C. Mollison.

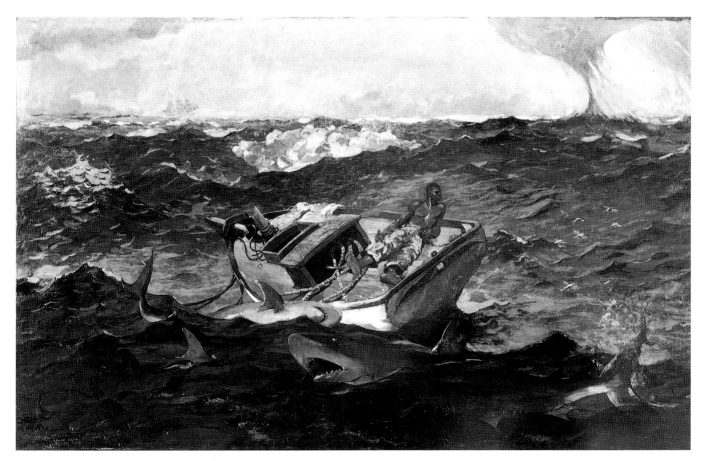

Fig. 20. Winslow Homer. *The Gulf Stream*, 1899, oil on canvas,
28 1/8 x 49 1/8 inches. The Metropolitan Museum of Art, Wolfe Fund,
1906. Catharine Lorillard Wolfe Collection.

Juvenile Court in Chicago. That same year he was com-
missioned to do a mural for a Chicago funeral home to
commemorate its eighth anniversary. Scott also completed
three religious murals for St. Paul's A.M.E. Church in
Glencoe, Illinois. At the time of these commissions the art-
ist was working on portraits of Julius Rosenwald, two
judges, and ten Chicago doctors, and a life-size portrait of
Haitian President Stanio Vincent, which was sent to the
city of Port-au-Prince.[25]

Between 1935 and the 1950s Scott completed thirty
murals for the field houses in the Chicago park district
and forty murals for Chicago churches. In 1942 he was
one of seven winners in a nationwide competition to paint
murals for the Recorder of Deeds building in Washing-
ton, D.C. In a letter to Scott informing him of his selection,
Edward B. Rowan, Assistant Chief of the Section of Fine
Arts, Washington, D.C., noted, "Your design was chosen
on the basis of the sincerity with which you depicted both
Lincoln and Douglass, and the spirit of reality that you
succeeded in putting into the setting."[26] His work *Frederick*

*Douglass Appealing to President Lincoln and His Cabinet to
Enlist Negroes* was finished in 1943. Upon its completion
Scott was commissioned to paint a mural commemorat-
ing the dedication of the Recorder of Deeds building,
which was installed in 1944.[27] Here Scott placed the figure
of President Roosevelt, who presided over the ceremonies,
within a bright sunlit triangle that the artist hoped "would
add interest and color" to the composition.[28] Scott was
adhering to his academic training, which taught him to
organize the figures within a triangular arrangement. In-
stead of idealizing his figures as academicians would ad-
vocate, however, Scott used numerous photographs to
create a realistic depiction of his subjects.

During the 1950s Pope Pius XII consecrated the first
black bishops of the Roman Catholic Church. To celebrate
this event, Scott painted *Pope Pius XII and Two Bishops*,
about 1953 (fig. 23). The pope, in his white vestments, is
centrally positioned above the bishops. His triangular-
shaped miter extends to the edge of the canvas, empha-
sizing his stature and power. The unadorned, geometrical

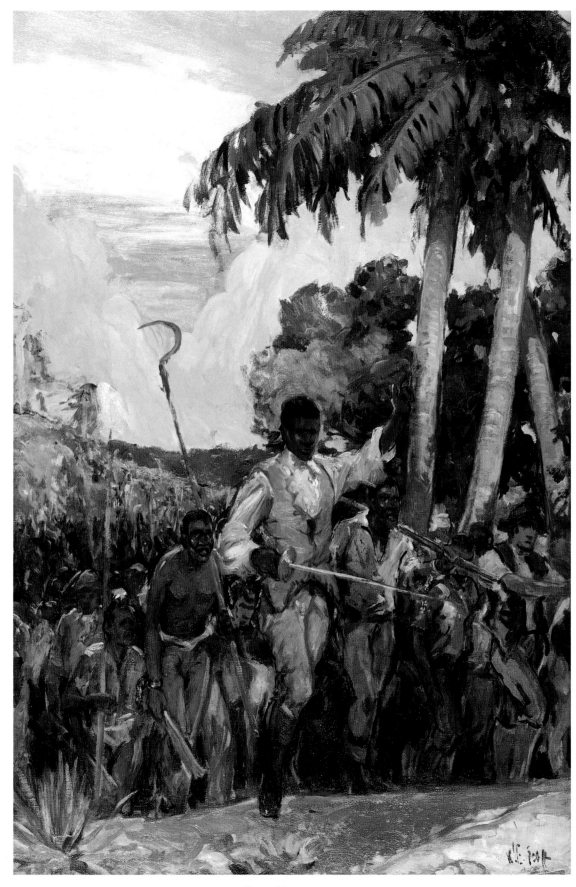

Figure 21.
William Edouard Scott. *Toussaint L'Ouverture*, oil on canvas, 40 x 22 inches.
Amistad Research Center, New Orleans, AFAC collection.

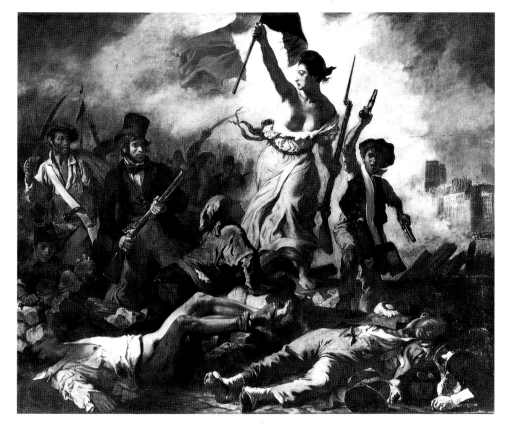

Figure 22. Eugene Delacroix. ***Liberty Leading the People, July 18, 1830***, 1830, oil on canvas, 96 3/8 x 128 inches, The Louvre, Paris. (Giraudon/Art Resource, NY)

background and the painting's triangular composition recall the style of Renaissance portraiture. Scott's positioning of the three bishops clearly suggests the trinity, symbolizing unity in diversity. This painting, a key work in Scott's career, not only epitomizes classical tenets, but also expresses the artist's vision of the future of race relations.

In 1955 Scott visited Mexico City with the intention of painting the area and its people. He completed several canvases during his visit, but while there he discovered he had diabetes. Although he was eventually confined to a wheelchair and developed problems with his vision toward the end of his life, the artist continued to paint until his death in 1964.[29]

Throughout his life Scott stayed within the realist tradition of Thomas Eakins and Winslow Homer. He neither followed the trend toward abstraction nor used African imagery in his art, as some of the younger African-American artists were doing. Scott steadfastly adhered to traditional methods of painting. In the introduction to a bro-

chure produced for an exhibition of Scott's work in 1970, the writer noted, "His paintings seem tepid now that the aesthetic credos under which he operated have been superseded, but he was a master of his craft in the context of his time, and the recognition accorded him was fully deserved."[30]

While Scott adhered to the precepts of the European academic tradition, he is considered one of the most outstanding African-American artists of the Harlem Renaissance. He epitomized the themes advocated by Alain Locke long before it became stylish to paint the black experience. Scott's goal was to persuade African-American artists to look at the world around them and to recognize the wealth of subject matter within their own communities.

■

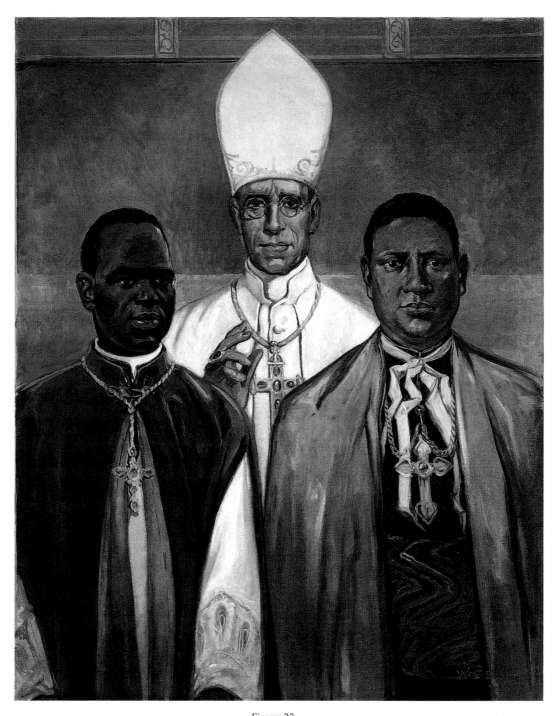

Figure 23.
William Edouard Scott. *Pope Pius XII and Two Bishops*, about 1953, oil on canvas, 40 x 33 inches.
Collection of Lester and Nancy McKeever.

John Wesley Hardrick

John Hardrick. Just remember the name, will you, please? And when in the distant future I turn about and say, "I told you so!" you may accuse me of having peculiar psychic powers, or whatever else you will. I can't quite explain why I have done so—perhaps just because I have a feeling in my bones that it will be—but I have put John Hardrick's name down in my little memorandum book as the name of a future great artist."[31]

Lucille Morehouse, the art critic for *The Indianapolis Star*, saw in John Wesley Hardrick a young man of exceptional talent. She wrote the above critique on the occasion of a 1913 exhibition that included students from the John Herron School of Art. Hardrick was then twenty-one years old and had been attending the art school for almost three years. The young artist's goal at that time was to study under one of the world's masters. But Hardrick married young, and his family grew quickly, leaving him unable to take advantage of the opportunities he was offered to study abroad. Hardrick remained in Indianapolis, painting the landscape and the people around him. The artist's distinctive impressionist style made him one of the city's prominent landscape painters, and his skill in capturing appearance and personality made him a sought-after portraitist.

Hardrick's landscapes are derived from the many trips he took to Brown County, about fifty miles south of Indianapolis. He traveled to the area at the peak of the autumn season, when the leaves were at the height of their color; during the summer, when the sun was bright and hot; and in the winter, when the ground was covered with snow. He did not sketch or paint during these visits.[32] Instead, the artist took in the different scenes and committed them to memory. Over the years Hardrick called upon these mental images to paint numerous landscapes enhanced by an exquisite sense of color and a strong feel for nature. There is often a pattern to these landscapes that includes a meandering road or stream surrounded by dense foliage and heightened by blue sky and billowing white clouds. Hardrick's landscapes are in the tradition of the

Hoosier Group, five Indiana artists who worked in an impressionist style around the turn of the century.[33] The young artist primarily followed in the footsteps of his teacher at the John Herron School of Art, William Forsyth, a prominent member of the Hoosier Group. Hardrick was particularly influenced by Forsyth's paintings of twisting roads flanked by autumn landscapes.

Although the Hoosier impressionists were Hardrick's main influences, he also admired Auguste Renoir, Edgar Degas, and the post-impressionists Vincent van Gogh and Paul Gauguin.[34] Hardrick was inspired by Renoir's brilliant, sensuous hues and his placement of women among flowers and foliage. In Degas he found the inspiration for his delicate pastel landscapes. Hardrick was most attracted to the expressive quality of color in the work of Gauguin and van Gogh and to the latter's bold use of impasto.

Hardrick applied his paint very thickly, using a palette knife to create a tactile surface. He relied on a brush only to blend or add a shape, and used his thumb to mold the paint as if he were shaping sculpture.[35]

When painting a landscape, Hardrick liked to work quickly in order to maintain a feeling of spontaneity. He generally arose early to begin work on "a landscape composition which he had visualized the night before.... The picture was so definitely in mind with regard to its general form and color that the artist started to work on it without eating breakfast. And he kept putting his dream of a lovely landscape into material form and color until it was finished shortly before noon."[36] Starting at the top of his canvas, the artist would begin with the sky, overlapping his paint as he worked toward the foreground. Hardrick disliked returning to his painting or reworking it, so he rarely spent more than two days on a landscape. He rendered them with ease and confidence, adding a significant amount of imagination to his memories of Brown County.

Charles Wharton, a young Indianapolis artist who watched Hardrick paint landscapes in 1954, noted: "In order to endow his paintings with feeling, Hardrick be-

came one with his landscape, experiencing the rustle of the trees as he painted, the warm sunlight or the cold, wet snow. He lived inside each canvas making it his total existence."[37] Hardrick pursued endless variations of atmosphere and light effects. Stimulated by the Brown County countryside, the artist arranged and rearranged his actual experiences to create sensuous views of the changing seasons.

Hardrick often allowed the paint to flow down the canvas and concentrated on its expressive qualities rather than its descriptive function. He also preferred blending his own colors and rarely used premixed formulas, as he liked the spontaneity of creating hues while he painted.[38] Combining imagination with observation, Hardrick created canvases vibrating with color and light. His magnificent scenes, with their vigorous application of paint and thick impasto, are spectacular visions of the Indiana landscape.

Typical of Hardrick's autumn views is *Untitled Landscape* (fig. 24). Here densely foliated trees are enveloped in a delicate blue atmospheric haze. The reflection of the landscape in the water produces a mirrorlike impression that enhances the illusion of a wet surface. Well aware of the need for a sharp contrast along the water's edge to heighten this illusion, Hardrick used the rock formation bordering the creek to create the required opposing element and complete the compositional effect.

Winter Landscape, 1945 (fig. 25), exemplifies Hardrick's treatment of snow scenes. A frozen creek winds through the landscape, its icy surface broken by the trees' shimmering reflections. Hardrick captures the effect of light glistening off wide expanses of snow. The trees are cut off below the top of the composition, eliminating the horizon line and imparting an abstract quality reminiscent of the work of the American impressionist John H. Twachtman. In typical impressionist style the frigid stream is cropped on the left, implying the wintry scene continues into the viewer's space.

His landscapes are filled with lush foliage glistening in the warm sunlight and vividly expressive of the artist's love of nature (fig. 26). Occasionally Hardrick hints at the presence of humanity in his landscapes by including a farmhouse nestled among the trees. A clear, blue sky with its soft, white clouds hovers over these tranquil scenes. Sometimes a figure appears in the distance or a horse-drawn carriage works its way up a meandering road in an imaginary countryside far removed from city life.

Hardrick follows in the tradition of two important African-American artists, Robert S. Duncanson (1821-1872) and Edward M. Bannister (1828-1901). Duncanson, a Cincinnati artist, was the first major African-American landscape painter. He painted romantic landscapes in the Hudson River School style. Bannister, who settled in Rhode Island, was influenced by the Hudson River artists but eventually preferred the more lyrical mode of the Barbizon School.

Despite his prolific production of landscapes, Hardrick always considered himself first and foremost a portrait painter. In comparing Hardrick's landscapes with his portraits, Lucille Morehouse noted, "The colored friends who posed were real personalities, and they are alive on the canvas, but the landscape and woodland settings are formed altogether from the artist's imagination."[39] His skill in the field of portraiture can be attributed to Otto Stark, his teacher at both Emmerich Manual Training High School and Herron. Stark had a strong interest in figure painting, which he passed on to his students. He replaced the traditional boring method of copying lithographs with drawing exercises designed to encourage students to express themselves in an inventive way using various media.[40] Hardrick was the beneficiary of Stark's innovative teaching methods as well as his expertise as a figure painter.

Although Hardrick painted a diverse group of Indianapolis residents, his most sensitive portraits are of the city's African-American community. In his numerous portraits of the black citizens of Indianapolis, Hardrick captured on canvas a record of an elite group of African Americans to whom he looked for "co-operation and encouragement." Hardrick won many awards for his portraits and did, indeed, receive the support he desired.

Figure 24.
John Wesley Hardrick. *Untitled Landscape*, oil on board, 29 $^{13}/_{16}$ x 23 $^{1}/_{2}$ inches.
Indianapolis Museum of Art. Jacob Metzger Memorial Fund.

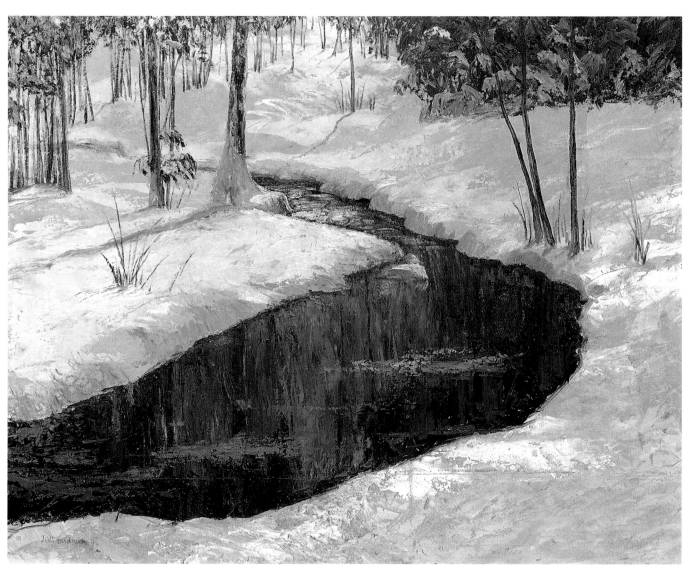

Figure 25.
John Wesley Hardrick. *Winter Landscape*, 1945, oil on board, 22 3/4 x 28 3/4 inches.
Indianapolis Museum of Art. Gift of the Indianapolis Chapter of Links.

Figure 26.
John Wesley Hardrick. *Summer Landscape*, oil on board, 28 x 34 inches.
Jack D. Finley Collection.

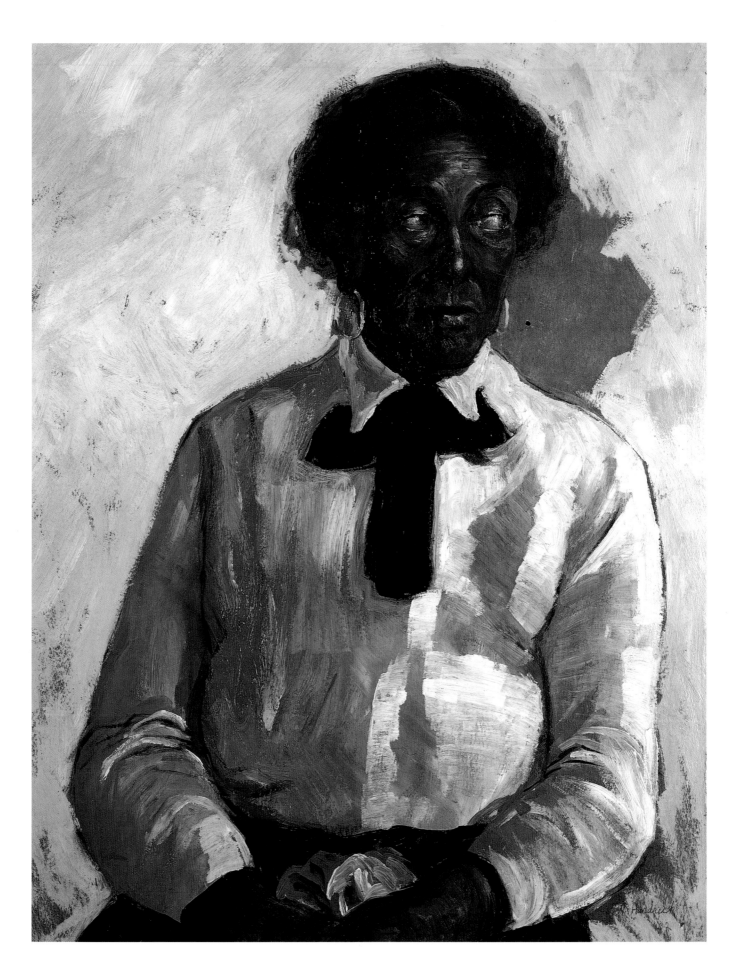

A Shared Heritage: Art by Four African Americans

Portrait of a Woman, 1932 (fig. 27), painted in one sitting, is a strong characterization of a ninety-year-old woman. It won first prize for an oil portrait and the outstanding painting prize at the 1933 Indiana State Fair.[41] The likeness is a convincing expression of individuality, set in an unadorned gold background that accents the sitter's facial features. An otherwise straightforward portrait is given a dramatic twist by the figure's sideward glance. Through this simple gesture, Hardrick extends the subject beyond the confines of the canvas, suggesting that an unseen figure has captured the sitter's attention.

Thou Good and Faithful Servant, 1930 (fig. 28), an engaging image of an old woman based on a scriptural quotation, was the subject of an extensive review when it was exhibited at a local YMCA the year it was painted. The writer praised the work and commented on its spiritual content:

The picture portrays an elderly Negro woman sitting in a shadowy room sewing on some bright-colored fabric that trails from her lap to the floor and plays an important part in both the color composition and the arrangment of line.

The painting of still life afforded by a yellow work basket and the red-dotted textile which it holds is little short of perfect. But the evidence of greatest artistic skill comes through the way the artist leads the eye of the viewer from his exquisite bit of work with the basket to the center of interest and then on to other objects that play their part in the composition.

A threadlike red ribbon draws one's eyes from the basket to the crimson fabric on which toil-worn hands are sewing. Following this, there is picked out in the shadows a little bouquet of red blossoms on the dimly outlined table, and from the flowers the eye goes naturally to a picture of Christ which hangs on the wall at the right. The figure in this bit of wall decoration is dimly suggested rather than clearly outlined, so that it takes its place as one of the objects in the interior design, its frame affording the rectangular lines that are needed in the composition to break up the large wall mass, while the spiritual significance of the suggested divine personality is an important touch that adds immeasurably to the religious sentiment of the painting.[42]

Through the manipulation of compositional elements in this dark interior, Hardrick sympathetically renders the image of old age and implies the importance of religion in the daily life of his people.

Woman in a Fur Coat (fig. 29) shows a young woman wrapped in a warm, silky black fur whose high collar frames her features. This elegant woman is set against a warm yellow background, which envelops her in its rich glow. The flesh tones contrast with the figure's black hair and deep brown, hypnotic eyes. In this work the fur coat suggests the woman's wealth and is as important to the painting as the sitter's features.

Springtime (Portrait of Ella Mae Moore), about 1933 (fig. 30), is a representation of the innocence of youth. Hardrick focuses on the young girl's quiet charm and refined beauty. He uses a delicate touch to bring out the soft texture of the sitter's chiffon dress. Conveying the quality of fabric was of particular interest to the artist, who enjoyed the challenge of painting fur, silk, and chiffon.

Hardrick often incorporated flowers and foliage in his portrait studies, creating compositions of charm and beauty. In *Little Brown Girl,* 1927 (fig. 31), and *Lady in Red,* also known as *Before the Party,* about 1931 (fig. 32), he uses floral backgrounds to enhance his figures. In both works red, a symbol of joy and energy, is the dominant color of the clothing and foliage.[43] Hardrick leads the viewer's eye around *Lady in Red* using the curves of the figure's back and arm, which culminate in her hands resting on her knee. Swirls of blue in the background echo the contours of the figure. Her direct gaze implies she is a woman of determination and spirit. Unlike the lady in red, the little brown girl casts her eyes away from the viewer. With vinelike flowers encircling her youthful features, the young girl is a demure contrast to the debonair woman. *Little Brown Girl* was one of five paintings by Hardrick to receive the bronze second-place medal in the 1927 Harmon Awards competition.

Many of Hardrick's portraits were of well-to-do black women, who were not only married to successful men, but who were, themselves, entrepreneurs. Xenia Goodloe (fig. 33) was a notable dress designer and the wife of the head baker at the L. S. Ayres department store in downtown Indianapolis. Her husband's Lady Baltimore cakes were considered prized culinary treasures. It is not surprising that Hardrick, the most prominent black portrait

Figure 27. John Wesley Hardrick. ***Portrait of a Woman,*** 1932, oil on board, 30 x 24 inches. Hampton University Museum, Hampton, Virginia.

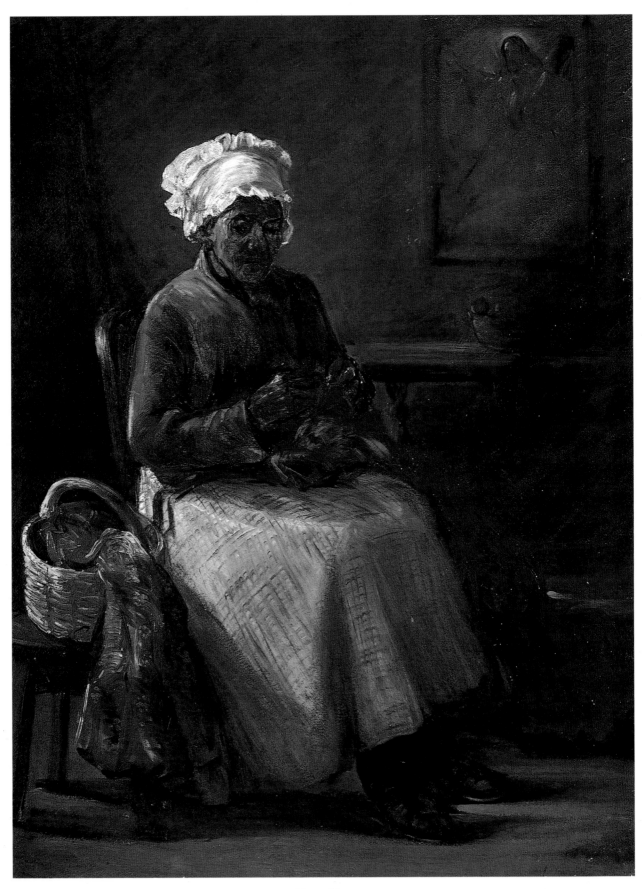

Figure 28.
John Wesley Hardrick. *Thou Good and Faithful Servant*, 1930, oil on board, 46 x 34 inches.
Collection of Dr. Stephen N. Butler.

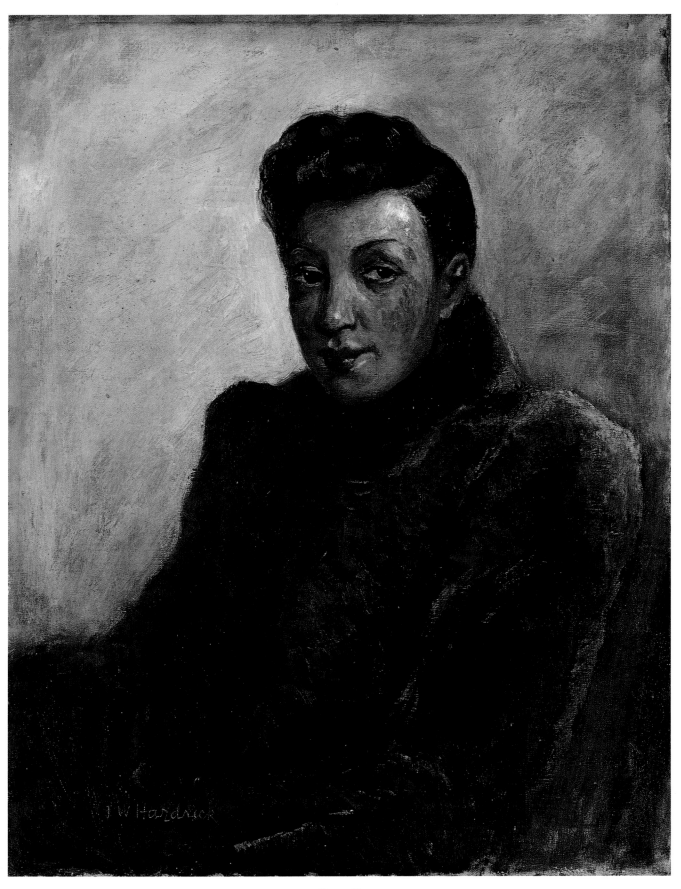

Figure 29.
John Wesley Hardrick. *Woman in a Fur Coat*, oil on canvas, 26 1/4 x 21 inches.
Collection of Dr. Stephen N. Butler.

Image and Identity: The Art of William E. Scott, John W. Hardrick, and Hale A. Woodruff 49

painter in Indianapolis, was the artist chosen in 1930 to capture Mrs. Goodloe's likeness on canvas. Hardrick selected a seated, full-length pose to present a woman wearing a sophisticated gown that is probably one of her own designs. The sitter's supple, elegantly provocative body contrasts with the rigidity of the large chair encircling her. A white handkerchief trails gracefully from her hand, accenting her features and the warm, brown tonality of her skin. By eliminating extraneous details, Hardrick focuses attention on the sitter, bringing her into prominence through the manipulation of the background color.

Hardrick chose the subjects of his noncommissioned portraits for their grace, poise, charm, and beauty. He concentrated on his models' facial features, paying special attention to the expressive quality of their eyes. The artist sometimes finished portraits in only a few sittings, but occasionally worked with sitters for several months of weekly sessions before completing his work. If his subject was a personal friend, Hardrick often focused on personality, bringing out in the final rendering a characteristic facet of his sitter's temperament.[44]

Hardrick was fond of painting portraits of his family. His subjects recall the work of Indiana-born artist William Merritt Chase, who liked capturing his children in the middle of a game or chore. *Dolly and Rach*, about 1930 (fig. 34), is a portrait of Hardrick's youngest daughters. Rachel, about age eleven, is seated on the sofa, while her younger sister, Georgia, about five years old, stands with her arm outstretched. On the large cushioned seat a crumpled pillow adds a brilliant crimson highlight, to which the viewer's eye is drawn.[45] At first glance it appears Rachel is holding her sister's hand, but she is actually putting on her watch. Hardrick caught his daughters in this delightful pose and asked them to stay still while he sketched them. In just a short time the artist sent the girls off to play and completed the painting from his quick drawing and his keen memory.[46]

Besides his portraits of Indianapolis's African-American community, Hardrick also painted many of the city's prominent white citizens. Dr. C. H. Winders, a white Indianapolis minister and executive secretary of the American Church Federation, posed for Hardrick during a painting demonstration. The artist was asked to give a demonstration of his rapid portrait painting technique at the opening of his one-man show in 1931 at the Phyllis Wheatley YWCA. It lasted an hour and a half and resulted in the completion of the sitter's head and a sketch of the figure. Dr. Winders was so pleased with the results that he agreed to subsequent sittings at the end of the week to complete the life-size, half-length portrait. A reporter noted, "The canvas will show Mr. Hardrick's skill in handling the flesh tones and textures in an example of portraiture of a member of the white race, in contradistinction to the work he has done in the many portraits of the darker-skinned race to which he belongs."[47]

Occasionally, Hardrick took his easel to downtown Indianapolis and painted as people watched. He often sold the still wet, newly finished work and then immediately put up another blank board and started again.[48] *Street in Indianapolis* (fig. 35) is an example of one of these quickly painted scenes. Here the artist captures the golden glow of an evening sunset and the flurry of people returning home after work or shopping. The images are loosely painted and exhibit a spontaneity exemplifying the impressionist idiom. Cars and buildings in the background are almost completely obscured by the misty atmosphere, but close scrutiny reveals the Hume-Mansur building, once a prominent office complex on Ohio Street.

Bus in a Snowstorm (fig. 36) depicts a group of people bracing themselves against the cold as they board a bus. Heavy snow obliterates the landscape, leaving no discernible landmarks. The artist renders figures using only a few strokes of his brush, and thus concentrates on gestures rather than features. Hardrick contrasts the blowing snow with the warm, yellow light emanating from the interior of the bus, a haven for the traveler on a cold, wintry day. The most prominent figure is a black man, separated from the rest of the crowd, battling the blowing snow. He may be the artist's symbol of the African-American's struggle against a hostile world. Hardrick rarely ventured into the realm of social realist art, but when he did paint in this genre, his statements were subtle, not overt.

During the Depression years and World War II, artists frequently focused on the theme of work. Manual laborers were glorified as the backbone of American soci-

Figure 30. John Wesley Hardrick. *Springtime* (*Portrait of Ella Mae Moore*), about 1933, oil on board, 48 x 32 inches. Private Collection.

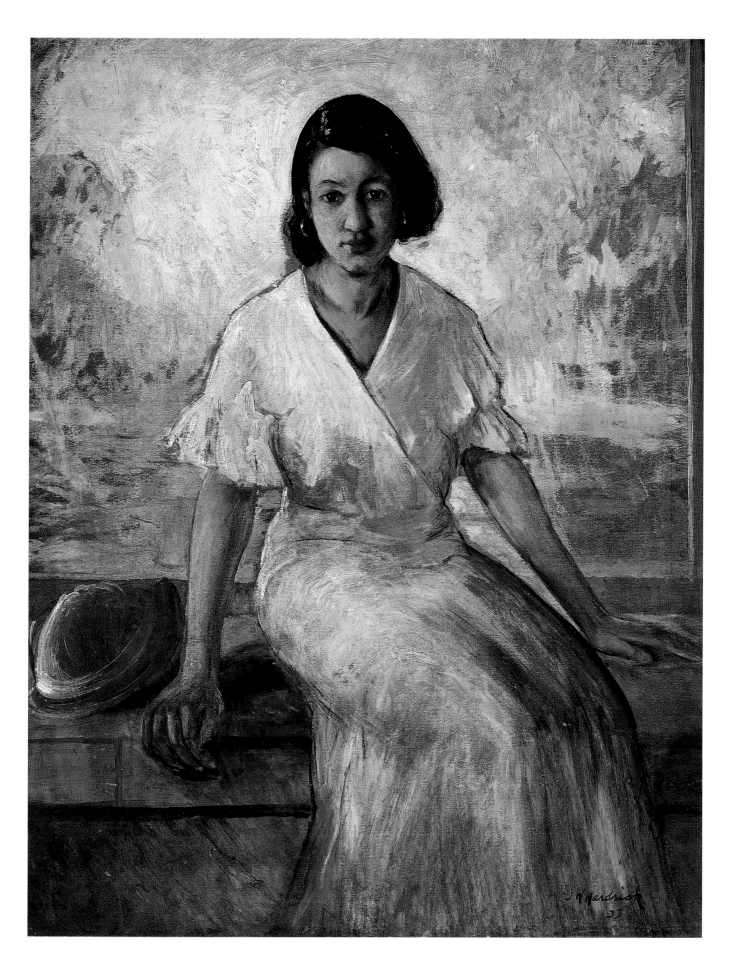

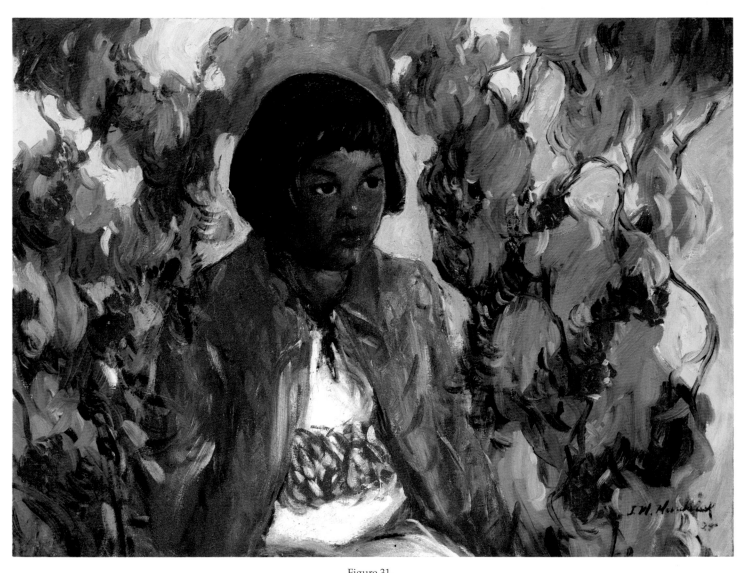

Figure 31.
John Wesley Hardrick. *Little Brown Girl*, 1927 (dated March 25, 1929), oil on canvas, 22 x 30 inches.
Indianapolis Museum of Art.
Gift of a group of African-American citizens of Indianapolis, April 16, 1929.

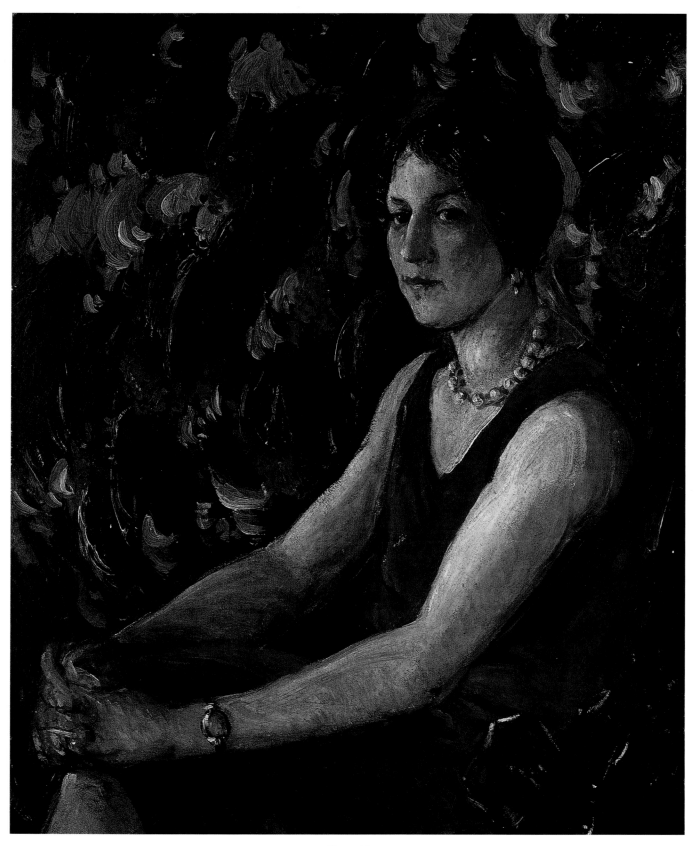

Figure 32.
John Wesley Hardrick. *Lady in Red* (*Before the Party*), about 1931, oil on board, 30 x 28 inches.
Private Collection.

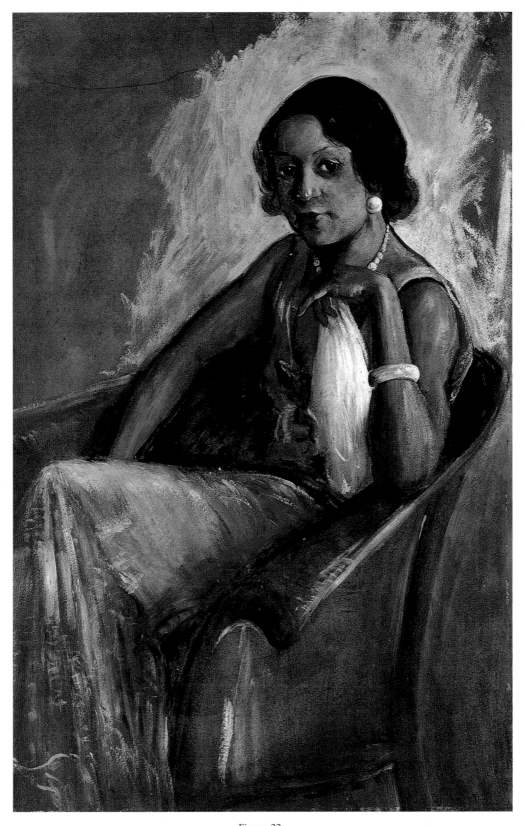

Figure 33.
John Wesley Hardrick. *Xenia Goodloe*, 1930, oil on board, 36 x 20 inches.
Collection of Derrick Joshua Beard.

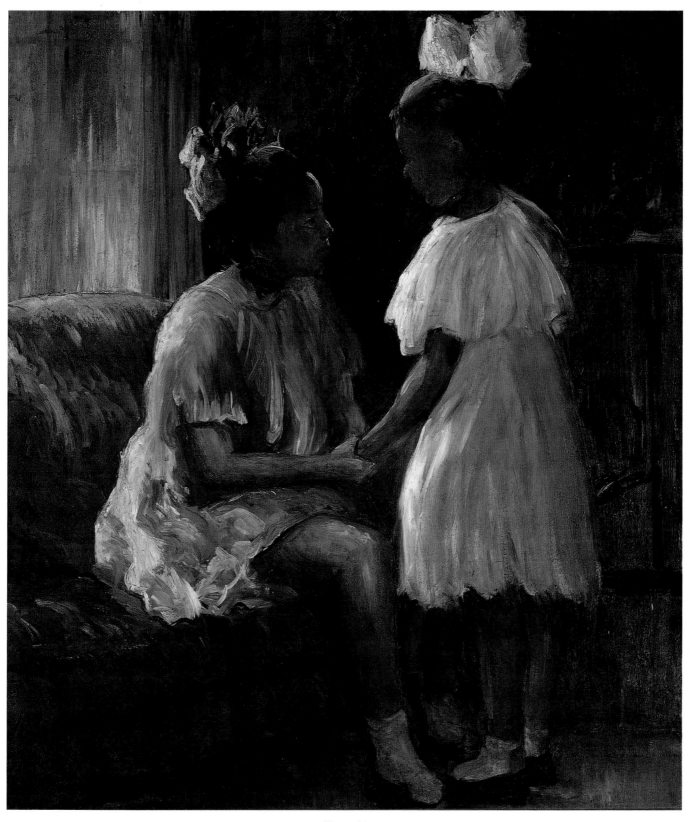

Figure 34.
John Wesley Hardrick. ***Dolly and Rach***, about 1930, oil on board, 38 x 33 inches.
Collection of Georgia A. Hardrick Rhea.

ety. Hardrick captures the essence of hard work in *National Malleable Company*, 1941 (fig. 37), a painting of men forging steel. The artist had firsthand knowledge of this subject through his experience working at the Indianapolis Stove Foundry while attending Herron. Here he focuses dramatically on the task of pouring hot molten steel into molds. The glow from the fire envelops the scene, echoing the intensity of Hardrick's response to his subject. Tonalities are subdued, with emphasis on shades of white and brown. A sense of movement and strain in the three foreground figures is enhanced by their bent backs and wide outstretched arms leading to the long handle of the pouring pots that dispense the hot steel. Framed by the machinery and the cross beams of the building, the men stand out against the dark interior. To balance the composition, Hardrick places three smaller figures, turning to leave, in the background. This painting is similar to a WPA mural the artist painted for Crispus Attucks High School in Indianapolis. The mural was never installed, probably because of an objection to the subject matter. Men dripping with perspiration from the hot fire were not the type of images of the African-American male the school wanted to convey to its students. According to Hardrick's eldest daughter, Rowena Tucker, school officials missed the meaning her father intended to convey. She feels he was portraying life without education and, therefore, the importance of staying in school.[49]

Hardrick explained his role as a black artist in a brochure accompanying his January 1914 exhibit at Allen Chapel in Indianapolis. He said:

On this occasion I feel the necessity to make a short explanation as to the object of the present exhibition. As a race, the negro has made wonderful progress in the last half century. It has produced great men as orators, statesmen, inventors, educators and musicians, and now the field of arts and crafts is open to the negro. Mr. H. O. Tanner has been about the first to successfully venture forth and at present he stands alone expecting for such promising men as W. Scott to take his place.

The object of the present exhibition is an attempt to stimulate an interest among the colored citizens of Indianapolis to encourage art; to inspire, if possible, some young talented boy or girl to realize that "Life without labor is crime, and labor without art is brutality."

For those of us who are now making a feeble attempt, we will fall without the support of our race. We need your co-operation, your encouragement in order to successfully explore the field of art. In conclusion, I will say in the name of John T. Moor:

> *"'Tis the coward who stops at misfortune,*
> *'Tis the knave who changes each day;*
> *'Tis a fool who wins half the battle,*
> *And throws all his chances away.*
>
> *There's little in life but labor,*
> *And tomorrow may prove but a dream,*
> *Success is the bride of Endeavor,*
> *And luck but a meteor's gleam.*
>
> *The time to succeed is when others*
> *Discouraged, show traces of tire;*
> *The battle is fought in the homestretch*
> *And won—'twixt the flag and the wire."*[50]

Hardrick was obviously aware of the importance of his contribution to the African-American community and its potentially far-reaching effects. He hoped his success as a local artist would inspire other young black students to pursue a career beyond laboring in foundries or in the fields. He saw a bright future for his people in the arts if they could obtain the needed support and encouragement of the community.

After the 1940s Hardrick's work consisted mainly of landscapes and a few portraits. He often painted by day and drove a cab at night. Although Hardrick was always compelled to labor at jobs unrelated to his art, his paintings typically suggest a restful environment distant from his workaday world. Hardrick was a model for the younger generation of aspiring African-American artists and endeavored to pave the way for their progress. His career spanned more than sixty years, during which time he not only exhibited in his hometown and around the Midwest, but also in San Diego, Atlanta, and New York. The scope of his reputation became apparent when he was asked to supply information for E. Bénézit's *Dictionnaire critique et documentaire des peintres, sculpteurs, dessinateurs and graveurs*, an international dictionary of artists. Hardrick had proven it was possible to achieve recognition without leaving Indiana. His ability to succeed as an artist, sometimes in the face of daunting odds, is vividly apparent in the abundant landscapes and portraits he produced, expressing his passion for nature and love for his people.

■

Figure 35.
John Wesley Hardrick. *Street in Indianapolis*, oil on board, 12 x 10 inches.
Indiana Historical Society.

Image and Identity: The Art of William E. Scott, John W. Hardrick, and Hale A. Woodruff 57

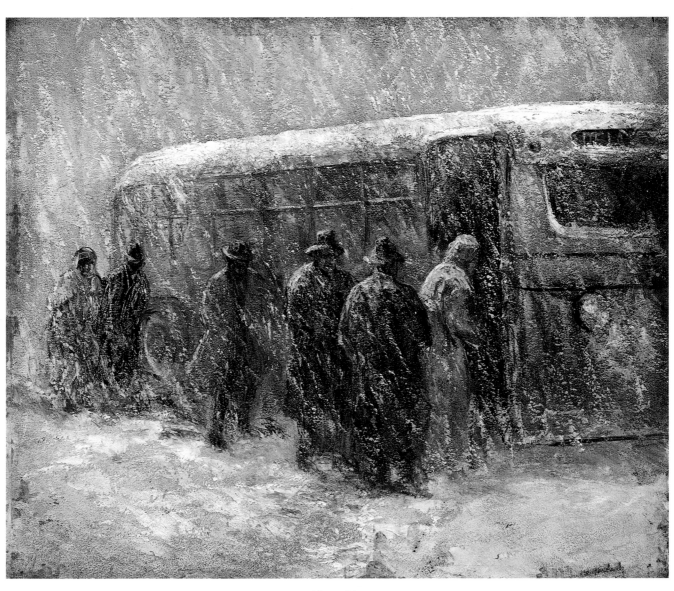

Figure 36.
John Wesley Hardrick. *Bus in a Snowstorm*, oil on board, 20 x 24 inches.
Collection of George and Terry Gray.

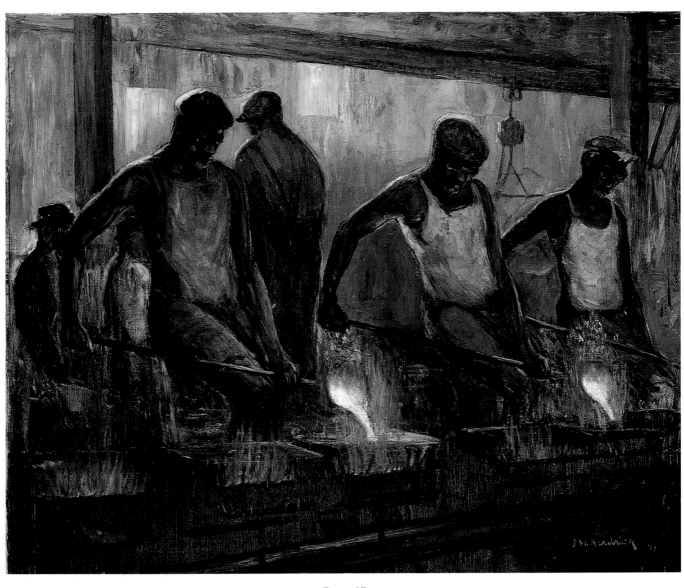

Figure 37.
John Wesley Hardrick. ***National Malleable Company***, 1941, oil on canvas, 30 x 40 inches.
Collection of Richard and Elizabeth Kramer.

Hale Aspacio Woodruff

*I*f Hale Woodruff were known only for his establishment of the Atlanta University Annual Exhibitions of Negro Art, his place in the history of American art would still be assured. But Woodruff was much more than the founder of this program; he was an important social realist painter and one of the nation's innovative abstract artists.

As a student at the John Herron School of Art, Woodruff painted numerous landscapes under the influence of his teacher, the Indiana impressionist William Forsyth. Many of these landscapes were imaginary views filled with explosions of vivid color that took the impressionist idiom to the brink of abstraction and that recall the expressive compositions of the Dutch post-impressionist Vincent van Gogh. The artist referred to his imaginary landscapes as "ultra-impressionist," far removed from realism but still recognizable scenes.[51] Throughout his career, Woodruff continued to interpret rather than record his surroundings.

In conventional portraiture Woodruff admired the work of his close friend and colleague John Wesley Hardrick, even though the older artist's approach was different from his own. Hardrick was concerned with the sitter's qualities, while Woodruff expressed his own thoughts about his subjects.[52] The two were most alike when Woodruff painted such portraits as *Countee Cullen*, 1928 (fig. 38). Cullen wrote poetry based on the African-American experience and was the recipient of the Harmon Foundation's first gold medal for literature in 1927. Woodruff shows the poet casually seated in a chair surrounded by the attributes of his profession. A statue of the Nike of Samothrace—the goddess of victory who descended to earth to crown the victor in a contest of arms, athletics, or poetry—rests on a table. Behind the statue a bookcase alludes to Cullen's literary skills.

Woodruff painted numerous conventional portraits, but he was primarily interested in figure studies. *Cigarette Smoker* (fig. 39) exemplifies his manner of portraying types rather than depicting specific individuals. Here Woodruff shows a forceful figure of an African-American male with strong facial features, hat tilted to one side, and a cigarette dangling from his mouth. He endows *Cigarette Smoker* with a monumental quality and sculptural form, enlivening the figure through a skillful use of line. Pride in his race and sensitivity to his subject are characteristic of Woodruff's approach to portraiture and figural work.

When Woodruff sailed for France in 1927, Paris was the center of the international art scene. The city attracted writers, artists, and musicians, many of whom were Americans. During this period the Harlem Renaissance, in full swing in New York, inspired a French version known as *La Tumulte noire*. Parisians, fascinated with black culture, created a racially tolerant atmosphere that attracted African-American artists like Woodruff.[53]

By 1927 Woodruff was already a recognized artist. He had exhibited extensively in Indianapolis and at the Art Institute of Chicago. In 1926 he was the recipient of the first bronze medal in fine arts awarded by the Harmon Foundation. During his stay in Paris he visited the distinguished painter Henry Ossawa Tanner. It was not the master's work, but "the image of H. O. Tanner as a man, artist and scholar" that would remain, for Woodruff, the most enduring aspect of this memorable meeting.[54]

Woodruff did not look to Tanner's academic style for inspiration: he focused instead on the innovative technique of Paul Cézanne. Woodruff admired the French artist's sense of structure, use of distortion, elimination of conventional perspective, and the expressive quality of his color.[55] Cézanne's influence is readily discernible in Woodruff's Parisian landscapes, with their simplified forms and interlocking shapes (fig. 40). Woodruff commented on the importance of Cézanne:

[He] opened up new doors for me…. I set about trying to find a means by which I could learn from these examples, not to simply paraphrase them and copy them, but to learn their basic ideas beneath them…. I understood why Cézanne tilted the tops of his table, how he brought things forward, how he eliminated so-called optical perspective and used space as surface construction.[56]

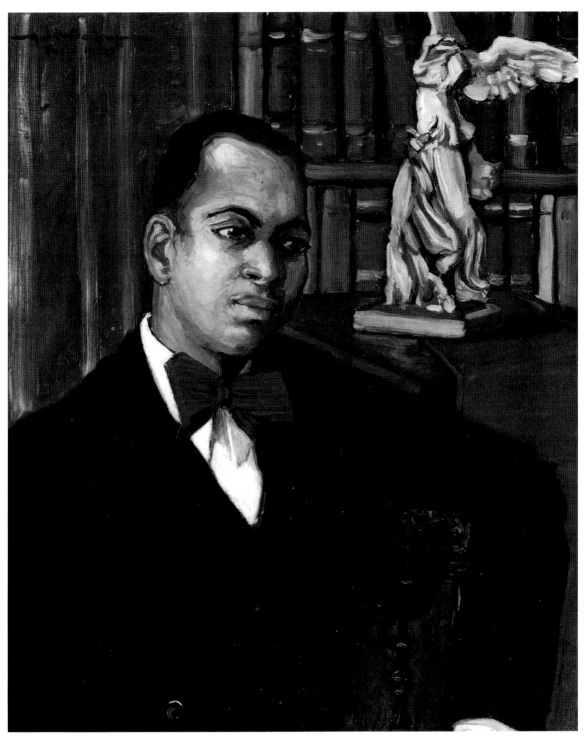

Figure 38.
Hale Aspacio Woodruff. *Portrait of Countee Cullen*, 1928, oil on canvas, 30 x 25 inches.
Amistad Research Center, New Orleans. AFAC Collection.

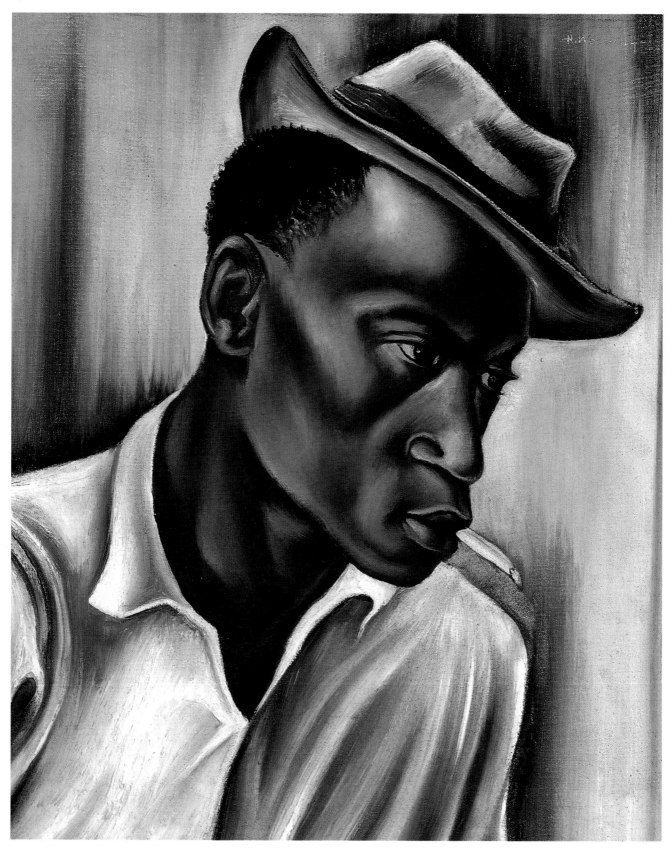

Figure 39.
Hale Aspacio Woodruff. *Cigarette Smoker*, oil on canvas, 18 1/4 x 15 1/4 inches.
Hampton University Museum, Hampton, Virginia.

Figure 40. Hale Aspacio Woodruff. *Castle of Villeneuve*, about 1928, oil on canvas, 24 x 19 3/4 inches. Collection of Derrick Joshua Beard.

The work of Chaim Soutine, an early exponent of modernism known for his free, expressionist brushwork, may have also inspired Woodruff. While in Cagnes-sur-Mer he lived in Soutine's old studio, and though he "felt the impact of Soutine's great work," Woodruff claimed, "I never succumbed to it."[57] Instead, exposure to European art encouraged Woodruff to experiment with a wide variety of motifs and styles and eventually motivated him to pursue abstract modes of expression.

Woodruff's *The Card Players*, about 1978 (fig. 41), is an example of a painting inspired not only by Cézanne, but also by the cubism of Pablo Picasso.[58] Although the impetus for Woodruff's subject was probably Cézanne's *Two Card Players*, 1890–1892 (Musée D'Orsay, Paris), its execution owes a considerable debt to Picasso's cubist interpretation of form. Woodruff spent many evenings playing cards with his friends the artist Palmer Hayden and the poet Countee Cullen. Cullen was in Europe for a two-year sojourn on a Guggenheim Fellowship. Hayden had won the Harmon Foundation gold medal in 1926, the same year Woodruff won the bronze. Both artists used their prize money to finance their European stays. *The Card Players* is

an interpretation of these late-night games, incorporating the tilted table and blocklike forms associated with Cézanne. The unusual placement of the checkerboard behind the head of the left figure and the facial features derived from African masks relate to Picasso's *Les Demoiselles d'Avignon*, 1907 (Museum of Modern Art, New York). As Woodruff later recalled: "The master I chiefly admired at that time was Paul Cézanne; then Picasso, who was certainly bolder and more courageous in his cubist work. When I saw his painting called 'Les Demoiselles d'Avignon'—cubist-like girls with black masks on—the whole thing was clarified for me."[59] The African influence in both Woodruff's and Picasso's masklike faces is derived from Fang sculpture. The Fang people are from Gabon in Central Africa, and their masks exhibit wide, convex foreheads and long, tapering, concave lower faces. With the assistance of Alain Locke, Woodruff had begun to collect African art at the Paris flea markets, and he eventually amassed a substantial collection. "I went back again and again and, between Cézanne's and the African work I was off and winging."[60]

In 1931 Dr. John Hope, president of the newly established Atlanta University, recruited Woodruff to teach fine arts to undergraduate students from Spelman College and Morehouse College. For almost fifteen years Woodruff was the primary teacher in the art department at the Atlanta University Center and, toward the end of his tenure, the originator of the Atlanta University Annual Exhibitions.

Woodruff's art during this period was influenced by American scene painting and social realism, the dominant forces in American art from the 1920s to the 1940s. The social realists looked closely and critically at the world around them and depicted the poverty and disillusionment brought about by the Depression. Some of Woodruff's Atlanta landscapes are indebted to the work of the midwestern regionalist Thomas Hart Benton, who frequently looked to the American South for his subject matter. Woodruff's *Georgia Landscape*, 1934–35 (fig. 42) with its twisted trees and curvilinear design, exhibits the influence of Benton's rhythmically expressionist style.

Although *Georgia Landscape* is a powerful work, it is not the type of composition for which Woodruff's Atlanta period is known. *Southland*, about 1936 (fig. 43), is more in keeping with the style and subject matter that made his Atlanta landscapes so forceful. Ravaged by erosion, this

grim wasteland with its discordant colors reveals the drama of the South. The hostile landscape is filled with broken, decaying trees, the skeletal remains of an abandoned church, crosses buried in the clay, and bleached mule bones. The earth itself is barren, and no sign of life is visible. Woodruff's bleak view of the southern landscape has a surrealist quality, making this isolated piece of land appear more ominous and threatening. The canvas successfully fuses social comment with the artist's flowing rhythms of color and form. In Woodruff's words, "There is much rich material in Atlanta and the Georgia landscapes are as fine as could be desired by any painter seeking subjects for his work."[61]

Woodruff's Atlanta paintings include several figure studies, such as *Sharecropper Boy*, 1938 (fig. 44), that exhibit his sensitivity to his subject. Sharecroppers rented land not with money but with a portion of their yearly crop: it was a common practice for blacks after the Civil War because they rarely possessed the means to purchase their own land. Woodruff's compassionate portrayal of a young southern farmer shows a stoic but proud boy holding a farm implement. He appears resigned to his fate despite the lack of reward for his labor. Behind the figure looms an almost barren, blood-red landscape and a gloomy sky. A partially visible shack in the distance alludes to the sharecropper's meager living conditions.

Woodruff's images of the South were not confined to landscapes and figure studies. In his series of woodcuts and linoleum prints of 1933 to 1939, the artist protests not only the severe poverty facing blacks, but also the constant threat of hanging. In *Giddap*, 1933–35 (fig. 45), a black man with a noose around his neck stands in a wagon. The driver, prodded by rowdy spectators shaking their fists and yelling, prepares to whip his horse and pull the wagon out from under his victim. Woodruff's sense of pattern and design keeps the image from becoming a devastating scene of horror, but this stark portrayal is vivid and compelling.

By Parties Unknown, 1933–35 (fig. 46), the companion piece to *Giddap*, shows the slain victim's body deposited on the doorstep of a black church. His head is down, his hands are tied behind his back, and the rope still hangs from his neck. These prints are clear pictures of the plight of the black man in a segregated society. Woodruff's lynching scenes were part of a 1935 exhibition held at the Arthur

U. Newton Galleries in New York. This exhibition also included works by the black illustrator E. Simms Campbell and by Wilmer Jennings, a promising student of Woodruff, as well as pieces by Thomas Hart Benton, Reginald Marsh, and Paul Cadmus.[62]

In summer 1936 Woodruff spent six weeks in Mexico on a grant from the General Education Board.[63] There the artist joined a crew preparing the walls and mixing the paint for the famous Mexican muralist Diego Rivera. As Woodruff described it, he wanted to "get into the mural painting swing."[64] Woodruff's subsequent mural art was inspired by Rivera's glorification of the working class. Rivera's influence is evident in *Poor Man's Cotton*, 1944 (fig. 47), particularly in the painting's shallow picture space, monumental but simplified forms, bold areas of color, and decorative patterning. Rivera's social realist style, however, is tempered by Woodruff's interest in abstraction. Although the men and women work in the cotton field, their bodies bent in labor, the design function of these figures is to form an abstract composition of twisting and turning shapes. Their rhythmic pattern is repeated in the hoes. The pulsating color and the swirling background landscape echo the composition's rhythms. Instead of lamenting the field workers' heavy toil, the artist creates a graceful and positive image of work. Woodruff stated, "Art can be local but it should transcend the scene. Reporting is not painting, and I try to present the local scene in unusual language."[65]

Woodruff felt strongly about the role of an artist in society: "I believe that every artist whatever his racial or national identity should interpret his life experience and beliefs in his own individual manner. Yet these experiences and beliefs may very well spring from the artist's genuine concern for the problems of man. For it is man, above all, whose purposes should be served by the talents and productions of his fellow man."[66]

In 1941 Woodruff was among the many artists commissioned by the Works Progress Administration to provide art for use in public buildings. Two companion paintings executed between 1941 and 1943 for placement in the Herndon Homes public housing units in Atlanta are social commentaries illustrating the importance environment plays in people's lives.[67] *Results of Poor Housing* (fig. 48) depicts the dilapidated living conditions of many African Americans before public housing, while *Results of Good*

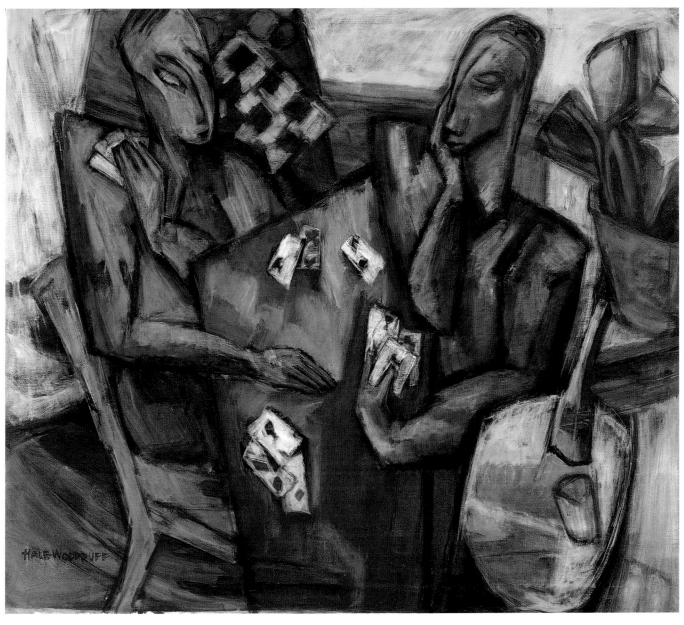

Figure 41.
Hale Aspacio Woodruff. *The Card Players*, about 1978, oil on canvas, 36 x 42 inches.
Collection of John H. and Vivian D. Hewitt.

Housing (fig. 49) shows families in a modern public housing unit.

Incised on the back of *Results of Poor Housing* is a list including disease, crime, vagrancy, lack of pride, poor citizenship, ignorance, and low morals. It is not certain whether Woodruff wrote this inscription, but it is clear from this image of rundown shacks and listless people that these were the conditions the artist was representing.

On the reverse of *Results of Good Housing* the inscription includes civic pride, good citizenship, education, health, and wise use of leisure. In this canvas the housing units are solid brick, newly constructed buildings in good condition. The family on the left is planting a garden, and the one on the right prepares the children for school. The paintings were designed to emphasize the anticipated positive effects of living in the new housing developments.

Woodruff regularly took his students on sketching trips around the Atlanta area, training them to look at their own environment for subject matter and to record its salient features and social conditions. Woodruff told *Time* magazine, "We are interested in expressing the South as a field, as a territory; its peculiar rundown landscapes, its social and economic problems, and Negro people."[68] Woodruff's Atlanta canvases reflect the artist's intense feelings about the impoverished living conditions he and his students observed on their expeditions outside the studio. He hoped these excursions, and the paintings they inspired, would serve as a catalyst for change.

During the last of Woodruff's Atlanta years, he turned away from realistic modes of expression to pursue more abstract concepts in his art. From his early years as an artist, Woodruff was drawn to the modern movements. When he arrived in Atlanta in 1931, he painted *Abstract Composition*, a nonrepresentational work in the cubist mode of Picasso and Braque. Woodruff stifled his tendency toward abstraction, not only because regionalism was the dominant style in America, but also to encourage his students to paint their people and the world around them.

In 1943 Woodruff received a Julius Rosenwald Fellowship to work in New York for two years. The New York art world was in turmoil when Woodruff arrived in the city, as regionalism and social realism were being challenged by the new movement, abstract expressionism. Woodruff returned to Atlanta to teach in 1945, but the excitement of New York and the developing nonrepresenta-

tional modes were hard to resist. He accepted a teaching position at New York University in 1946 and upon his arrival began to develop an abstract style of his own.

One of Woodruff's early New York paintings, *Central Park Rocks*, also known as *Rocks in Central Park*, 1947 (fig. 50), is a work in which natural forms give way to abstract shapes and rhythms. The geometry of the composition is broken only by trees, which become less discernible in the distance. Foreground rocks sway left and right, creating a tension repeated throughout the landscape. This rhythmic movement of opposing elements connotes musical counterpoint. *Central Park Rocks* is an optimistic composition expressing the artist's enthusiasm for his new surroundings. It is a harbinger of Woodruff's movement toward abstraction and his entry into the New York art world.[69]

Almost half of Woodruff's career was spent in Atlanta, where he made his mark as a teacher and an artist. He lectured extensively and left copious notes for future generations to study and ponder. An outspoken advocate of art for the betterment of man, Woodruff used his talents to bring about favorable changes in the lives of African Americans.

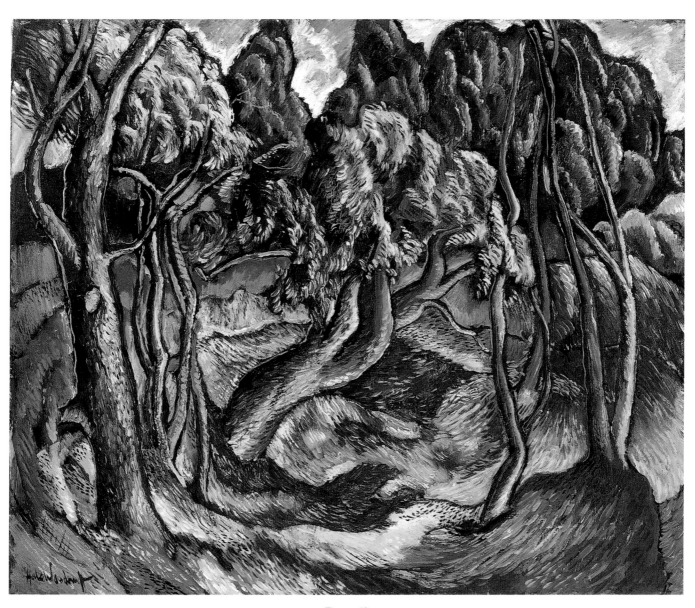

Figure 42.
Hale Aspacio Woodruff. *Georgia Landscape*, 1934–35, oil on canvas, 21 1/8 x 25 5/8 inches.
National Museum of American Art, Smithsonian Institution.
Gift of Mr. and Mrs. Alfred T. Morris, Jr.

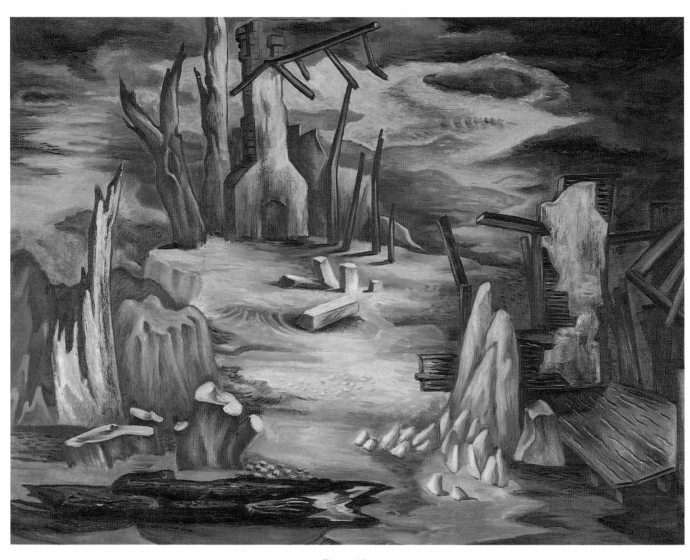

Figure 43.
Hale Aspacio Woodruff. *Southland*, about 1936, oil on canvas, 30 x 40 inches.
Amistad Research Center, New Orleans. AFAC Collection.

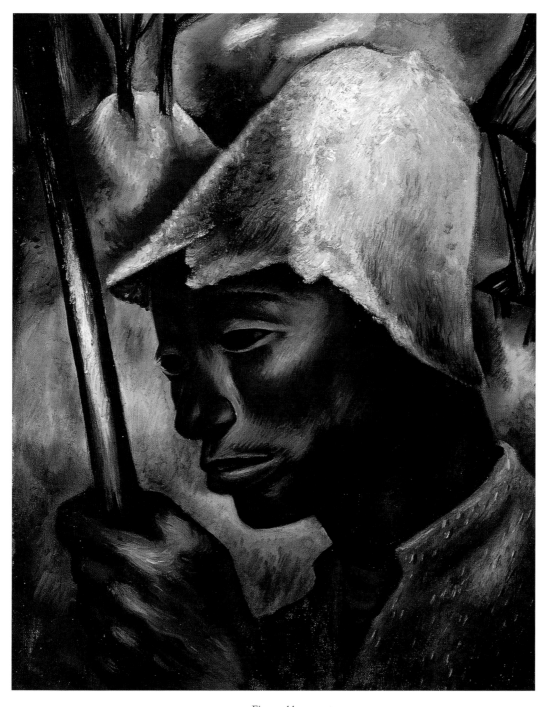

Figure 44.
Hale Aspacio Woodruff. *Sharecropper Boy*, 1938, oil on canvas, 20 x 15 inches.
The Harmon and Harriet Kelley Collection.

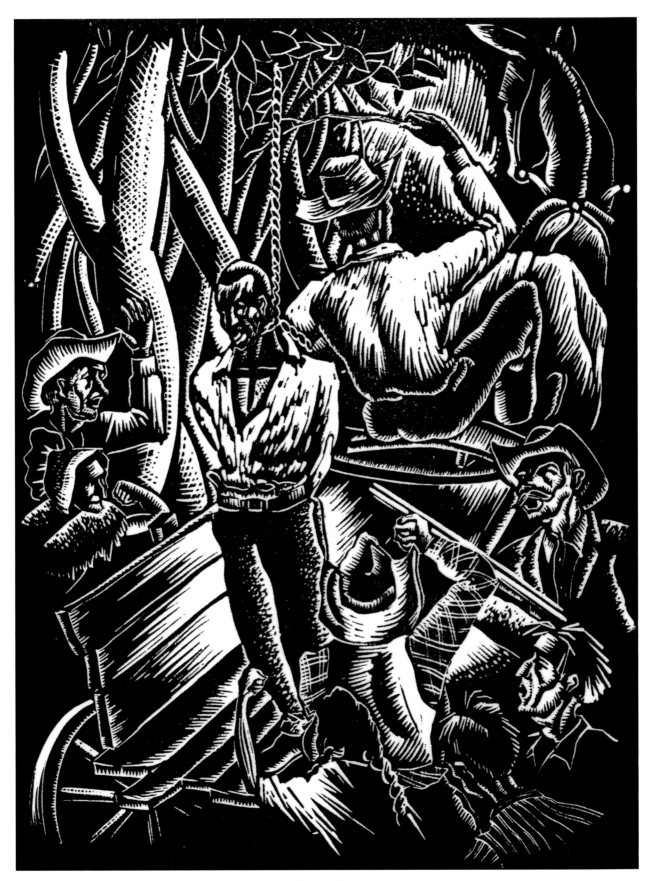

Figure 45.
Hale Aspacio Woodruff. *Giddap*, 1933–35, woodcut, 13 x 10 inches.
Museum of the National Center of Afro-American Artists, Boston.

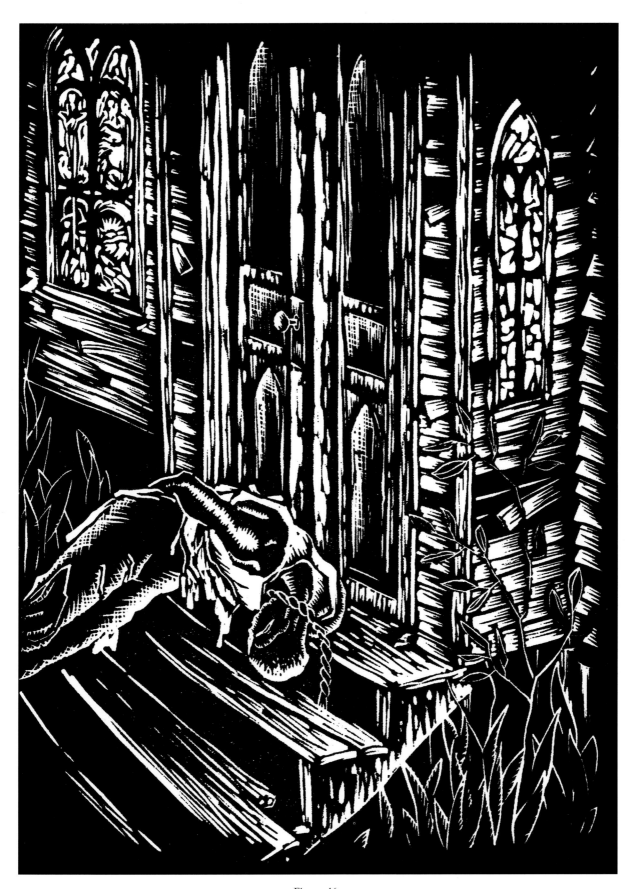

Figure 46.
Hale Aspacio Woodruff. *By Parties Unknown*, 1933–35, woodcut, 13 x 10 inches.
Museum of the National Center of Afro-American Artists, Boston.

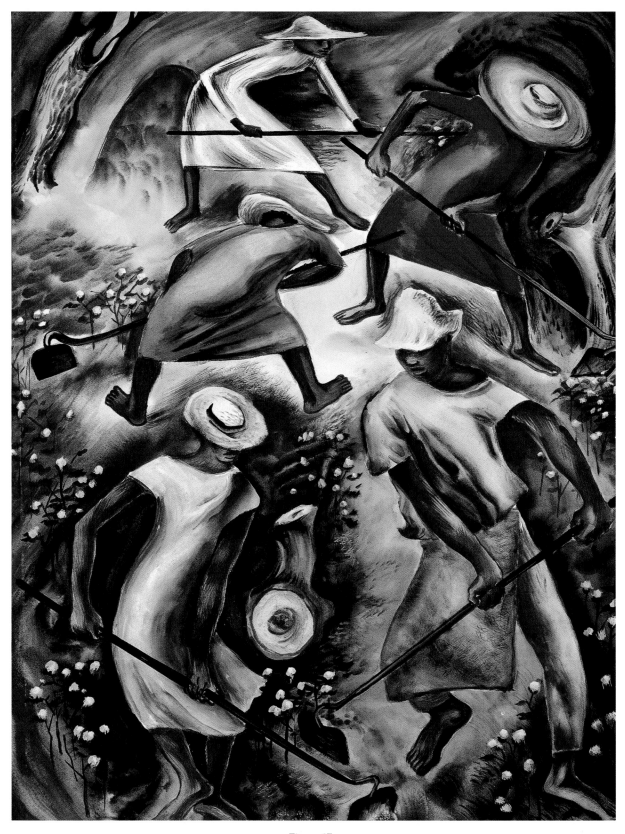

Figure 47.
Hale Aspacio Woodruff. ***Poor Man's Cotton***, 1944, watercolor and gouache on paper, 30 1/2 x 22 1/4 inches.
Collection of The Newark Museum.
Purchase 1944, Sophronia Anderson Bequest Fund.

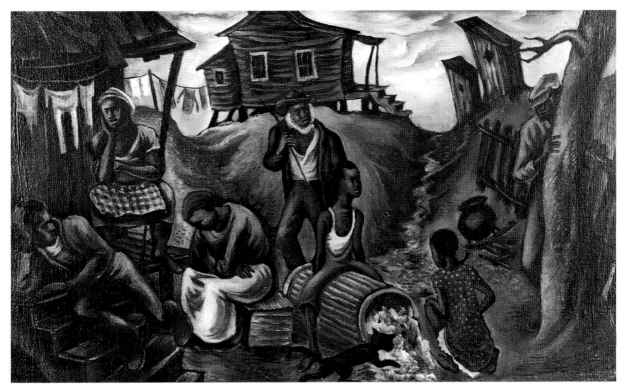

Figure 48.
Hale Aspacio Woodruff. ***Results of Poor Housing***, about 1941–43, oil on board, 14 ⁷/₈ x 24 ⁷/₈ inches.
High Museum of Art, Atlanta. Gift of Mrs. Burma Therrell in memory of James H. Therrell, 1984.87.

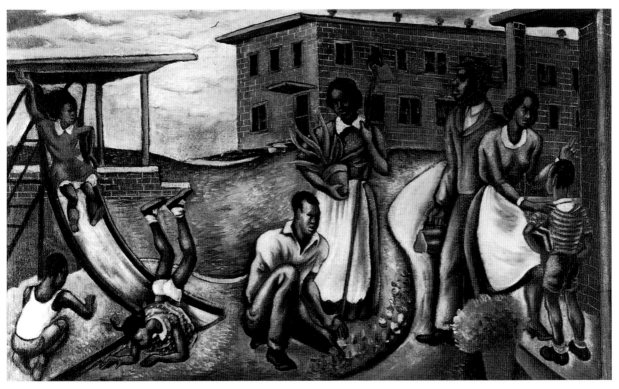

Figure 49.
Hale Aspacio Woodruff. ***Results of Good Housing***, about 1941–43, oil on board, 14 ⁷/₈ x 24 ⁷/₈ inches.
High Museum of Art, Atlanta. Gift of Mrs. Burma Therrell in memory of James H. Therrell, 1984.86.

Figure 50.
Hale Aspacio Woodruff. ***Central Park Rocks*** (***Rocks in Central Park***), 1947, watercolor, 13 x 20 ¹/₄ inches.
The Harmon and Harriet Kelley Collection.

Notes

1. "Colored Artist to Study Negro," *The Indianapolis News*, 16 January 1915, 2.

2. Peter J. Roberts, "William Edouard Scott: Some Aspects of His Life and Work," Master's Thesis, Emory University, 1985, 14.

3. Theresa Leininger, "The Translatlantic Tradition: African American Artists in Paris, 1830–1940," in *Paris Connections: African American Artists in Paris*, ed. Asake Bomani and Belvie Rooks (San Francisco: Bomani Gallery, 1992), 14.

4. "Colored Artist to Study Negro," 2.

5. Columbus Salley, *The Black 100: A Ranking of the Most Influential African-Americans, Past and Present* (New York: Citadel Press, 1994), 17.

6. Unfortunately, this 1916 portrait of Booker T. Washington could not be located. It is in the collection of the George Washington Carver Museum, Tuskegee Institute, Alabama, but repeated searches by the institution failed to uncover the painting.

7. Kenneth Estell, *African America: Portrait of a People* (New York: Visible Ink Press, 1994), 666–67.

8. William E. Taylor, "William Edouard Scott: Indianapolis Painter," *Indiana's African American Heritage*, ed. Wilma L. Gibbs (Indianapolis: Indiana Historical Society, 1993), 197.

9. Gary A. Reynolds and Beryl Wright, *Against The Odds: African-American Artists and the Harmon Foundation* (New Jersey: The Newark Museum, 1989), 14.

10. "An Art Treasure at Home," *The Crisis Advertiser* 17 (March 1919): 253.

11. *William Edouard Scott: An Artist of the Negro Renaissance* (Beloit, WI: Theodore Lyman Wright Art Center, Beloit College, 1970), n.p.

12. Estell, 26.

13. "W. E. Scott Given Art Study Award," *The Indianapolis Star*, 22 March 1931, n.p.

14. Roberts, 37.

15. Philippe Thoby-Marcelin, *Art in Latin America*, trans. Eva Thoby-Marcelin (Washington, D.C.: Pan American Union, 1959), 3.

16. Huldah Skinner, "William Edouard Scott and the Billingsley Model." Interview with Mr. Pierre-Noel. Master's Thesis, School of Social Work, Howard University, about 1975, 118.

17. Quote appeared in *Le Matin*, a Port-au-Prince newspaper, in 1932. The exact title and date of the article are unknown. From the archives of the Schomburg Center for Research in Black Culture, The New York Public Library.

18. Tina Dunkley, "William Edouard Scott 1884–1964," in *Afro-American Painting and Prints from the Collection of Judge Irvin Mollison: A Gift to the Atlanta University Collection* (Atlanta: Atlanta University Waddell Gallery, 1985), n.p.

19. Ute Stebech, *A Haitian Celebration: Art and Culture* (Milwaukee: Milwaukee Art Museum, 1992), 89.

20. James G. Leyburn, *The Haitian People* (Westport, CT: Greenwood Press, 1941; reprinted 1980), 195.

21. Ibid., 296.

22. Stebech, 28.

23. Ibid., 50.

24. Ibid., 40.

25. Roberts, 53, 56, 58.

26. Letter to William Edouard Scott from Edward B. Rowan, Assistant Chief, Section of Fine Arts, Federal Works Agency, Public Buildings Administrator, Washington, D.C., 5 April 1943.

27. Roberts, 60.

28. Letter from William Edouard Scott to Edward B. Rowan, 26 June 1943.

29. Roberts, 65.

30. Theodore Lyman Wright Art Center, *Scott*, n.p.

31. Lucille Morehouse, "Art and Artists," *The Indianapolis Star*, 15 January 1913, n.p.

32. Conversation with Rachel Buckner, 31 March 1994.

33. The Hoosier Group included Theodore Clement Steele, William Forsyth, John Ottis Adams, Otto Stark, and Richard B. Gruelle. They are often considered the first regional group of American impressionist painters.

34. Interview with Charles Wharton, 26 May 1994.

35. Ibid.

36. Lucille E. Morehouse, "In the World of Art: John Hardrick Has Art Exhibit of Merit in Richmond Church," *The Indianapolis Star*, 16 July 1933, 30.

37. Charles Wharton stayed with his parents in Indianapolis while attending John Herron School of Art from about 1954 to 1956. Hardrick lived with the Wharton family on and off from about 1947 and maintained a studio in their basement. Wharton would watch the artist paint and ask questions, which Hardrick was happy to answer. He credits Hardrick with teaching him the technique of constructing a landscape and how to mix primary colors to obtain a desired hue.

38. Interview with Charles Wharton.

39. Morehouse, "In The World of Art," 30.

40. Judith Vale Newton, *The Hoosier Group: Five American Painters* (Indianapolis: Eckert Publications, 1985), 44.

41. Bird W. Baldwin, "Art and Architecture—Indiana," *Magazine of Art* 26 (October 1933): 474.

42. "Hardrick Paintings on Display in City," *The Indianapolis Star*, 21 December 1930, 13.

43. For a contemporary review of Lady in Red, see "In the World of Art: Oil paintings of John Wesley Hardrick Shown at Wheatly Y.W.C.A.," *The Indianapolis Star*, 14 June 1931, 12.

44. Conversation with Rachel Buckner, 8 September 1994.

45. "Child Portraits Add New Note To Hardrick Exhibit at Pettis," *The Indianapolis Star*, 13 July 1930, 33.

46. Conversation with Rachel Buckner, 8 September 1994.

47. "In the World of Art: Oil Paintings of J. W. Hardrick Shown at Wheatley Y.W.C.A.," *The Indianapolis Star*, 14 June 1931, 12.

48. Interview with Mary Kathalyn Stuart Mance by William Taylor, 24 February 1994.

49. Conversation with Rowena Tucker, 8 September 1994.

50. "John Hardrick's Art Exhibit catalogue" (Indianapolis: Allen Chapel, 1019 Broadway, January 1914), n.p.

51. "Woodruff the Negro Artist Off for 2 years to Paint and Study Masters," *The New York Sun*, 1927, n.p.

52. Winifred Louise Stoelting, "Hale Woodruff, Artist and Teacher: Through the Atlanta Years," Ph.D. Dissertation, Emory University, 1978, 176.

53. Introductory pamphlet for the exhibition *Jazz Age in Paris, a presentation of America's Jazz Heritage*, a Partnership of the Lila Wallace-Reader's Digest Fund and the Smithsonian Institution, 1995, n.p.

54. Hale Woodruff, "My Meeting With Henry O. Tanner," *The Crisis* 77 (January 1970): 12.

55. Betty Powell, "Portrait of Hale Woodruff," *Raven* 1 (1 June 1971): 1.

56. Stoelting, 181.

57. Letter from Hale Woodruff to Edwin Coates, 16 August 1973, Hale Woodruff Papers, Archives of American Art, New York.

58. *Card Players* was originally painted in 1928–29 and is now badly deteriorated. In summer 1978 Woodruff repainted *The Card Players*, which appeared in his retrospective exhibition at The Studio Museum in Harlem in 1979.

59. Interview with Hale Woodruff by Albert Murray, 18 November 1968, from the Hale Woodruff papers, Amistad Research Center, New Orleans.

60. Romare Beardon and Harry Henderson, *A History of African-American Artists: From 1792 to the Present* (New York: Pantheon Books, 1973), 204.

61. Ralph McGill, "Hale Woodruff," *Atlanta Constitution*, 18 December 1934, n.p.

62. M. M., "Art Commentary on Lynching," *Art News* 33 (23 February 1935): 13.

63. A discussion of this award can be found in Stoelting, 213.

64. Winifred Stoelting, Mary Schmidt Campbell, and Gylbert Coker, *Hale Woodruff: 50 Years of His Art* (New York: The Studio Museum in Harlem, 1979), 81.

65. Judith Kay Reed, "Hale Woodruff," *Art Digest* 19 (15 April 1945): 15.

66. Hale Woodruff, "Statement of Artistic Aims." Hale Woodruff papers, Archives of American Art, New York.

67. Peter Scott, "AHA takes steps to save 4 Hale Woodruff paintings," *The Atlanta Journal/The Atlanta Constitution, Intown Extra*, 27 December 1984, 1.

68. "Art: Black Beaux-Arts," Time, 21 September 1942, 74.

69. For a discussion of Woodruff's New York period, see Chapter 2 in this book.

2

Hale Woodruff: African-American Metaphor, Myth, and Allegory

Corrine Jennings

Hale Woodruff: African-American Metaphor, Myth, and Allegory

Corrine Jennings

y the time Hale Woodruff was forty-five and moved to New York, he had become a noted painter of scenes of the American South. His migration to the North marked a shift in his direction from social realism to abstraction. In the abstract works he painted in the North, he brought to bear his entire artistic experience and his long struggle to create a language of his own that would, according to Woodruff, convey a sense of "selfhood and dignity" to his people.

What sets Woodruff's work apart from that of his contemporaries—both black and white—in New York during the 1940s is the richness of this artistic experience and the scholarship from both the oral and written traditions that informs his paintings. Woodruff was keenly interested in working out the problem of the transformation of visual information. He sought a transformation that was not solely identified as symbolic, nor was it decoration, but rather a personal expression—an emotional statement that was grounded in years of observation and study. It is this expression that consistently separates his work from mere formalism, distinguishes the greatness of his artistic achievements, and defines his contribution to African life and history in the United States.

Woodruff grew up amidst the cultural ferment of the Upper South in the border states along the Mississippi River and its tributaries. The nourishing of this crescent region followed the pattern begun eons ago in Africa. As it is said in the oral tradition, early African people brought the fertile cultural sediment from the South to the North by following the Nile River to the Delta region in Egypt; so, too, in North America, African Americans brought the richness of the African culture from the South in New Orleans to the North along the Mississippi, reaching places like Memphis, St. Louis, Kansas City, East St. Louis, and Chicago. This map traces a spiritual linking expressed through the oral tradition in all the arts, most famously in music, where African-American jazz musicians have drawn parallels and displayed the transference of culture from the African continent to the American. This is the

environment in which Woodruff grew to manhood and the tradition that was to emerge in his own art.

That Woodruff identified early on with African art and that this complex identification became a passionate lifelong concern is, therefore, not surprising. Nor is it surprising that he would produce a consistent body of work that also reflects the dual consciousness—as an African and as an American—that W.E.B. DuBois, an early patron and later colleague, spoke of in his seminal work *The Souls of Black Folk* (1903).

Woodruff was gentle, urbane, energetic, curious, and determined to be a part of the great contemporary ideas to which he had been exposed early on. He received support, training, and education from the leading figures in African-American culture in politics, literature, history, and philosophy. Brilliant, inspiring men like W. E. B. DuBois, William Edouard Scott, Countee Cullen, Walter White, Mordecai Johnson, and William Pickens regularly came to the Senate Avenue YMCA in Indianapolis—the largest segregated Y in America—where Woodruff worked as secretary from 1923 to 1927.[1] Ultimately, this exposure inspired Woodruff to study in Europe and assisted in providing the means for him to achieve this goal.

Woodruff left New York at the height of the Harlem Renaissance and arrived in Paris in 1927. The summer of 1927 in Paris was a heady period: there he met those whom Claude McKay called the "Harlem elite"—Walter White, John Hope, Countee Cullen, and Alain Locke[2]—and spent time with other young artists, like painter Palmer Hayden, writer Eric Walrond, and sculptor Augusta Savage, who first said that Woodruff was "going modern." These and other young artists formed the "Negro Colony," which also included the entertainer Josephine Baker.

A number of recently recovered works painted by Woodruff in France, such as *Medieval Chartres* and *Castle at Villeneuve*, about 1928 (fig. 40), reveal the initial stage in the development of the characteristic elements that structured his paintings throughout his career. In a recent discussion of *Medieval Chartres*, Catherine Bernard notes the

"strong composition organized with geometric patterns, mainly rectangles, rhythmically arranged in dark and light shades, darkly outlined. The colors," she continues, "create areas of distinct attention. The coherent organization gives the ensemble its strength; verticals and horizontals create a grid and give monumentality to the painting."[3] Another work from this period, *Card Players*, 1928–29 (similar to fig. 41), presents a paradigm of the artist's painting concerns and indicates his regard for African sculpture. As the Great Depression affected the worldwide economy and spread to Paris in 1929 and 1930, Woodruff went south to the artists' colony Cagnes-sur-Mer. As his circumstances deteriorated, he worked as a laborer on the road with young men from North and West Africa.[4] Hearing of the young painter's difficulties, Dr. John Hope, president of Atlanta University, offered him a teaching position. Woodruff arrived in New York in 1931 with a trunk of African art, lingered for a few days at the Harlem YMCA, and eventually made the wrenching decision to teach, rather than to pursue his life solely as a painter.[5]

An early work entitled *Abstract Composition*, 1931, which appears in Locke's *American Negro Art*, shows Woodruff's continued exploration of modernist ideas and the influence of Georges Braque in its cut-out shapes and curvilinear patterns as well as its references to African art. Other works from Woodruff's early years in Atlanta illustrate that his abiding interest in African art continued to develop in a more realistic mode than in his *Card Players*. Even while Woodruff was working within the realist mode, he continued to trace the ties connecting African Americans to their ancestral origins. This is evident in *Little Boy*, 1939, where the face of the child echoes a Baule mask from the Ivory Coast. Judith Wilson also notes the masklike features of *Suzetta*, 1939,[6] "in which the solemn young subject has the winged brown and inverted teardrop-shaped face found in many Dan masks. Woodruff, in fact, advertised ancestral ties while exposing the contemporary malaise."[7]

The summer of 1936 that Woodruff spent grinding fresh color for Diego Rivera's mural at the Hotel Reforma in Mexico City enabled the artist to refine his muralist's skills.[8] It also permitted firsthand exposure to the ancient Amerindian cultures that inform, in part, the Atlanta University murals, 1950–51, and solidified the philosophical intentions of his later paintings, including those catego-rized as abstract. A fragment of a painting of a matador and bull that Woodruff exhibited in the 1939 World's Fair in New York suggests the impact of the experience in Mexico in providing direct source material for many later works.[9]

Woodruff was hesitant to leave Atlanta, where he had developed many roots, yet he felt he needed the opportunity to work in what had become the leading art center in the United States, New York City. Unlike African-American artists residing in the North, who applied to the Julius Rosenwald Foundation to work in the South, Woodruff applied for a Rosenwald grant to work in New York.[10] It was not until 1943 and 1944, however, through the foundation support, that Woodruff received the treasured time to concentrate on his own work, and thus to explore his modernist interests.

Shortly after he arrived in the city in 1943, Woodruff expressed a sense of freedom, not only from the social constraints of the South, but also from the career limitations and what he considered a galling lack of information.[11] Woodruff felt he needed to work away from rural isolation, and in New York he was not only more anonymous, but also found the freedom to explore new directions. He believed he would be able to expand the opportunities for his art and answer the challenge to work within both the African ancestral and the African-American folk traditions that Locke articulated in 1925.

Woodruff's first studio in the city was located at Eighth Avenue and 55th Street, not far from Central Park, and at first he worked outdoors, as he had during his teaching days in Atlanta. In 1945 he produced a rather bleak illustration of a cotton field, small shack, and pig corral, juxtaposed to a skyline view of Manhattan, for the book jacket of *They Seek a City*, a volume by Arna Bontemps and Jack Conroy about the African-American migrations. He also presented his first one-man exhibition in New York City at the International Print Society in 1945.[12]

The watercolor *Poor Man's Cotton*, 1944 (fig. 47), and the later, recently located oil *Girls Skipping*, 1949, reproduced in black and white in Dover's *American Negro Art* (1960), suggest that in the first phase of Woodruff's career in New York he worked with regional subjects, both southern rural and northern urban themes. At the same time, these paintings reveal the progression of Woodruff's interest in kinesthetic forms and motion relating to illu-

sion in painting. Probably influenced by film clip studies of motion and the animated films that captivated the popular culture of the 1930s and 1940s, Woodruff seems to have been interested in a physicalization of time that was made possible by animated images. Without a doubt, he was concerned with movement as it applies to the functional aspects of African art. Woodruff frequently noted that African, Pre-Columbian, and other non-European people understood and achieved this sense of fusion, that African masks were worn while dancing, and that movement was a primary consideration.[13] In addition, *Poor Man's Cotton* illustrates the continuous development of Woodruff's preoccupation with structure and refers to the elliptical compositions of earlier paintings like *Castle at Villeneuve*.

Girls Skipping, with its spinning motion, can be compared to the whirling workers rapidly hoeing the rows in *Poor Man's Cotton* and to the frozen movement of the child standing on her head in *Results of Good Housing*, 1941–43 (fig. 49). These works are also figurative and narrative, revealing Woodruff's social and political concerns.

In the works from the 1940s and others in the skipping rope/children's play series, Woodruff explores lyrical and shimmering color as it relates to dimension in compositions that are precursors of the frontal plane he adopts in later years. In 1944 and 1945 he was also working directly on paintings that were clearly abstract, and he presented untitled works to two artist-friends to announce the shift in his direction.[14] Both of these abstract works are fully developed compositions with textured pigment, and both works introduce formally abstract visual ideas that indicate Woodruff was an abstract painter by the middle of the decade. It is interesting to note that his recent abstract work was evidently not shown in the spring 1945 International Print Society exhibition.

In 1947 Woodruff accepted the offer to teach in the art education department at New York University. Between 1947 and 1949, while he was teaching, producing abstract paintings, and becoming involved in New York's active cultural life, Woodruff accepted a commission in Los Angeles to produce two murals documenting the history of African Americans in California for the new headquarters of the Golden State Mutual Life Insurance Company. The murals have been cited for their extensive range of color and interwoven triangular composition. As part of

Woodruff's practice of thorough preparation, he traveled to California to research the historical background. Woodruff interviewed African-American pioneers and searched for material in the California State Archives.

On one of his journeys to the West, he stopped in Phoenix, Arizona to visit his friend and former student Eugene Grigsby and created a *plein-air* oil, *Desert Rocks*, about 1949. Its cubist-inspired triangular organization and geometric structure are consistent elements within Woodruff's earlier work, yet *Desert Rocks*, created a year or so after the watercolor *Central Park Rocks*, 1947 (fig. 50), reveals an incipient, powerful direction in Woodruff's work. The encapsulated areas of *Desert Rocks* would become an intricate part of the artist's most important mural *The Art of the Negro*, 1951–52. *Desert Rocks* also indicates that Woodruff was interested in the elemental forces of the stone in pyramids and had begun to focus on Egypt as a source of interest.

The year 1950 was a watershed year in American painting that marked the emergence of abstract expressionism on the New York art scene. Glyphs, signs, writing, and pictographs were beginning to appear in paintings by Woodruff and other noted artists like Adolph Gottlieb, Lee Krasner, and Bradley Walker Tomlin. As Woodruff searched for a compelling aesthetic base, his techniques of handling paint began to change. He drew from the abstract expressionists some of the sense that color and brushwork have meaning in themselves, and his use of underpainting became more important. But his intentions were different, and most of his paintings have readily accessible meaning, which perhaps is one reason why some critics consider his work as outside New York abstract expressionism.

Most of Woodruff's abstractions created after he moved to New York City express the freedom of the city in the brisk brushwork, drip washes, and loosened paint that replaced and, therefore, created patterns. Seemingly applied with a dry brush, these thin layers of paint are put on in tiers of turpentine washes, like glazes that create a final smooth surface and a matte finish. The lack of glare and the encaustic-like surface create a flat impression, which adds to the directness and frontal quality of some of Woodruff's work. At the same time, the paintings are rapidly rendered, and the traces of paint are not actually drips, but rather tails of paint from sketchy ends or

beginnings of his painted gestures. They are not acciden-tal as in automatic writing. The consistency of his brush strokes is like the consistency of a master drummer hit-ting a beat, so that they become a personal pulse beat. The nature and scope of these brush strokes and their edges are the signature of Woodruff's late paintings. In many of the later abstract works, he also drew with the brush in the same way that a woodcarver uses his chisels, and this cutting line is, in some way, his signature as a painter as well.

The year 1950 was a turning point for Woodruff. Though he had left the Atlanta University sanctuary he considered his home, and though he was traveling, he still wanted to create murals that would be a lasting con-tribution to the institution that had given him support and where he had invested so much of his life. A break-through occurred when President Clements approved the Trevor Arnett Library site. Unlike previous commissions, Woodruff was free to select the subject and style of the mural.[15] He wanted to focus on African art, and so the six eleven-foot panels entitled *The Art of the Negro* (figs. 84–89) became his pivotal mural project. Evolving from what is currently called an Afrocentric world view, *The Art of the Negro*, in essence, explicates the movement of African cultural contributions throughout the rest of the world. Woodruff amassed information from wide-rang-ing sources, and his absorption of these ideas ultimately shaped the direction of his studio paintings, laying the foundation for much of his later work. An interesting pro-gression occurred: by exploring materials he had discov-ered and identified during the preparatory stages for the Atlanta murals, Woodruff was able to create a body of significant and related paintings over the subsequent thirty years of his career.

Woodruff later told writer Albert Murray that he con-sidered the carefully organized murals to be one of his most significant achievements.[16] Many of his close artist friends and confidantes, seeing the six-paneled mural as decorative and illustrative and failing to understand the depth of Woodruff's intentions, did not agree.[17] Only in recent years has the extraordinary contribution of the six murals begun to be fully examined and understood. Many of the abstract works in this exhibition represent what Woodruff called his "semi-abstract, symbolic work," and relate directly to the research for the Atlanta murals.

Two 1950 easel paintings, *Carnival* (fig. 51) and *Afro Emblems* (fig. 52), created during the preparations for the murals, allude to a key compositional device found in five of the panels. Both paintings seem to refer to ancient con-structions from around the world, such as the totem carv-ings of the Pacific rim, notably American Northwest Coast, or the Egyptian pyramid at Gizeh and the elaborate ob-servatory and calendar stones of the Pre-Columbian Mayan and Aztec civilizations in present-day Guatemala and Mexico—massive constructions that allowed the cal-culation of time according to the sun.

The compositional device embodies many intercon-nected images, all evocative and resonant. It occurs in the very first mural panel, *Native Forms* (fig. 84), which aligns itself with the earliest period of mankind, acknowledging both cave-painting and figure-carving in stone. The divi-sion of space within this and other panels evokes all these ancient constructs through the encapsulated, rigid spatial areas or compartments Woodruff used to isolate and de-fine specific zones of visual information.

Carnival, as a ritual masque, connects to the murals in its association with ancient seasonal rites like the vernal equinox, its segmented structure, and the lines carved or scratched upon its sandy surface, which suggest glyphs or pictographs. *Carnival* is a large and glowing painting whose field of color is reminiscent of the burning of Benin City, Nigeria, in the mural panel *Dissipation* (fig. 86). As Ann Gibson notes:

[Carnival] presents breathtaking fluctuations between sur-face and deep space, [and] on the other hand plays off a heavily textured, resolutely flat surface against changes in value and tone—light warm versus dark and cool—that plunge the viewer from sandy surface into an indeterminate depth…. Woodruff places the viewer in a tenuous situation, stretched between the impossibility of penetrating the resistantly earthy surface and the inevitability of wallowing in the soft violets below.[18]

In *Carnival* Woodruff positions a segment of the cen-tral Melanesian totem figure found in the mural panel *Parallels* (fig. 87). This corresponding "fin-shaped and float-ing figure" located in the upper center of the painting was identified by Ann Gibson in the essay "Two Worlds: Afri-can-American Abstraction in New York at Mid-Century."[19]

Afro Emblems connects to the murals in its structure as well as subject. It is a flat painting based on a grid of five verticals, like totems, consisting of isolated, shaped ob-

Figure 51.
Hale Aspacio Woodruff. *Carnival*, 1950, oil on canvas, 42 x 33 ¹/₂ inches.
Wadsworth Atheneum, Hartford, Connecticut. The Ella Gallup Sumner and Mary Catlin Sumner Collection.

Figure 52.
Hale Aspacio Woodruff. *Afro Emblems*, 1950, oil on linen, 18 x 22 inches.
National Museum of American Art. Smithsonian Institution.
Gift of Mr. and Mrs. Alfred T. Morris, Jr.

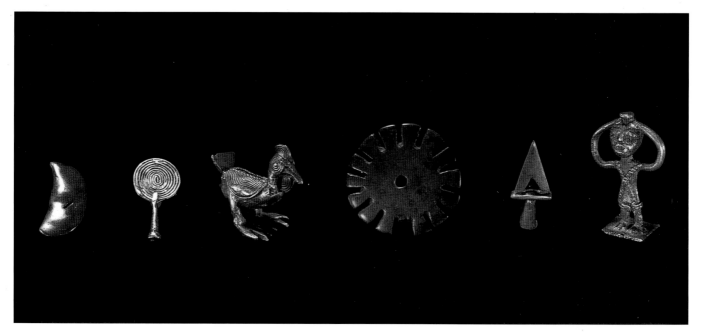

Figure 53. Asante people, West Africa (Ghana), *Gold weights*.
Left to right: peapod, 1 5/16 inches; fan, 1 7/16 inches; cock, 1 5/8 inches; geometric, 1 3/4 inches; figure, 1 3/4 inches; dagger, 1 3/8 inches. Indianapolis Museum of Art. Gift of Mr. and Mrs. Harrison Eiteljorg.

jects that appear to be placed in twelve zones. In these totemic structures, some shapes are identifiable, such as the bear clan mask of the Tlingit people of the Northwest Coast and the female fertility figure in the upper right. The sound-script cryptograms in the upper left remain undeciphered. Cryptograms, favored in many of Woodruff's later works, make their first appearance in *Afro Emblems*.

In addition, a small red-orange square in the lower right and to the left of the signature contains a gold-weight image. It is known that in his works from the 1960s, Woodruff incorporated iconography particular to the Akan culture of West Africa. Some critics considered these Asante gold weights (fig. 53), as they are called, merely "design elements" incorporated into his paintings. Their appearance in *Afro Emblems*, however, suggests that this is an early example of Woodruff's incorporation into his work of the oral and written African tradition.

Some gold weights are mnemonic devices, serving to remind people of proverbs or events without actually displaying them. Others are more pictorial, representing an action or a scene from which a proverb or saying is derived. Some are simple, others sophisticated and many layered. According to Warren Robbins, many of these proverbs exist in African-American culture: "Ashanti Gold

weights… provide an enormous range of subject matter, a microcosmic view of tribal life. In many cases, they illustrate tribal proverbs, some of which have survived in American Negro folklore."[20] The gold-weight image in *Afro Emblems*, moreover, includes a fragment of the Adinkra symbol, Akyinkyum. The word *adinkra* means goodbye or farewell, and the hand-stamped symbols were made for textiles often worn at ceremonies in honor of departing guests.[21] This figure combines the idea of Kyin (to wander) with searching, Akynkyin, or the restless, wandering search. The idea is expressed among the Akan people of Ghana and the Ivory Coast as:

> *You have many parts to play*
> *Oytadee yie*
> *See the young leaves wave and break not*
> *In the raging storm and rain;*
> *Flexible, adroit and free*
> *Avoid the hermit crab's shelter*
> *Or the shell fish on the beach.*
> *Seek exposure, get involved*
> *So you can accept and be*
> *Ripe experience for young minds.*[22]

Another direct translation of this figure is Nkyinkyin (Ohammas Nkyinkyin), which contains the meaning of changing oneself, of playing many roles.

By 1950–51, then, Woodruff was incorporating meaning through the Akan gold weights, and he was inserting a sign-script into his painting. In all but one of the Atlanta panels, Woodruff expresses his thoughts in a symbolic lan-

guage, creating a dialect on numerous levels that would allow him an authentic visual voice. While these symbols are present in many of his later works and are difficult to decipher, Woodruff himself preferred to deflect questions by referring to them as doodles.[23] If he did not wish them to be precisely identifiable, they are, in any case, related to glyphs. There is a familiarity to them that evokes Egyptian or Asiatic languages or a Minoan language that had not been deciphered at the time of the murals. Occasionally, they are recognizable as bird symbols, the mythic and ancient messenger. This mysterious practice in Woodruff's work seems analogous to the unknown tongue of the African-American evangelical church: to initiates they are understandable.

The first panel of the Atlanta murals, *Native Forms*, also includes a small cartoonlike tableau in the lower right-hand corner that contains a mischievous depiction of Woodruff's nascent interest in primordial myths. In this small area he indicated the earliest rock carvers and cave painters (probably assuming they were men) and the ancient dissolution of the matriarchal system. The tableau seems to narrate the demise of Ancaeus, the last survivor of Jason's Argonauts. When stranded on the island of Majorca, Ancaeus encountered powerful female nymphs, here indicated by the way Woodruff attenuates the handless, outstretched arms of the Holy Mother figure or the so-called Venus figures. Regrettably, Ancaeus told the nymphs that the patriarchal culture of Greece had supplanted the worship of female deities; he was abruptly sent away, only to be torn apart by the goat men.[24]

The inclusion of material such as this indicates Woodruff's familiarity with James George Frazer's *The Golden Bough* and the work of Robert Graves, as well as the work of scholars who traced the African origins of world civilization. This corner of the mural foreshadows Woodruff's later use of mythological allegory and prefigures his passage into mystical and spiritual territory.

In the mural *Interchange* (fig. 85), the astronomers working within the center of the picture plane are the forerunners of those who built the ancient sites that allowed the observation of sun time, as opposed to observations of the moon. A related painting, *Equinox*, about 1954 (fig. 54), seems to explore his interest in the ancient Egyptian $365 \, ^1/_2$ day sun-time calendar that appears in emblematic form in *Interchange*. *Equinox* combines the pastel shades

of spring with the rust-colored darker shades of autumn, and, in terms of composition, dark and light areas are balanced equally. It also combines the Cézannesque quality of Woodruff's brushwork and the luminosity of Henry Ossawa Tanner's theory of light.[25]

Like other of Woodruff's imaginary landscapes, this composition evokes rock formations, mountains, the openings of caves, or a temple in the desert; perhaps he is referring to the Temple of Karnak in Egypt or Carnac in Brittany and Stonehenge in England. Temples such as these, built to observe the sun and the movement of the stars, contained rows or avenues of stones to mark the seasonal changes. In *Equinox* these stones become stars and planets, and the vista appears as a topographical map with patterns. Here these star clusters, which appear frequently in his later paintings, may refer to the rise of the constellation Pleiades, whose appearance signals the season for fertility and planting in many parts of the world. The perspective used in *Equinox* suggests the arch of the temple; its equal shadow is separated by a narrowly defined white line.

Thirteen years earlier, during his protest painting phase, Woodruff had produced a mural, *The Underground Railroad*, for another library, the one at Talladega College. Like that work *Equinox* could also refer to the idea of equality, and then its meaning would be very political. The defined white line in the painting could represent the Mason-Dixon Line, the barrier drawn in air that separated the slaveholding states of the South from the free states of the North. Whirlwinds of stars might represent the crossing from South to North, the crossing of hills and lakes; and the stones also seem to become lines, like lines full of quilts that enslaved Africans carried with them to trace the escape routes to the North and Canada. There is also a possible reference to Ursa Minor, the Dipper, and the North Star, which are still important references in the African-American oral tradition as the signs that led to freedom.

A later painting, *Landscape with Constellations*, 1973 (fig. 55), is also connected to Woodruff's preparatory studies for the Atlanta University murals and to his interest in the spread of the sun culture. It shares with *Equinox* a concern for solar events. In *Landscape with Constellations*, a seated ancestral priestess figure, delineated against the yellow tones of a reflecting sun, assumes a frontal pose against the landscape. The work connects to *Equinox* in

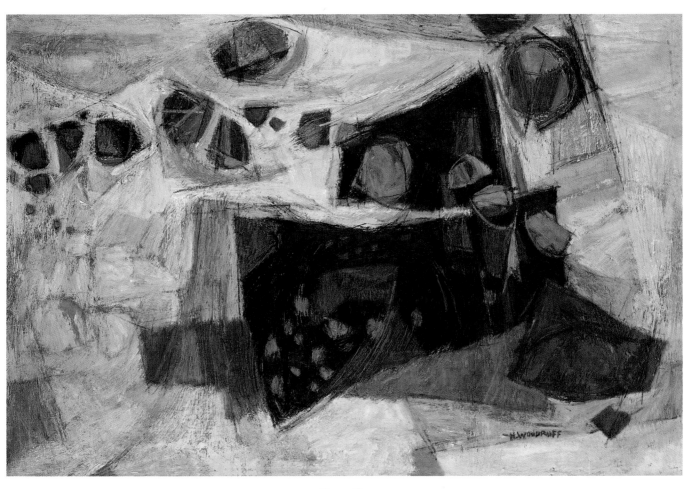

Figure 54.
Hale Aspacio Woodruff. *Equinox*, about 1951, oil on canvas, 27 x 41 inches.
Michael Rosenfeld Gallery, New York.

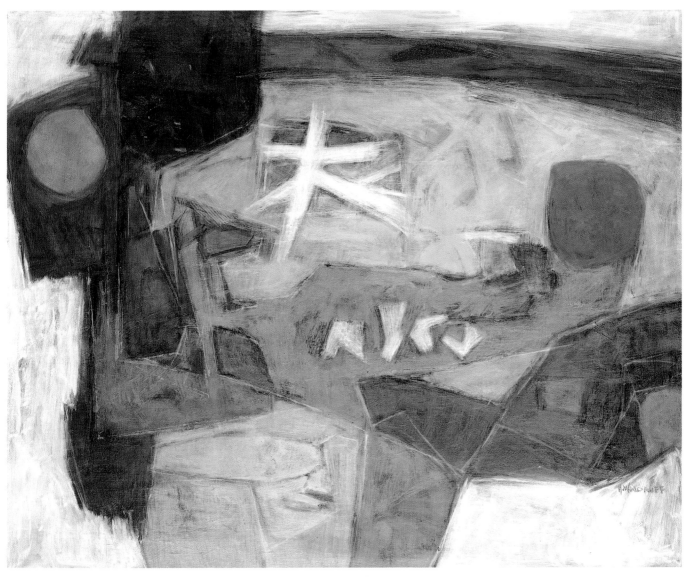

Figure 55.
Hale Aspacio Woodruff. *Landscape with Constellations*, 1973, oil on canvas, 40 x 50 inches.
Indianapolis Museum of Art. Mr. and Mrs. Julius F. Pratt Fund.

that the woman serves in the composition as the pole separating the light from the shadows that form the axis line. A custom among some ancient societies, particularly West African and Melanesian, where an elder or a priestess sits on a rock to identify the time for sowing, is suggested here. The sense of the patient, quiet, contemplative sacred moment is communicated in a work that is at once abstracted, figurative, and narrative. The world as described in this painting seems alive with spirits, and the enigmatic sign-script in the central plane seems to relate to the sowing and planting season, and, thus, to fertility. Beautiful in its richly colored earth tones and golden hues, *Landscape with Constellations* satisfies Tanner's admonition regarding the primacy of the figure in the landscape and the importance of luminosity of color.

Woodruff frequently developed his compositions from both a horizontal and vertical perspective, and often attached wires for hanging them in either direction. *Landscape with Constellations* seems to be a horizontal painting, but if viewed vertically, a mask associated with the Fang people of Gabon and Cameroon appears on the left, and the elongated shape of a Chi Wara antelope headpiece of the Bamana (Bambara) people of Mali is centrally located in transparencies of yellow ochre. Several fine examples of Bamana sculpture were included in Woodruff's personal collection of African art. In the catalogue of his collection, Woodruff noted that "a mythical being called 'Chi Wara' is traditionally believed to have taught the Bambara to cultivate grain."[26]

From the time of the Atlanta murals until his death, Woodruff continued to produce work that he described as semiabstract, symbolic painting. In discussing his involvement with this genre, Woodruff said, "I am no longer working directly from nature, but I observe nature. It is the wellspring from which ideas come. I might make a superficial separation of drawing and nature, but I still see them as one. Cézanne said, 'When I draw I paint and when I paint, I draw.'"[27]

In his early investigations, Woodruff was already exploring an antidote for his disillusionment with European painting (and perhaps the system that supported it), which he was to speak of in the 1960s.[28] In all the murals and in the later years of his painting career, Woodruff seems to have looked back to the beginning of time in search of a purer, more elemental form of expression; and to reach this essential expression, he explored many ideas from various points of view and vantage points. The proverbial idea that recommends going back and retrieving from the past what is needed for the present is particularly indicative of Woodruff's mode of development.

A richly defined ink drawing, *Totem*, 1955, which appears as the frontispiece of Dover's *American Negro Art*, illustrates a facet of Woodruff's interest in motion, here manifested in rapid brushwork. *Totem* marks a shift of interest from stone carving to woodcarving. An article entitled "Totem" that Woodruff wrote in 1957 for *School Arts* magazine speaks specifically of Native American woodcarving in the Northwest Coast, but expresses, in general, an understanding of the spiritual base of totemic carving among people outside the Western world.

By the late 1950s Woodruff was exploring the first of his series of works focusing on major female myths. One of the earliest works appearing around 1958 concerned the Europë and the Bull myth. In this myth, Europë is a Phoenician cow herdess and, therefore, an incarnation of the Egyptian deity Isis. According to Robert Graves, Zeus, father of all Greek gods, disguises himself as a divine bull and enchants Europë, first to decorate his horns with flowers and then to follow him down to the sea. Once away from the shore, Zeus captures Europë and carries her off to Crete, where he ravishes her.[29] It is a myth that resonantly underscores the rape of Africa and presages the spread of both African culture into Greece and the worship of the sun culture into the northern fields of Western and Central Europe. Woodruff's most familiar version of this myth is the swirling expressionist painting *Europa and the Bull*, which is similar in style to his *Leda and the Swan* in the collection of the Studio Museum in Harlem.[30] Another known work in this series, titled *Africa and the Bull* (fig. 90), was specifically created in black and white for the exhibition of the Spiral group of African-American painters in 1965.

Woodruff prepared the powerful, dramatic painting *Ancestral Memory* (fig. 56) for the First World Festival of Negro Arts held in Dakar, Senegal, in 1966. At that moment many nations on the African continent were struggling to remove the shackles of colonialism, and in many regions bloody battles for liberation were being waged. At first glance *Ancestral Memory* appears as a large red map of Africa dominated by a carved Sphinxlike face with

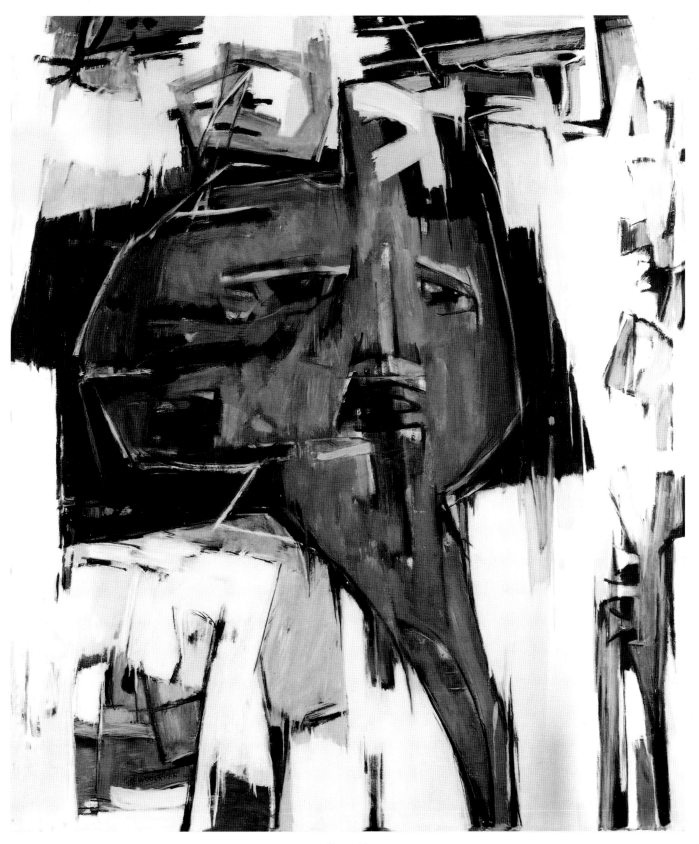

Figure 56.
Hale Aspacio Woodruff. *Ancestral Memory*, oil on canvas, 60 ¹/₈ x 52 ¹/₈ inches.
The Detroit Institute of Arts, Founders Society Purchase.
African Art Gallery Committee Fund.

two different expressions--a piercing, fierce eye on the left and a compassionate, saddened eye on the right. Thus, the expressive, bloody (Janus) face of the predominant mass of the canvas represents a battered and bruised, yet still strong, Africa.

On second look Woodruff seems to be working with the symbolism of shape rather than that of a literal map in *Ancestral Memory*, and it seems to be a part of the sequence exploring the myth of Europë and the Bull, or more precisely *Africa and the Bull*. Here, the head appears as that of a massive black bull with horns, and the stream of red blood from the savage fight flowing down to the bottom of the canvas now appears as a sinewy leg. Woodruff also uses a carved black line, like a rock carving, for significant definition. Both the red and black hues have the same intensity. The bull is turning away, turning from right to left in cubist fashion. While the bull faces front, the body shifts to the opposite direction; in this way, Woodruff shows animation in the manner found in Egyptian friezes. It is, moreover, a distinctive expression of his continuing interest in motion. He completes the composition with the decor of the bullring: darts and lances in the neck of the bull; a red cape and the flying flags of the ceremony. He has also incorporated various totems as well as the iconography of the gold weights.

The composition *Ancestral Memory* participates in the contemporaneous aesthetic of abstract painting, but compared to many works that were soft and organic, Woodruff's edges are sharp, hard, and delineated by rapid, brushy strokes. He manages to cool the hot content by opening up space, and the intense color of the mass is cooled by an overlapping patchwork of whites, tans and blues, creams, and light ochre that appears along the edges of the canvas. Flitting calligraphy of carved rock drawings circles the edges, which are excited and agitated. Asante images, such as the Adinkra handcuffs, fall down on the left, and the notched ladder and Toguna post of the Dogon people of Mali rises on the right. Gold-weight images are as incidental as rain; his mysterious sign-script, like the unknown tongue it is, tarries alongside.

The series of paintings entitled *Celestial Gates* (figs. 57 and 58) that Woodruff began to produce in the late 1960s are among his most well-known and most mystical works. They are frequently considered the culminating events of his long painting career. Resonating figures—the Akan

gold weights and the image of the bull, totemic structures and sign-script, allusions to sun cultures and ancient mythologies—derived from his Atlanta murals appear in the *Celestial Gates* series as well. In part, the symbolic idea of the gates is grounded in African-American mythos, in musical and oral folklore, and subsequently in written lore that speaks or sings of ladders and staircases. These archetypal motifs often express the idea of attainment, as in many spirituals where there are images of heavenly gated cities or glittering doorways to heaven—"Dem Pearly Gates," as in the spiritual Marian Anderson made famous. It has been noted that "Many of these paintings are lyrical in their 'singing' colors. There is a great sense of liberation and freedom and transcendence. Woodruff's paintings of the gate series have a strong sense of universal appeal, in communicating an inspired sense of heightened aspiration."[31]

It is entirely possible that the horizontal passages in Woodruff's *Celestial Gates* developed, in part, from the Europa and the Bull series of the late 1950s and early 1960s. This can be seen in the progression that evolved in three particular paintings. *Untitled*, about 1958, a work in the collection of the Museum of African American Art in Los Angeles, presents a stylized version of a passage in the Europë myth. In this painting, sharply angled figures ride astride three bulls in friezelike arrangement. In a second, rhythmical, more abstracted painting also in this California collection, the Europë story is retold against a background field of color resembling the reds and golds of earlier works like the Atlanta mural panel *Dissipation*.

A third work, the serigraph *Celestial Gate*, 1977, offers an important key to understanding Woodruff's process of developing the gate series. (Commissioned for the United Negro College Fund, it was printed through Robert Blackburn's Printmaking Workshop in New York.) The print derives from an earlier transitional painting, *Three Tiered Gate*, 1974.[32] The serigraph shows three elongated, geometric, abstracted bulls stacked up like the isolated totems of the 1950s. The interior space of the outlined bulls is articulated with the shapes of the Akan gold weights. In mythology the *Three Tiered Gate* relates to the woman goddess and has ancient sexual connotations. While not always dated, or accurately dated, these works always indicate the theoretical and metaphysical nature of Woodruff's work.

Woodruff's interest in composition and structure, as

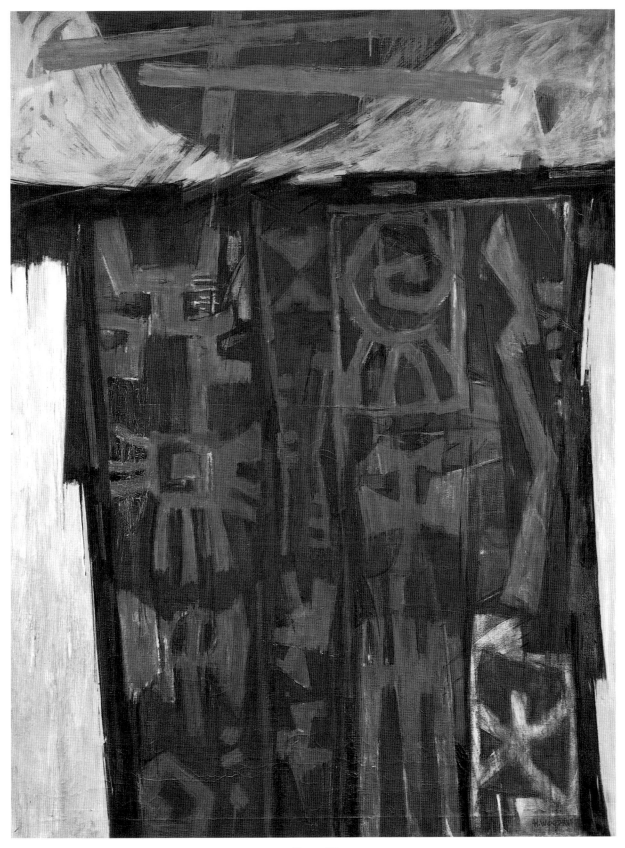

Figure 57.
Hale Aspacio Woodruff. *Celestial Gate*, oil on canvas, 60 x 46 inches.
The Spelman College Collection, Atlanta.

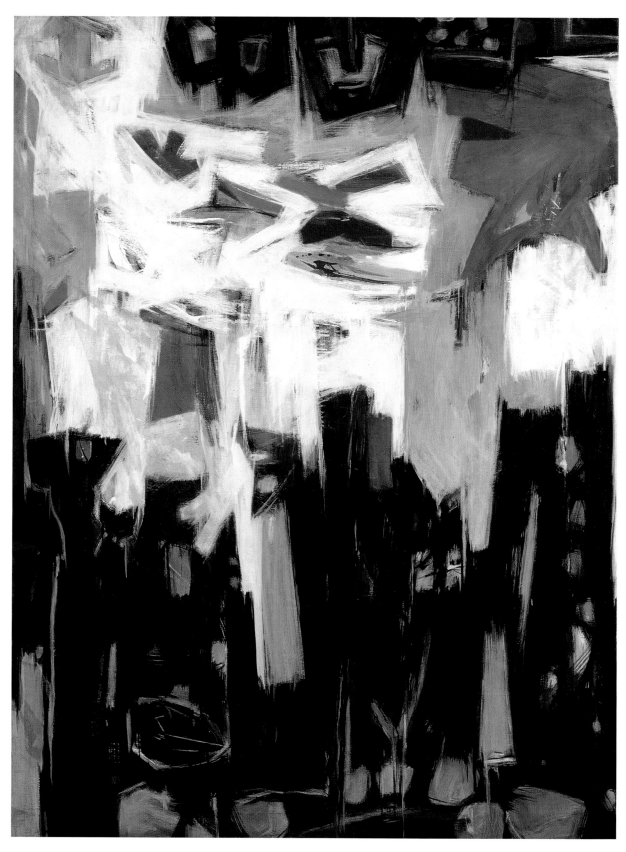

Figure 58.
Hale Aspacio Woodruff. *Untitled* (*Celestial Gate Series*), oil on canvas, 56 x 43 inches.
Kenkeleba House, New York.

seen in the early paintings *Pont Neuf* and *Medieval Chartres*, is fully realized in the *Celestial Gate* works. Many of the early gate/door paintings have three or four basic divisions, appearing in horizontal layers that eventually Woodruff integrates rather than isolates. These divisions suggest the idea that there are four steps to Paradise, with Heaven as the highest level, and they contain all sorts of visual glossolelia, including the mysterious sign-script of the unknown tongue filling up the space between the divisions. The *Celestial Gate* in the collection of Spelman College (fig. 57), perhaps the most well-known gate painting, uses a vertical grid of four sections rather than the horizontal pattern. This large gate is closely connected to Dogon granary doors. Although Woodruff said that he was influenced by certain European bronze doors, such as Ghiberti's doors in Florence, the art of the doors of the Dogon and the Yoruba people of Nigeria and neighboring Benin (Dahomey) were particularly important for the gate series.

The Spelman College *Celestial Gate* serves as a metaphor for the experiences of African people in the United States by combining the Icarus myth and the image of the gate. In the Icarus myth, Daedalus helps his son Icarus to fly by attaching wings to his back with wax. But Icarus flies too close to the sun. The idea of aspiration and extending goals, however, persists in African-American vernacular culture, as for example, in the words of Zora Neale Hurston's mother, who admonished her to "Jump at the Sun."[33] The gate, itself a long-lived metaphor of hope and aspiration, may also appear as a ladder, door, or wall. It is the central figure in Langston Hughes's famous poem "Mother to Son," with its admonition to climb steadily and to keep climbing. This, of course, suggests that if we are grounded in the traditions of our ancestors, we can climb slowly toward the "City Called Heaven"; the ladder works. If one flies too close to the sun, however, then there is imminent destruction. In the Spelman College *Celestial Gate*, the sun has been approached and soaring flight is possible, but we are reminded of dangers.

Many critics suggest that Woodruff's use of African sources like the gold weights as a part of his iconography is primarily decorative rather than connotative.[34] According to Judith Wilson:

Among the various emblems to be found in Woodruff's Celestial Gate (Spelman College collection) is an open-work spiral with four short diagonals radiating from its curved bottom. The artist borrowed this motif directly from the tiny brass weights known as abramoa, which various Akan people of Ghana and the Ivory Coast had used since the early fifteenth century to measure gold-dust, their currency in pre-colonial times... Its precise meaning was probably unknown to Woodruff, but the form recurs in several of his Celestial Gates. Indeed the Akan proverb associated with this spiral could easily have served as his motto: Sa nko fa t Kyeri fa! (Go back and retrieve it!).[35]

The Sankofa spiral appeared frequently in the work of African-American artisans of the eighteenth and nineteenth century. That Woodruff's library contained important works on African art, including scholarly texts, suggests that he indeed knew the meaning of these symbols.[36] That others could trace the symbols demonstrates that many sign-symbols in Woodruff's work are encoded with potential meaning, that he was, indeed, retrieving the past and bringing it into the present.

By the time Woodruff painted *Untitled, Celestial Gate Series* (fig. 58), he had combined his references to rock carving with an exploration of ancient practices of wood carving. *Untitled* is probably early in his movement toward the *Celestial Gate* series and perhaps emerges as a nocturnal cityscape from the three-quarter vertical perspective of some distance, as in the view of midtown Manhattan at night from the vantage point of Long Island City or the Brooklyn side of the East River. The painting is densely packed with reflected light, with neon lights, billboards, and signs—the idols of the urban, industrial landscape found in Times Square.

The painting expands and contracts in contrapuntal arrangements that suggest the high decibel sounds of the city. In the dark area at the bottom, the structured, skyscraping totems line up in four vertical zones. These clashing forms spread across the surface and merge into one another, into the free forms that suggest tall city buildings as well as such forms as the forked-tree Dogon Toguna post evoking the human figure found on the bottom left of the canvas.

This work is an astute, balanced painting with a complex arrangement and highly energized, agitated brushwork. In this overwhelmingly dark canvas, the overlapping of paint and its underpainting are important in breaking the plane and establishing the asymmetrical perspective. There is a swiftness to Woodruff's play with light

and dark values across the canvas, and he uses color almost as sculpture, rotating it in rhythms. Golden red and orange hues peer out beneath dark verticals as though through windows or as light coming out of deep recesses or interiors. African imagery is superimposed; these silhouettes turn into heads, and masks turn into landscapes.

A star cluster, as reflected light, cascades down along the lower right side of the painting. Against a blue-gray sky, a cloudlike, luminous, steamy light of thin overlapping washes settles down upon the city from the upper left toward the center of the canvas, creating a sense of three-dimensionality. Embossed on this white vapor are golden and red carvings resembling Asante stools or birds. The cooling mist eases the tension somewhat, for there is oppression in this work, or pressure as if the light is being squeezed out of the center.

In a later work, *African Memory*, 1967–68 (fig. 59), Woodruff validates the importance of the ancestors within African culture and infuses modern America with that value. The double meaning of the title itself stands as an example of his concern. Woodruff's source in *African Memory* is in the powerful Kanaga masks of the Dogon which are danced at momentous celebrations held in ten-year cycles.[37] Symbolizing unity and the ascendance of the generations, the spirit of the Dogon is renewed as each new generation augments those of the past and joins in the remembrance of the ancestors. Amplifying the mystical theme is the Kanaga tradition the Dogon children call the Bird in Flight.[38] According to Marcel Griaule's *Conversations with Ogotemmeli*:

The African people had developed a vividly imaginative account of the evolution of the universe and of the biological development of man from a cellular structure. This account is dramatically expressed in the great kanaga, a towering mask-cross combination which, to the little Dogon children, is known as Bird in Flight and which carries a rich supply of iconographic meanings.[39]

Woodruff's *African Memory*, which is probably part of his oracle and shrine series, relates to *Celestial Gates* and other works that incorporate the mythic images of the ladder and the totem. Against an obliquely angled, cool, harmonic cerulean blue, the top of a towering structure incised with cutout shape/signs in earth red, Kaolin white, and ochre thrusts forward and upward on the canvas. The perspective of the painting, like that of *Untitled, Celestial*

Gate Series, is a three-quarter vertical perspective, an interesting point of view in that the viewer confronts the tops of towering images. The striated angular background suggests the watery, fertile, deep space indicated in the mystical creation myths of the Dogon, and the wavering angles of the background suggest the movement of the dance.

In the dark frontal field of view in *African Memory*, Woodruff also includes on the left the upper portion of an abstracted Bamana antelope headpiece, or Chi Wara, as well as several linear representations of the polelike fetish known as the "mother of all masks."[40] Within the dark Kanaga structure are various symbolic shapes of a vaulted door, a stool, and an ax delineated in the traditional African hues available in nature. While these are highlighted for illusion, Woodruff looks at color in this work as if it might be a figure itself. In this way, he places a three-dimensional composition onto a two-dimensional surface. He uses turpentine washes, and the dominant blacks are brown-black with red underpainting; the black has been painted in last. The primary effect in this painting is of a smooth, waxlike, delicate surface, yet Woodruff's chiseling with the brush permits a sculptural undercurrent.

Sentinel Gate, 1977 (fig. 60), is a late work that continues Woodruff's exploration of the gate concept and his interest in vertical structures. The subject matter concerns a guardian image, or a sentinel, and the transmission of messages. One archetypal messenger, a large Senufo bird figure, appears in the ghostly white negative vertical space on the left. The sculptural central figure seems to combine more than one idea, and appears as both a fetish and a container of a nearly subdural image. This veiled interior image, delineated by a white line with a red and blue base, alludes to the Poro Society mask of the Toma people of Liberia and neighboring nations that is said to have the powers to release the souls of the dead.[41] From the manner in which the sentinel appears to be rotating, it seems to carry symbolic weights or masks upon its shoulders. The outer epidermal image of the sentinel seems to be a figure used by the Bwami association of the Balega (Lega) people, who live along the border in the northeastern region of Zaire and who have also been called the Warega

Figure 59. Hale Aspacio Woodruff. *African Memory*, 1967–68, oil on canvas, 52 x 27. Collection of Mary H. Jennings.

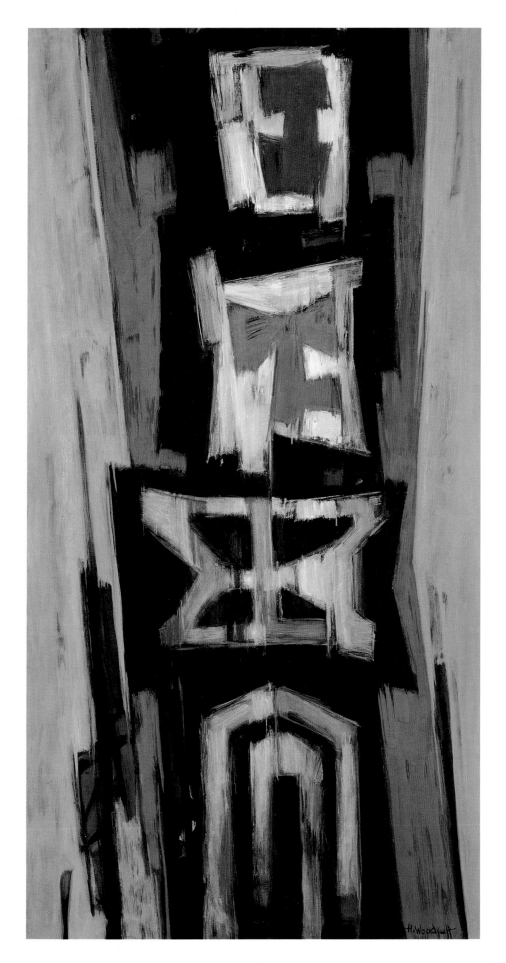

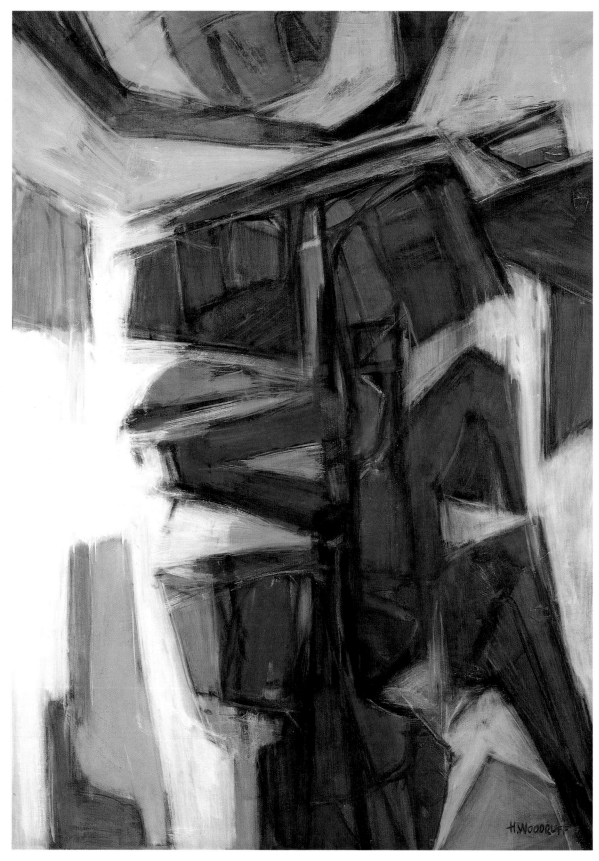

Figure 60.
Hale Aspacio Woodruff. *Sentinel Gate*, 1977, oil on canvas, 40 x 30 inches.
Collection of John H. and Vivian D. Hewitt.

in Swahili.[42] Woodruff's *Sentinel Gate* incorporates the small guardian figures that, attached with raffia, hang head down from the rafters or ridge poles of the initiation hut.[43]

In this exhibition *Sentinel Gate* presents a final poignant example of Woodruff's ingenuity in fusing the fragments of African culture that had been torn apart by the system of slavery and demonstrates his ability to articulate the fusion in his own visual language. *Sentinel Gate* connects Woodruff's paintings to his interest in the oral tradition and the ways of the folk. As in other of Woodruff's works that refer to proverbs, tales, and the ironic African humor, the Balega figure here is connected to a tale told in the form of a proverb that is sung: "The bat hangs with head downward because of the bad words it was told by the sun."[44]

In the *Sentinel Gate* Woodruff seems to acknowledge his approaching death, and, thus, the painting reveals an astonishing confluence of ritual and meaning, art and existence. While he prepared *Sentinel Gate* for exhibition in 1977, Woodruff was also beginning precise preparations for his own departure and personal meeting with the guardian at Heaven's Gate.

■

Notes

1. Winifred Louise Stoelting, "Hale Woodruff, Artist and Teacher: Through the Atlanta Years," PhD Dissertation, Emory University, 1979, 7.

2. Albert Murray, Interview, in *Hale Woodruff: 50 Years of His Art* ed., Winifred Stoelting, Mary Schmidt Campbell, and Gylbert Coker (New York: The Studio Museum in Harlem, 1979), 71. Claude McKaye's account of the summer of 1927 in Paris can be found in "The New Negro in Paris," from *A Long Way Home*, in Richard A. Long and Eugenia W. Collier, eds., *Afro American Writing, An Anthology of Prose and Poetry* 2 (New York: New York University Press, 1972), 380–392.

3. Catherine Bernard, *Afro-American Artists in Paris, 1919–1939* (New York: The Bertha and Karl Leubsdorf Art Gallery, Hunter College of the City University of New York, 8 November–22 December 1989), n.p.

4. Claude McKaye's novel *Banjo* focuses on the life of the workers from North and West Africa who repaired the roads and worked on the docks in the south of France during this time. Woodruff told a journalist in 1977 that he had posed as a North African in order to obtain necessary papers to work as a road laborer. Jane Alston, "Why Not a Wooodruff?" *The Indianapolis News*, 6 March 1977. Amistad Research Center, New Orleans, box 8, folder 13.

5. Stoelting, 56.

6. *Little Boy* and *Suzetta* appear in Alain Locke's *The Negro in Art* (New York: Hacker Art Books, 1970), 56.

7. Judith Wilson, "Go Back and Retrieve It: Hale Woodruff, Afro-American Modernist," in *Selected Essays: Art & Artists from the Harlem Renaissance to the 1980's* (Atlanta: National Black Arts Festival, 1988), 42–43.

8. Romare Bearden and Harry Henderson, *A History of African American-Artists from 1792 to the Present* (New York: Pantheon, 1993), 207 and Stoelting, 213.

9. Collection of E. Thomas Williams.

10. Murray, 78. Woodruff received an earlier Rosenwald to paint in Mississippi and in part to focus on soil erosion. He also expressed some bitterness in that he felt Locke had caused him not to receive a foundation grant at an earlier point in his career because of his modernist leanings.

11. Ibid., 80.

12. None of the watercolors or oils listed in the exhibition program are dated, but *Pyramid Near Cuernavaca* and *Poor Man's Cotton* have the same titles as two watercolors that were listed in the catalog for Woodruff's 1937 exhibition at the Atlanta University library gallery and, therefore, may have been earlier works.

13. Hale Woodruff interview with Esther G. Rolick, 10 November 1970. Wilmer Jennings papers, Kenkeleba House, New York.

14. The artists who received these works were Wilbert Roy Holloway and Wilmer Angier Jennings.

15. Bearden and Henderson, 212.

16. Murray, 75.

17. Conversation with Harry Henderson, February 1995.

18. Ann Gibson, "Two Worlds: African-American Abstraction in New York at Mid-Century," is the title of an unpublished essay written for *The Search for Freedom*, an exhibition held at Kenkeleba Gallery in New York 19 May–14 July 1991, 11.

19. Ibid.

20. Warren Robbins, *African Art in American Collections* (New York: Praeger, 1966), 16.

21. Louis E. Jefferson, *The Decorative Arts of Africa* (London: Collins, 1974), 97.

22. Albert W. Kaypah Mensah, *Sankofa, Adinkra Poems* (Tema, Ghana: Ghana Publishing Corp., 1976), 31.

23. Unidentified paper associated with the National Conference of Black Artists, about 1977. Amistad Research Center, New Orleans, box 8, folder 7.

24. Robert Graves, *The Golden Fleece* (London: Cassell and Co., 1944).

25. Tanner had explained his theory of light when Woodruff visited him while he was a student in Paris.

26. Woodruff kept a detailed cataloguing system to record works in his collection. This statement handwritten by Woodruff is cited on a card as being from Margaret Trowell and Hans Nevermann, *African and Oceanic Art* (New York: Abrams, 1968), 74. Hale Woodruff papers, Amistad Research Center, New Orleans, box 7, folder 2.

27. Woodruff interview with Esther G. Rollick, 10 November 1970.

28. Woodruff and fifteen other African-American artists formed the Spiral group in 1963 initially as a discussion group to resolve some of the problems faced by African-American artists. According to member Richard Mayhew, Woodruff suggested the name for the group based on the progressive mathematical symbol of the early African mathematician Archimedes. Interview with Richard Mayhew, 29 January 1995.

29. Robert Graves, *The Greek Myths* (New York: George Braziller, 1955), 1:194.

30. Illustrated in *Hale Woodruff: 50 Years of His Art*, 40.

31. Unidentified paper associated with the National Conference of Black Artists, about 1977. Amistad Research Center, New Orleans, box 8, folder 7.

32. *Three Tiered Gate*, 1974, illustrated in J. Eugene Grigsby, *Art and Ethnics: Background for Teaching Youth in a Pluralistic Society* (Dubuque, Iowa: W. C. Brown Co., 1977) on page 108 seems to be the same image denoted in the Studio Museum of Harlem catalog on page 46 as an undated *Celestial Gate*.

33. Robert E. Hemenway, *Zora Neale Hurston: A Literary Biography* (Urbana: University of Illinois Press, 1978), 14.

34. Dore Ashton, *Art Digest*, 15 September 1953. Amistad Research Center, New Orleans, box 8, folder 13.

35. Wilson, 41.

36. When Ann Gibson surveyed Woodruff's library, it contained at least one work by Marcel Griaule, one of Wilson's own sources.

37. Conversation with Keletigui Kaba, February 1995.

38. J. Newton Hill, "A Look at African Sculpture," *Journal of the Art Department*, The Barnes Foundation, V:l (Spring 1974): 47. Hill was Woodruff's colleague at New York University, and this journal was included in Woodruff's library.

39. Ibid., 47.

40. Jean Laude, *African Art of the Dogan* (New York: Brooklyn Museum and Viking Press, 1973), n.p., fig. 89. This work was included in Woodruff's library.

41. Conversation with Keletigui Kaba, May 1995.

42. William Fagg and Margaret Plass, *African Sculpture, An Anthology* (New York: Dutton, 1970), 37–38.

43. Ibid., 38

44. Ibid.

■

3

William Majors:
Aspirations and Beliefs

Harriet G. Warkel

William Majors:
Aspirations and Beliefs
Harriet G. Warkel

*T*he first artistic assignment William Majors received was making anatomical and pathology drawings for the medical staff at Sunnyside Sanitarium, where he was a tuberculosis patient for seven years. This exposure to human anatomy played an important role in the artist's use of biomorphic forms in his paintings and works on paper. He understood anatomy not only from the point of view of life drawing or figure drawing in art classes, but also from a medical perspective.[1]

Many of the works Majors completed after he was released from the sanitarium in 1953 and prior to his trip to Europe in 1960 contain recognizable subject matter. His drawings during this period, produced while attending art schools, consist of landscapes in which he often concentrates on a specific form in nature such as a tree trunk. These images, tightly drawn with an abundance of fine lines and intricate detail, are transformed in later work into abstract compositions executed in a similar manner. Majors preferred to suggest rather than define his themes, supplying only the essential elements and leaving the rest to the viewer.

While a student at John Herron School of Art, Majors used figurative imagery which focused on form, design, and pattern. In *Crucifixion* (fig. 61), completed about 1958, three ladders allude to Christ and the two thieves. A foot in the upper center of the canvas suggests the figure of Christ, while a ray of light in the distance implies the presence of God or of a heavenly realm. Even at this early stage in his artistic development, Majors had a highly personal and abstract approach to his biblical subject matter.

Several of Majors's early works exhibit an affinity to abstract expressionism, the first American art movement to become an international style. It developed around 1943 and was at its peak by the time Majors left the sanitarium in 1953. Influences from this movement can be seen in Majors's paintings of the late 1950s, such as *Burning Bush*, *#3*, and *Untitled Abstraction*. Rather than deriving his imagery primarily from the unconscious mind as many ab-

stract expressionists did, Majors based his work on his observations of nature, the human form, and the world around him. *Burning Bush*, 1961 (fig. 62), is an interpretation of the Old Testament parable of the bush that burned but was not consumed. Majors often returned to this theme in later work. The painting has quick, animated strokes layered on an umber-red background with yellow, off-white, and pastel blue-gray color variations accented by dark lines that delineate the flames.[2] The agitated, loosely applied strokes found in *Burning Bush* are juxtaposed with flat, geometric fields of color in *#3*, 1958–59 (fig. 63). A closer look at this painting reveals a face peering open-mouthed from the multicolored layers of paint. In *Untitled Abstraction*, 1958–60 (fig. 64) Majors's vigorous strokes of orange and red hover over a geometrically composed area of blue-green and off-white, reminiscent of a sandy beach on a hot sunny day.

In a drawing of the crucifixion executed for the Herron art school's newspaper, *The Chronicle*, at the time of the artist's 1960 graduation, the imagery is clearly figural. Majors piles the forms on top of each other, incorporating them into an abstract composition. The twisted, intertwined figures vividly illustrate the agony and torment associated with the theme.

While living in Florence from 1961 to 1962, Majors studied the early Italian artists, particularly Massacio and Giotto, and was deeply inspired by the grandeur of their work. He chose Florence for the purpose of studying religious art, and it fulfilled his expectations. The city itself had an extraordinary impact on Majors, who found its history and cosmopolitan environment conducive for painting. The respect he received from the Europeans simply because he was an artist gave Majors added encouragement to pursue his work. He had never experienced this kind of support and appreciation.[3]

By the time Majors moved to New York in 1962, he had already developed his own idiom of abstraction incorporating biomorphic forms. His job as a guard at the Museum of Modern Art offered him an unusual opportu-

Figure 61.
William Majors. *Crucifixion*, about 1958, oil on canvas, 41 x 30 inches.
Collection of Wendell L. Parker.

William Majors: Aspirations and Beliefs 101

Figure 62.
William Majors. *Burning Bush*, 1961, oil on canvas, 62 x 48 inches.
Collection of Dr. Daisy Riley Lloyd.

Figure 63.
William Majors. **#3**, 1958–59, oil on canvas, 50 x 36 inches.
Collection of Kelley Majors.

Figure 64.
William Majors. *Untitled Abstraction*, 1958–60, oil on board, 30 x 24 inches.
Collection of Betty Joan Owsley.

nity to study the works of European as well as American artists. The museum held a retrospective exhibition of the work of Arshile Gorky the year Majors arrived in the city. A precursor of the abstract expressionist movement, Gorky painted biomorphic images rooted in the surrealism of contemporary artists, such as Joan Miró and Matta. Majors discovered that his own art had many affinities to Gorky's and was excited to learn the two shared a common artistic language.[4] Susan Stedman Majors notes:

There are many artists' works which Bill examined and savored. He kept exploring to satisfy a very eclectic range of interests, for example, from LeBrun's figures, Klee's imaginative language, Villon and Peterdi's finely etched line work, Diebenkorn's color and composition to Kandinsky, Schwitters, Goya, and Morandi. He called on many sources. This also was a conscious, deliberate effort to be as inclusive as possible in teaching. During the 1960s Bill was deeply inspired by African art as well as the art of other indigenous cultures such as Native American and Oceanic. He was inspired as much by Sung scrolls as by Senufo relief carving.[5]

Soon after arriving in New York, Majors briefly enrolled in a printmaking course and began concentrating on etching and aquatint techniques, which immediately became primary processes in his work. His composition *Genesis II*, 1965 (fig. 65), combines these printmaking techniques with glue to create a print similar in appearance to action paintings or automatism. The composition derives in part from sketches Majors made on small sheets of paper of tree branches against the skyline. In these drawings Majors was working out the connection between positive and negative space, which resulted in the kind of interlacing forms found in *Genesis II*.[6] For this print the etching plate surface was prepared on three levels. Background color is monochromatic brown, while dark, medium, and light shades of brown make up the etched lines. Burnt sienna and sepia inks are used with the aquatints underneath the lines. When the aquatinting process was completed, Majors dripped Duco cement onto the plate to give the paper a slightly embossed impression in printing. Although the finished work appears randomly composed, it is a controlled and disciplined print meticulously conceived and executed by the artist.[7]

In 1965 the Junior Council of the Museum of Modern Art published Majors's series of eighteen prints, *Etchings From Ecclesiastes* (figs. 66–68), in a limited edition of ninety copies. An introduction by Fritz Eichenberg, then professor of art history and printmaking at Pratt Graphic Art Center, opens the series, and specific texts selected by the artist and his future wife, Susan Stedman, from the Book of Ecclesiastes accompany each of the etchings. Eichenberg wrote: "Ecclesiastes has certainly spoken to William Majors, an artist of talent and perception searching for truth. The prints speak of a love for man and for the work of his hands. [Majors] is a gifted artist guided by profound convictions."[8]

Several of the etchings in this series are very small, only a few inches across. Majors's wife noted that he "wanted to offer an intimate viewing experience that was in deliberate contrast to the flamboyant, wall-sized, gestural paintings of the Abstract Expressionists."[9] The series was of particular significance to Majors, who was concerned "with giving visual interpretations to my belief that the elements of the world in which I live are of a religious nature, hence the source of my art. The purpose and method of my work is to help others give expression to their hopes, aspirations, and beliefs through artistic experiences."[10] Composed of delicate lines and biomorphic images suggesting human anatomy, *Ecclesiastes* represents Majors's reflections on the essence of life and the forces behind man's existence.

The forms in Majors's etching *Figure*, 1967 (fig. 69), are built up inside the image in a manner akin to the cubist work of Juan Gris and Georges Braque, whom he appreciated. Although the human form has been simplified into its essential components, the composition is actually made up of very complex elements. A circle in which three triangles are suspended floats above the rectangular head of the figure, whose facial features are composed of a group of geometric forms. Majors utilizes the background's negative space to create an intricately woven series of etched lines. The figure, boldly outlined in white, seems to be in movement, hovering in another realm. As Susan Stedman Majors explains. "He translated rhythms and movement observed in the street as well as in dance. Through friends he had learned about the work of the great master of mime, Etienne Decroux, which also affected his use of calligraphic forms. The third element these forms refer to is African relief carving; and the fourth, is calligraphy and ideographs found in many languages of antiquity and the present."[11]

Figure 65.
William Majors. *Genesis II*, 1965, etching with aquatint, 22 ³/₈ x 24 inches.
Collection of Susan Stedman Majors.

Figure 66.
William Majors. *Etchings from Ecclesiastes*, 1965, III-3, aquatint and intaglio on Rives BFK paper, 16 ³/₄ x 13 ⁷/₈ inches.
Indianapolis Museum of Art. Gift of the Art School Committee, Herron School of Art.

Figure 67.
William Majors. *Etchings from Ecclesiastes*, 1965, V-15, aquatint and intaglio on Rives BFK paper, 13 $^7/_8$ x 16 $^3/_4$ inches.
Indianapolis Museum of Art. Gift of the Art School Committee, Herron School of Art.

Figure 68.
William Majors. ***Etchings from Ecclesiastes***, 1965, VI-12, aquatint and intaglio on Rives BFK paper, 13 $^{7}/_{8}$ x 16 $^{3}/_{4}$ inches.
Indianapolis Museum of Art. Gift of the Art School Committee, Herron School of Art.

Figure 69.
William Majors. *Figure*, 1967, etching with aquatint, 27 ⁷/₈ x 22 ¹/₄ inches.
Collection of Susan Stedman Majors.

In the Studio, 1966 (fig. 70), a painting so characteristic of this period, shows Majors's use of calligraphic motifs to represent figures. The rectangular shape in the upper right corner resembles a completed canvas set on an angle. A tribute to Henri Matisse, whom he greatly admired, the composition is whimsical in nature, suggesting a crowded studio of curious spectators contemplating the painting in front of them. Here Majors creates a scene that will be repeated in the real world every time this work is viewed.

Another work executed at this time, *Liberation*, 1967 (fig. 71), reveals a calligraphic figure encased in a multi-layered impenetrable cell. Title and imagery allude to Majors's feelings about the barriers people must breach to achieve their full potential. Here he encircles the figure in dark and somber colors. The artist adds a lighter blue area on the left side of the canvas to suggest a brighter world outside the realm of the confined figure.

In an untitled pencil drawing from 1970 (fig. 72), similar to his collages, two ovals and a small rectangle overlap as if they were on different planes. Majors sets these softly modulated floating gray images against a black, elongated rectangle. By setting up this barrier, Majors creates a dynamic balance between forms, reminiscent of the abstract expressionist Robert Motherwell's ovoid shapes held in tension between vertical elements.

Majors created a series in 1973 based on the River Niger (fig. 73), the principal river of West Africa. Using a variety of graphic media, the artist created linear patterns and free-flowing compositions that express the changing nature of the river. Majors commented on the meaning of this series:

The River Niger *suites have evolved out of the black experience. They are addressed to the uniqueness of that experience. Thematically, water in all its variety of forms denotes both the constant as well as the ever-changing nature of our common experience and I have utilized a wide range of graphic techniques in these series..., to make visible this concept. I have selected the most direct expression—"making a mark"—in creating the imagery of the suites.*[12]

Majors's drawing *Allegory to Love*, 1973 (fig. 74), executed on a highly polished gesso panel, shows two abstract female forms. Adjoining these biomorphic images is a triangular form that contains a shape resembling an open seed pod, a sign of the fecundity of nature. The surreal quality of this drawing lies in the juxtaposition of the eroticism and naturalism of the figurative forms with two more literal shapes illustrating traffic lights. The artist referred to the traffic lights as symbols of the negative controls society exerts on human relationships in general and on love in particular. Majors uses metaphors and visual symbols to create a universal language that conveys images associated with the composition's title. Another example of his personal metaphorical imagery can be found in the etching *Allegory to Love*, 1974 (fig. 75), part of a series in which Majors portrays a praying mantis and incorporates many of the same elements that are found in the 1973 panel drawing.

In his collages Majors employs a wide variety of papers on which he uses inks, paints, or dyes applied with rollers, pens, and brushes. Some are pre-tinted and then wiped or rubbed to create different textures, while others have a highly glossed surface. The carefully torn papers have irregular edges, accenting the colors that range from deep to faded shades. Occasionally, Majors incorporates printed materials. Several collages are untitled, stimulating viewers to use their own imaginations and experiences to interpret the images. In *Untitled*, 1975 (fig. 76), the overlapping forms are pasted on linen, creating a textured surface. Many of the collage compositions evolved later into paintings; however, the artist did not regard them, for the most part, as preparatory studies.

In *Gestation*, 1975 (fig. 77), Majors clearly shows a torso on the right. If it is turned upside down, the image resembles a pregnant woman, echoing one of the forms that appears in the drawing *Allegory to Love*. Held in the upright position, internal organs such as a uterus are discernible. The papers vary in size, color, and texture, suggesting the various stages of cell growth leading to the development of the fetus.

The magazine and newspaper print incorporated into *Ghetto on 7th Avenue and 30th Street, N.Y.C.*, 1975–77 (fig. 78), recalls the collages of Gris, Kurt Schwitters, Picasso, and Braque executed about 1913. Majors often looked down from his third-floor New York loft on Seventh Avenue and observed the patterns people made on the street as they stood and talked together. Here the artist creates the feeling of a crowded, noisy, densely populated area by overlapping the shapes in several layers. He groups his elements into rhythmic arrangments of form and color, making use of the principles of color interac-

Figure 70.
William Majors. *In the Studio*, 1966, oil on canvas, 49 $^1/_2$ x 60 inches.
Collection of David and Carol O'Connor.

Figure 71.
William Majors. *Liberation*, 1967, oil on canvas, 72 x 62 inches.
Collection of the Chase Manhattan Bank, N.A.

Figure 72.
William Majors. *Untitled*, 1970, pencil on paper, 29 $\frac{1}{2}$ x 21 $\frac{5}{8}$ inches.
Collection of Susan Stedman Majors.

Figure 73.
William Majors. *River Niger*, 1973, etching (silver roll with black ink on sheet music), mounted on Kozo paper, 16 $^{1}/_{2}$ x 23 $^{1}/_{4}$ inches.
Collection of Susan Stedman Majors.

tion. Only a few small areas of clear space are left around the edges of the collage. Majors did not do any preliminary sketches for his collages. He tore, cut, and arranged the shapes of paper on his surface with a conscious awareness of nature and human form.[13] All his collages demonstrate his deliberate attention to the elements of color, composition, space, and the picture plane.

Majors developed many different ways of expressing his knowledge and awareness of nature, the movement of the body in space, human anatomy, and internal organs. He constructed a personal idiom of biomorphic forms and calligraphic shapes that owe a debt to cubism, surrealism, and abstract expressionism. According to Susan Stedman Majors, "His work shows joy, not gloom, and he was interested in universal expression, not something that related to one group of people at a particular moment in time."[14]

Figure 74.
William Majors. *Allegory to Love*, 1973, pencil (colored and graphite), gold leaf on gessoed board, 24 x 30 inches.
Collection of Susan Stedman Majors.

Figure 75.
William Majors. *Allegory to Love*, 1974, etching (silver roll with black ink), 22 ³/₄ x 28 ¹/₄ inches.
Collection of Susan Stedman Majors.

Figure 76.
William Majors. *Untitled*, 1975, collage on linen, mounted on paper, mounted on masonite, 18 x 24 inches.
Collection of Susan Stedman Majors.

Figure 77.
William Majors. *Gestation*, 1975, collage with mixed media on gessoed paper, mounted on gessoed board, 17 $^{15}/_{16}$ x 23 $^{7}/_{8}$ inches.
Collection of Susan Stedman Majors.

Figure 78.
William Majors. *Ghetto on 7th Avenue and 30th Street, N.Y.C.*, 1975–77, collage with mixed media mounted on gessoed masonite, $19\,^7/_8$ x 30 inches.
Collection of Susan Stedman Majors.

Above:
William Majors. *Untitled* (Tondo)
From Allegory Series, 1976, collage
with mixed media on gessoed
masonite, mounted on cardboard
panel, 16 $^{11}/_{16}$ inches diameter.
Collection of Susan Stedman
Majors.

Left:
William Majors. *Study VIII
for Paintings - The Blues*, 1976,
colored pencil on paper,
22 $^{1}/_{8}$ x 29 $^{7}/_{8}$ inches.
Collection of Susan Stedman
Majors.

Notes

The author would like to thank Susan Stedman Majors for her role as research advisor on this essay.

1. Christine Temin, "Majors' Posthumous Show Is an Affirmation Of Life," *The Boston Globe*, 22 January 1987, 1.

2. Interview with Susan Stedman Majors by William Taylor, 23 August 1994.

3. Phone conversation with Richard Mayhew, 6 April 1995.

4. Anthony Panzera with Susan Stedman Majors, "Conversation with Susan Stedman Majors," in *William Majors, Distinctions: Approaches to Drawing* (New York: The Bertha and Karl Leubsdorf Art Gallery, Hunter College of the City University of New York, 11 February–26 March 1993), 8.

5. Ibid.

6. Interview with Susan Stedman Majors by William Taylor, 23 August 1994.

7. Ibid.

8. Excerpts from this introduction are in the article by Temin, *The Boston Globe*, 1.

9. Ibid.

10. *Artist's Proof: A Journal of Printmaking*, The Pratt Graphic Art Center, 6:9–10 (1966): 18.

11. Panzera and Majors, 8.

12. *Majors: Graphics*. An exhibition of the winter artist-in-residence, Dartmouth College, Beaumont-May Gallery, Hopkins Center, 28 January–6 March 1977.

13. Interview with Susan Stedman Majors by William Taylor, 23 August 1994.

14. Temin, *The Boston Globe*, 1.

■

4

The Mural Tradition
Edmund Barry Gaither

The Mural Tradition
Edmund Barry Gaither

Murals have a long history in American art, extending back to projects such as John Trumbull's proposal for the Capitol in Washington. Such works typically advanced civic themes and were generally associated with governmental or religious commissions. Thus, after the launching in 1934 of the Works Progress Administration (WPA) by the administration of Franklin D. Roosevelt, interest in murals rebounded. Fed partly by the need to buttress national cohesion in the face of the Depression and partly by a resurgence of regionalism, with its emphasis on American narratives, murals were a dominant visual form through the second quarter of the century. Leading figures associated with mural activity and regionalism include Grant Wood, John Steuart Curry, and Thomas Hart Benton. As modernism, especially abstract expressionism, gained in importance in the fifties, however, murals, figuration, and historical depictions came to be viewed as parochial, conservative, and outdated. The easel painting and its association with individual expression and personal iconographies quickly carried the day as American artists increasingly sought a place within international modernism.

Interestingly, African-American artists were out of sequence with this development. They often felt obligated to give way to the collective sense of self-worth needed to survive the onslaught of Jim Crow, racism, and pervasive injustice. They wanted to offer their community a narrative that would inspire the challenge, while also teaching history not yet acknowledged in the larger society. In this context, black muralists such as Aaron Douglas, William Edouard Scott, Charles White, Hale Woodruff, and John Biggers valued the visual and didactic power of the mural. Their dedication to the task of restoring black peoplehood through heroic history paintings simply grew more vital after the Second World War. They did not, like their white American peers, retreat from mural making in the postwar period. An examination of murals by Scott and Woodruff offers an opportunity to explore African-American mural art during the first half of the twentieth century and to demonstrate the change from narrative to abstract content.

William Edouard Scott

William Edouard Scott, a gifted and versatile artist, worked during the first half of the twentieth century as an American realist with a deep respect for the lessons of impressionism. Having received sound training for a career as a painter, he furthered his development with study at French academies and also enjoyed the encouragement, guidance, and support of Henry Ossawa Tanner, the towering giant of nineteenth-century African-American artists.[1] Though born twenty-five years apart, both painters enjoyed exploring religious and genre themes, and both delighted in experimentation with light for its dramatic possibilities. Both also deeply respected the prevailing conservative canons of their professions, almost never venturing toward abstraction or other modernist explorations of the pre-World War II period.

Booker T. Washington, Hampton Institute graduate, founder of Tuskegee Institute, and voice for southern blacks, rejoiced when he thought Tanner, upon finishing *The Banjo Lesson*, 1893, was turning his attention toward the sympathetic presentation of black life through the visual arts.[2] His excitement proved to be premature, since Tanner did not choose to pursue this subject matter. It was Scott, barely a generation later but too late for Washington, who began to define this genre. Scott, in a sense, fulfilled the latent promise of the expatriate Tanner by becoming one of the earliest black painters of history themes and perhaps the first to paint Afro-Caribbean scenes for a popular, black audience.

A very productive artist, Scott executed many paintings, among them an extraordinary volume of murals. Before undertaking this essay, I was unaware of the extent of Scott's activity as a muralist, although his paintings had interested me for many years. Now I feel only the surface of his work as a muralist has been scratched. Many more questions, for which answers exist, need to be

pursued. Scott will reward the thoughtful art historian who is really a detective at heart.

At the outset of my work, I had the benefit of a partial compilation of known murals executed by Scott.[3] The list specifically identifies more than forty sites where previous records indicate the existence of murals. The sites include eight churches, seven schools, two hospitals, seven youth centers, six government buildings, two hotels, one college, two field houses, five banks, and one newspaper office. In excess of forty other murals in churches and schools are mentioned, though no particular sites are referenced. Of the murals said to exist in specific places, quite a number, such as those in the Pilgrim Baptist Church in Chicago, were found. Many of the buildings where murals had existed have been renovated or demolished, and records of the paintings have been lost. This was true for the Wabash Avenue YMCA murals in Chicago. Still other sites are not extant because the companies or organizations no longer exist. In this category is the black Binga State Bank of Chicago. Some sites, such as Fisk University, acknowledge having paintings by Scott but possess no knowledge of holding murals. In a few instances, such as the Harlem YMCA, murals are still in place but too soiled and darkened to study. Occasionally, murals could be found, but the relevant records are missing or lost. Finally, provoking the greatest delight, new murals, such as *Commerce*, 1909, at Lane Technical High School, were unexpectedly discovered.[4] Scott and his mural production remain a rich field for new work.

Scott's murals merit several general observations, which, for the most part, hold true for works executed over the period from about 1910 to the mid-1940s. First, his approach remained rooted in realism, where he preferred naturalistic settings, plausible figurative arrangements, and a sense of physicality in the environment. He avoided heroic presentation, eschewing oversized figures and extraordinary feats in favor of a more democratic attitude. His murals are focused at eye level, and the figures who populate the paintings sweat, strain, laugh, talk, and labor in a context of equality. With the exception of specifically moralizing themes, Scott's murals seem honest, direct, and engaging.

Scott enjoyed the challenge of complex figurative compositions. Never did he shy away from massing large numbers of figures, whether in crowds or small ensembles.

Obviously, he was comfortable with configuring groups in ways that make them seem naturally related to one another. When necessary, he added into the mix portraits of key personalities on whom the story may depend. In many cases, his portraits, appearing as they do within well-populated settings, are identified through his skill in revealing the person's character rather than by way of slavish attention to the rendering of details. For example, Abraham Lincoln is identified more through his gaunt face, lanky body, and impression of plain humanity than by his eye color or facial moles. By means of such broad characterization, Scott brought to his murals a psychological quality, a mood that helps shape understanding of the activity being portrayed.

In his more effective murals, such as *Commerce*, 1909 (fig. 79), Scott often constructed his composition so that light plays a leading role in defining both the character of the event and our sense of having an intimate relationship with it. The most frequently used device for this purpose involves introducing the light into the mid-ground of the painting and leaving the immediate foreground figures darkened. The result is that the viewer feels he or she is approaching the event along with the foreground figures and is drawn into the center of activity. We become, in a sense, intimate witnesses standing at the inner edge of the crowd. At its best, this is an exceedingly effective foil for setting up the vital center of the mural.

Scott often delighted in composing his murals as panoramas, very wide scenes in which multi-episodic adventures occur in contiguous spaces that flow into each other. These wide views, rich in compositional complexities, have a linear, cumulative quality that introduces into the mural a literal aspect of duration, since the scene must be panned sequentially for the viewer to comprehend its substance and intent.

A preliminary classification of Scott's murals might offer the following groupings: history themes or paintings interpreting or recalling some passage of our national saga; documentation themes or paintings recording nonpolitical aspects of our national life; religious themes or paintings interpreting the narratives of the Christian faith; and moral themes or paintings intended to convey a lesson in moral or social values through symbolic iconography and guiding text. This study examines more closely examples relevant to each of these aspects of Scott's mural art.

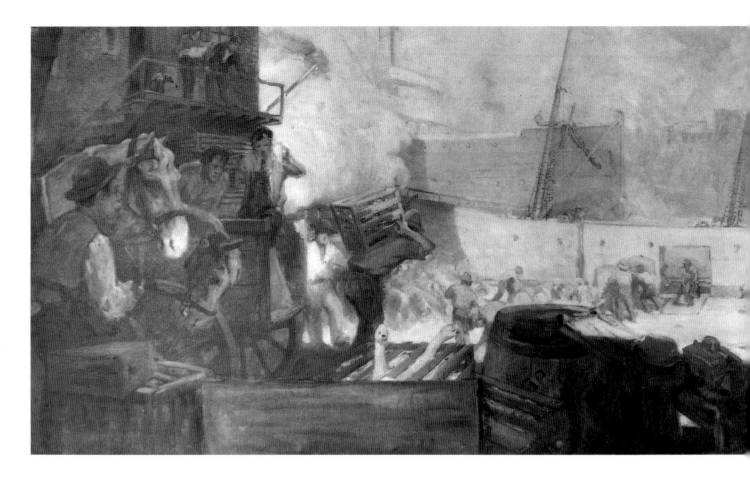

In the American mural tradition, the grand paintings not only celebrate formal history and its defining events, but also sometimes document the broader sweep of developments in society. Certainly Scott's 1909 mural *Commerce*, painted for the Lane Technical High School in Chicago while he was still a student at the Art Institute, serves this purpose. In a period of optimistic growth and development in the heartland, Chicago celebrated its industrial accomplishments.

Commerce is the third in a set of murals created by Art Institute students through an arrangement with the Chicago Public School Art Society and Mrs. Buckingham, its president, to pay tribute to the progressive growth of Chicago. The murals celebrate: 1) the operations of the steel mills, representing the production of raw materials for factory and assembly line operations; 2) the construction of skyscrapers, the cathedrals of modern cities and the dramatic evidence of the triumph of architecture over the limitations of space and natural construction materials; and 3) the vital commerce represented by shipping

Figure 79. William Edouard Scott. *Commerce*, about 1909, Lane Technical High School, Chicago.

and receiving as essential elements of modern industrial flourish. The class president at the Lane School thought the "three panels form an admirable interpretation of modern industrial life," and she judged the works a success, as "the painters seem to have caught the spirit of industry and to have embodied it in a vivid and realistic way."[5]

Commerce is quite a remarkable mural, especially for an artist still in training. Showing a panoramic view of the busy wharf, the mural employs the unusual device of casting all the foreground figures in shadow and opening up the mid- and background areas with a wash of warm light. Scott buttresses a pyramidal compositional arrangement ascending from several barrels on the left and from a man towing a two-wheel dolly on the right. Surmounting the triangular mound are two men moving a large wooden crate. To the right, a second man stoops over a barrel, half lifting and half rolling it. Behind him a rotund fellow in a dark vest checks the inventory of things coming and going. All of these activities are revealed in brown tones, as if the viewer were emerging from a shed whose shadow is cast over the immediate foreground. In the middle ground, teams of men are loading ships, barges,

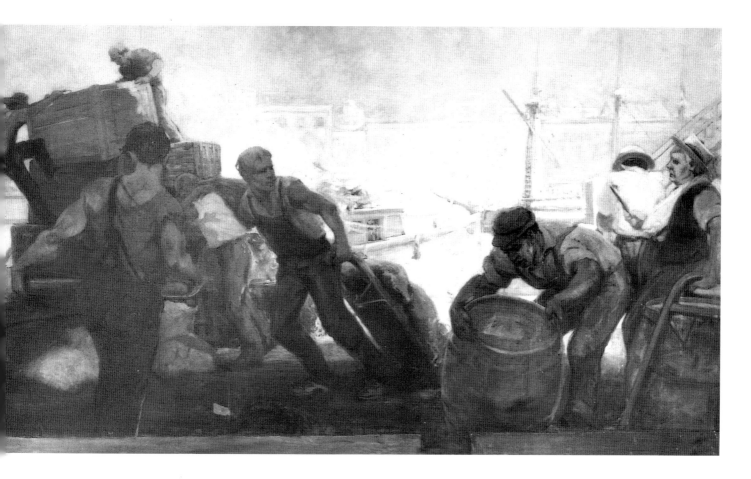

and boats, which, with their masts and chimneys, merge into the greenish light of the distant water and sky.

Commerce offers a dynamic vista of a vitally active and energetic port bustling with trade. Its figures are the characters of a Walt Whitman poem: masculine, muscular, sweaty, purposeful, quintessentially American. They are immigrant, regionalist, black, and white. Like the characters of other Scott murals, they seem to share a common bond of democratic labor and joint enterprise. In that aspect, they suggest an optimism about equality that is pervasive in Scott's historical and documentary murals.

History constitutes an important interest for Scott, who seemed especially transfixed by the stories describing relationships between President Abraham Lincoln and abolitionist Frederick Douglass. In the painting *Lincoln at Springfield* (Amistad Research Center, New Orleans), Scott fully characterized this encounter between the reluctant emancipator and the activist ex-slave and orator.[6] The scene as depicted posits a belief in democratic justice as a possibility, if not yet a fact. In a panoramic format, Scott shows a lanky and tall President Lincoln, wearing an intent expression and attired in a dark gray suit, black bow tie, and yellow vest. In front of him, extending a hand as if in greeting, is Frederick Douglass, wearing brown pants and a long, dark frock coat. Though Douglass is slightly shorter than Lincoln, the two standing men dominate the center of the painting with their encounter. Closing the space behind Lincoln is a train from which he has just alighted. An elegant white couple fills the space beyond the Lincoln/Douglass exchange. Behind Douglass are a comparable black couple, an older black gentleman, and a nanny and child. The startling thing about the scene is the absolute equality given both sides of the picture. Douglass is not a petitioner but rather an equal man with Lincoln. *Springfield* symbolizes the possibility of equality in the post-Civil War era. In fact, Lincoln and Douglass became recurring figures in this dialogue about freedom and manhood.

Another Lincoln/Douglass encounter brought Scott significant attention. On April 2, 1943, he was selected to execute a painting of Douglass appealing to Lincoln to authorize black regiments to fight in the Civil War. The award followed a nationwide competition in which 360 designs were submitted by 124 artists.[7] The guidance given

to the artists was that their theme should "reflect a phase of the contribution of the Negro to the American Nation."[8] Winning murals were to be installed in the lobby and library of the Recorder of Deeds building in Washington, D.C. The jury, headed by painter Nan Watson, consisted of Dr. William J. Thompkins, Recorder of Deeds; Captain Henry Billings, muralist; Kindred McLeary, muralist; James V. Herring, chairman of the art department at Howard University; and Edward B. Rowan, Fine Arts Section, PBA/WPA.[9] Considerable care was taken to assure that the selection process would be as fair as possible. Artists were required to send their full color oil or tempera sketches without signatures. Using a system of tracing numbers, the winning entries would be matched with the names of their creators only after the selection process was completed.

The process gave what one observer considered an ideal result: "The high quality of the work shown, the variety of approach, the geographical distribution of the seven successful artists and the fact that four of them were men, including one Negro painter and three were women is a source of satisfaction to all concerned and illustrates the impartiality and the care which the jury showed in making the selection."[10] Of Scott's winning sketch juror Rowan wrote, "Your design was chosen on the basis of the sincerity with which you depicted both Lincoln and Douglass, and the spirit of reality that you succeeded in putting into the setting."[11]

As finally realized, the painting was trimmed to fit the 5' 10" by 5' space allocated. This was accomplished by removing portions from the left and right sides of the work. Additionally, the composition was simplified a bit: a large table lamp, a Union soldier-guard, and a background figure, all of which appeared in the sketch in the newspaper, were removed. The painting retained its sense of an honest encounter. In Lincoln's office, the president sits on the left with a paper in his hand and casts a pensive gaze downward. His sunken face is accented by his bow tie. His limp right hand dangles over the arm of his chair. Opposite Lincoln stands Douglass, who addresses himself forthrightly to his Commander in Chief. Standing behind the table, two of Lincoln's aides witness the exchange. Scott, in his manner of depicting the exchange between Lincoln and Douglass, suggests that the fiery orator is here the aggressive speaker. Whereas Douglass, hands extended slightly, shifts his weight forward while speaking to Lincoln, the president appears to avoid looking into Douglass's eyes and concentrates on listening to his words. His face gives no hint of his response, though it shows clearly his concern with the issue at hand. Lincoln is portrayed as receiving information that he must now ponder carefully before he acts. His aides seem to distance themselves from the matter under discussion.

The appeal Douglass brought to Lincoln was problematic for the president. At a point when the Civil War was proving much more difficult than the Union leadership had expected, Douglass asked Lincoln to authorize the creation of regiments of black soldiers. Although blacks had fought in both the Revolutionary War (1775–83) and the War of 1812, many whites resisted the notion that African Americans could be effective soldiers. Lincoln, who believed that there were differences between the races, had to decide whether to authorize such enlistments as part of the extreme measures needed to win the war or simply to honor existing discriminatory practices. In the end, Lincoln authorized the black musters, and almost immediately the Massachusetts 54th Regiment was formed. Among its men were the two sons of Frederick Douglass.

For a commission fee of $500, Scott completed a second mural for the Recorder of Deeds building.[12] This work, *Dedication of the Recorder of Deeds Building*, 1944, is less satisfying than *Douglass Appealing to President Lincoln*. The twenty-five figures on an announcement platform, including President Franklin Delano Roosevelt and the First Lady, appear somewhat stilted and overly conventional. It seems to capture a moment just before the beginning of the ceremonies. The president is leaning to the side to receive a short briefing from an aide. His platform guests, including several high-ranking military officials and at least one black figure in the left, back row, are awaiting the commencement of the program. Overhead, two flags hang in the breezeless air. Flags and shields bearing stars and stripes adorn the bannister, which too firmly separates the world of the picture from that of the viewer. Perhaps Scott felt the weaknesses of this composition and sought to give the work greater energy through a more creative use of light. In a letter to Rowan, overseer for the commission, Scott wrote, "I thought it would add to interest and color to break sunlight across the front of the platform to form a `V,' leaving the two shields and lattice

work in shadow."[13] Despite this innovation, the mural remains below the high standard set by such early murals as *Commerce*.

Many of Scott's murals were religious in character, and several of his most interesting mural complexes appear in church settings. Perhaps Tanner, a primarily religious master, exerted some influence on the younger painter in this direction. Maybe rapidly growing black churches, responding to the flood of the great migration and its lingering steady stream of southern black migrants, saw in Scott's murals both the opportunity to celebrate a black artist in their midst and to distinguish themselves as progressive and successful congregations. No matter what the influences, they converged to foster the perception of Scott as a church muralist.

I use the phrase "mural complexes" quite deliberately, since Scott often painted numerous individual murals, though not necessarily adjacent to each other. In some cases Scott seems also to have executed portraits at the same time. These may be entirely independent of the murals. An example is the complex of paintings Scott executed in 1943 for the Pilgrim Baptist Church in Chicago. At Pilgrim, eight irregularly shaped panels adorn the area of the two choirs and the altar. In the narthex of the church he painted a frieze as well as two portraits. The environment of the church is rich in paintings that present the life of Christ as well as aspects of the life of Pilgrim Baptist Church.

The Pilgrim murals are built on a long history of religious paintings by Scott. Among the most ambitious earlier undertakings were the series of more than a score of paintings executed for the Burdsal Wing of the Indianapolis City Hospital in 1915.[14] These "decorations" were in two groups: In the women's medical ward were murals titled *Four Scenes from the Life of Christ*. A contemporary report in *The Indianapolis Star* of October 31, 1915, details the murals and their locations. The account offers an expansive view of the scope of the project, which, remarkably, was completed in just half a year. According to the article, the lobby featured the *Expulsion from the Garden of Eden*, the *Annunciation to Mary*, and three panels showing Moses, St. John, and St. Paul. In the main room were *The Boy Christ*, the *Three Magi and the Star in the East* (fig. 80), *The Nativity*, *Christ with Simeon*, *Christ as Carpenter*, *Flight into Egypt*, and *Christ in the Temple with the Elders*. A nearby

corridor continued the story with two large panels showing *Suffer the Little Children to Come unto Me* and *He Who Is without Sin*. Overlooking the sundeck are five more scenes: *Zacharias in the Tree*, the *Sermon on the Mount*, *Christ before Pilate*, *Christ Appearing to Mary after the Resurrection*, and *The Triumphant Entrance into Jerusalem*. Finally, two forty-foot panels in the upper level of the main room present the women of the Old and New Testaments.

These scenes were designed to underscore practical and spiritual ideas about the central place of children in society. Consider, for example, the panel presenting Simeon and Christ. The scene depicted is taken from verses 25-32, chapter 2, of the Gospel according to St. Luke. Scott describes the interior of the temple as spacious and opulent. Simeon seems frail but ramrod-straight as he, holding the baby Jesus, raises one hand in thanks for the blessing of this encounter. Joseph, with a cage containing doves brought as an offering, stands somewhat awkwardly nearby, and Mary peers over his shoulder. Christ appears as a ruddy child with a full head of hair. Neither Simeon, Joseph, or Christ approximate the prevailing image of pale, Nordic innocence so popular on calendars and in church publications. Rather, they all seem a bit dark and Near Eastern. *The Indianapolis Star* reporter asserts that Dr. William Weir Stewart (*sic*) posed for the Joseph figure and Miss Martin, a supervising nurse at the hospital, posed for Mary.[15] From the Simeon story, Scott probably meant for visitors and expectant mothers to recognize that children are a blessing for which they should be thankful.

Among other sets of religious murals by Scott is the series executed for the Stuart Mortuary in Indianapolis in 1948. These, too, center on scenes from the life of Christ and use some previously cited compositional devices. For example, in the three-panel mural depicting the crucifixion, both the Roman soldier holding his sword on the left and the bare-shouldered figure on the right appear in shadow, as if the light source were in front of them and the viewer behind. A similar handling of light applies to the pair of soldiers in the center panel, who are engaged in preparing the vinegar and gall to be administered to Christ later.

The moment chosen for primary depiction comes before the actual crucifixion. The post hole, already dug, appears just to the left of the soldiers in the foreground of the center panel. The soldiers and execution aides shown

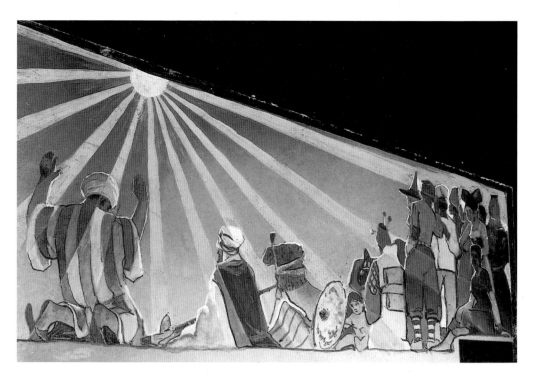

Figure 80. William Edouard Scott. Sketch for mural *The Three Magi and the Star in the East*, Burdsal Wing of City Hospital (now Wishard Memorial Hospital) Indianapolis. Collection of William E. Taylor.

in the left panel are standing over the tool box containing the hammer and spikes needed to attach the Savior to the horizontal bar of the cross. Simon of Cyrene, visible at the end of the shaft of the cross, helps Jesus drag it to Calvary, or Golgatha. Close by, soldiers wait for the crucifixion and priests and scribes prepare to mock and taunt him. In the distance Christ's mother and followers find their way along behind him. I am tempted to speculate that the moment in the story was chosen partly because Simon of Cyrene has often been visualized as a black man. Scott has rendered this figure a little darker than the others in the scene.

Since murals are often placed in public buildings at the behest of civic or religious institutions, they frequently are expected to advance a moral argument fostering appropriately desirable behavior. *Constructive Recreation: A Vital Force in Character Building*, a mural in the lobby of Chicago's Davis Square Field House, is a work in this tradition. The large mural is developed in three divisions. In the left portion is a surveyor along with representative players of tennis, football, and baseball. Associated with the cluster of athletes are a football and basketball, both of which appear almost as icons. In the distance, which separates the athletes from the central allegorical grouping, is a javelin thrower.

At the middle of the mural a seated image of Columbia (Liberty) with a torch and wreath is flanked on one side by Drama reading from an open book. Behind Drama is a globe and the mask of Tragedy. On the other side, Painting holds a palette and brushes. Both allegories are women.

To the right is a grouping consisting of eight women in a doorway. The central woman holds a silver urn. In the foreground of the composition is a ewer in a stand. The remaining women are busy in various activities, such as carrying baskets and filling tall vases. In the far right corner, Scott's signature and the date of the painting are partly obscured by the molding of the frame.

The three sections of the mural offer a coherent interpretation. The left figurative grouping underscores the Grecian ideal of a healthy, physical body as a proper vehicle for noble character development. Associated with athleticism are the virtues of competition, discipline, team playing, and enhanced physical beauty. The central figurative cluster, with its allegorical personages, underscores the role of the expressive arts in developing well-rounded character traits and in acquiring the knowledge vested in humanistic and artistic studies. These are an essential part of the balanced life needed to make liberty with responsibility possible.

In the absence of a legend, I offer an interpretation of the figurative grouping on the right based on its apparent context. The last cluster of women represent productivity, plenty, and regeneration. These are aspects of character that make family and community possible and are the divi-

dends of self-discipline, learning, competition, and team effort rightly applied in one's life. Certainly, this interpretation is in the spirit of the title of the painting, *Constructive Recreation: A Vital Force in Character Building*.

Although Scott took up the mantle Tanner declined, he nonetheless remained conservative in his treatment of race. Like nineteenth-century African-American artists, he steered clear of the emphatic embrace of black physiognomy. But like twentieth-century black artists, he regarded matters impinged upon by race as acceptable subject matter. He is entirely comfortable with portraying Frederick Douglass as clearly black, yet in works such as *Commerce*, where he had considerable discretion about whom to represent, few black figures appear. In religious works, figures such as Simon of Cyrene are racially ambiguous. This contrasts sharply with the next generation of African-American painters of religious subjects, such as Boston's Allan Rohan Crite, whose Holy Family and many of the saints are frequently black. Scott seems to have enjoyed an unusually balanced view of race and artistic production, giving equal importance to general history and religious themes, but never retreating from the treatment of black historical themes and not afraid to include black figures in his mix of American characters.

Scott remains an exceedingly interesting figure in African-American as well as American art. A figurative and realist painter with great talent, flexibility, and wide interests, he doubtlessly deserves a wider reputation. His murals and other works merit finding a broader audience and greater critical assessment.

Hale Aspacio Woodruff

"For the fifteen years that he taught in Atlanta, Woodruff's art address[ed] itself to the social and historical realities around him," noted Winifred Stoelting. [16] Indeed, all of Woodruff's murals prior to *The Art of the Negro*, which was completed after he accepted a professorship in art education at New York University, depicted heroic sagas from black history or, like *Shantytown*, portrayed crushing rural poverty. Like many other American artists who built careers before the late 1940s, Woodruff was deeply impressed by the revolutionary thrust of Mexican social art. His "debt to Diego Rivera and Jose Clemente Orozco," asserts one art historian, "illustrates the influence some Mexican muralists had on African-American

artists in the United States during the 1930s and 1940s."[17]

Over his career, Woodruff painted six murals and mural clusters. These are: *The Negro in Modern American Life: Agriculture and Rural Life; Literature, Music and Art*, completed in 1934; *Shantytown* and *Mudhill Row*, completed in 1934; *The Amistad Mutiny*, 1939; *The Founding of Talladega College*, about 1940; *Settlement and Development*, dedicated in 1948, and *The Art of the Negro*, installed in 1952. These murals and clusters may be divided into three groups according to their artistic maturity.

Group one consists of *The Negro in Modern Life*, *Shantytown*, and *Mudhill Row*, which are early, not entirely successful projects. Woodruff himself was unhappy with *Shantytown* and *Mudhill Row* despite the favorable comments in local newspapers.[18]

The Amistad Mutiny, Founding of Talladega College, and *Settlement and Development* constitute the second group. These works share a strong commitment to the episodic, narrative tradition and rely on figurative and textual elements to render their messages clearly. Additionally, these works are strongly disciplined by a historical script.

Alone in the last group is *The Art of the Negro*, a mural cluster characterized by freedom from literal, visual reportage and by an enthusiastic embrace of African-inspired, modernist aesthetics.

The murals of group one grew out of opportunities advanced via the Graphic Arts Division of the WPA, which, in 1934, "provided Woodruff and a student, Wilmer Jennings, funds to produce two sets of murals—*The Negro in Modern Life: Agriculture and Rural Life; Literature, Music and Art*."[19] The first mural, consisting of four panels, was placed in the David T. Howard School, in Atlanta, although this facility has been renovated and the murals are no longer on display there.

The second mural, with its two panels *Shantytown* and *Mudhill Row*, was installed in the School of Social Work at Atlanta University. Ralph McGill, editor of the *Atlanta Constitution* and a leading figure in what was to become known as the New South, said of the work: "Both of them hurt with garish poverty and their stark bleakness. Yet [Woodruff] has not exaggerated a single line nor forced a point.... Both of them, especially *Mudhill Row*, are splendid illustrations of the modern school. The climbing hill of raw, red clay, eroded and twisted is a vista of ugliness and harshness. It speaks with a thousand silent tongues."[20]

Although obviously interested in the southern scene at the foundation of his Atlanta development, Woodruff lacked the temperament for effectively depicting the brutal, debilitating effects of poverty and racism. He was much better, as shown by prints such as *Country Church*, at capturing the solitary character of rural, or "quarter," life.[21] Moreover, such themes often could be more successfully presented in the smaller format of prints or easel paintings.

The Talladega Murals

Woodruff's first critically important mural, *The Amistad Mutiny* (figs. 81–83), was dedicated in 1939. A separate but related mural celebrating the founding of Talladega College in Alabama was completed in 1940.[22] *The Amistad Mutiny* mural project corresponded with the opening of the new Savery Library and the centennial year of the *Amistad* mutiny. Both mural projects paid honor to the American Missionary Association (AMA), which had grown out of the *Amistad* revolt and helped found Talladega College. With energy and excitement, Woodruff spent three months researching the events surrounding the mutiny. Nine months was spent painting the murals and preparing them for installation.[23]

In the course of his study, Woodruff, using documents at the Yale University Library and the Archives of the New Haven Historical Society, became more and more fascinated by the extraordinary tale of heroism. He found a rich body of study materials, including paintings and prints made at the time.

What are the essentials of the *Amistad* mutiny or revolt?[24] In summer 1839 Don Jose Ruiz and Don Pedro Montez, Cubans from Puerto Principe, purchased fifty-three Africans from the Mende ethnic group, who had been transported, in violation of international law, to Cuba by Portuguese slavers. To move the slaves from Havana to Guanaja, Ruiz and Montez hired Ramon Ferrer, owner and captain of the ship *La Amistad* (*Friendship*).

On the third day of the journey, the captives revolted under the leadership of Sing-be, who later came to be known as Cinque. In the mutiny Cinque and his confederates slew the cook and the captain and forced Ruiz and Montez to sail the ship toward the sun. Their effort to return to Africa was defeated because at night, using the stars, Montez and Ruiz sailed north instead. On August 26 the *Amistad* anchored off Long Island, New York, to secure food and provisions. The ship and its cargo were seized and taken to New London, Connecticut. Following the discovery of Ruiz and Montez tied up below the deck, Cinque and his followers were arrested. The Spanish government demanded the release of the ship and slaves and the return of both to their "rightful" Cuban owners.

By now American abolitionists, seeing the windfall opportunity presented by this mishap, took action, and in September 1839 Lewis Tappan, Simeon S. Jocelyn, and Joshua Leavitt, all New Yorkers who met as the "friends of liberty," formed the Mende Committee to defend the *Amistad* captives. Right away, they appealed for public support to cover expenses. Eventually, with the help of John Quincy Adams, the case for the captives was argued before the U. S. Supreme Court, where, on March 9, 1841, Justice Joseph Story ruled that the Mendians were free and should be "dismissed from custody of the court…to go without delay."

Without a ship or jobs, the captives now had to rely for shelter and food on their friends at the Mende Committee. Eventually, the surviving thirty-five Mende men and women returned to Africa accompanied by five missionaries and teachers.

To provide continuing help for the returned Mendians, Lewis Tappan and his associates founded the American Missionary Association in 1846. Shortly thereafter, the AMA launched missionary work in the Caribbean, Africa, and the American South. In time the AMA played a role in the establishment of many black colleges and normal schools, including Atlanta University, Talladega and Tougaloo colleges, and Straight (presently Dillard) University.

Drawing on works such as A. Hewins's 135-foot painting *The Massacre*, related popular engravings, Nathaniel Jocelyn's *Portrait of Cinque*, and other historical records, Woodruff prepared three small cartoons, or mural studies, showing in detail all aspects of the proposed mural.[25] From local records he was able to make all but four of the seventy-five faces in the mural portraits. These studies were then, using grids, produced on paper at full scale. Through a system of perforations, the drawings were transferred to the canvases and final work was begun. Athough several students assisted Woodruff with this

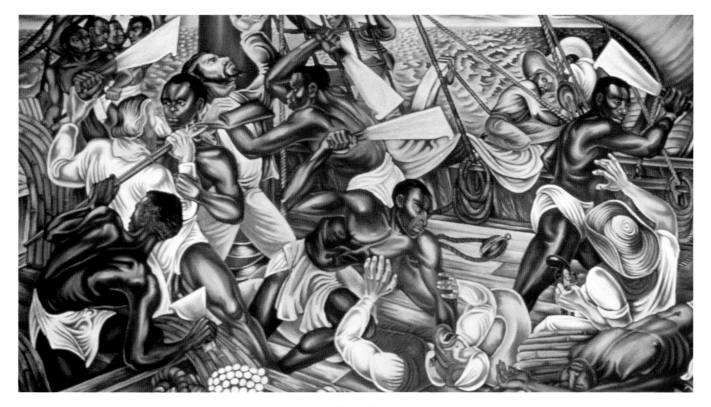

Figure 81.
Hale Aspacio Woodruff. *The Amistad Mutiny, 1839*, 1939. Panel 1, *The Mutiny Aboard the Amistad, 1839*.
Savery Library, Talladega College, Alabama.

undertaking, his principal aide was Robert Neal. Woodruff said of Neal: "He kept my sketches and equipment in order. He transferred the cartoons to the actual canvas. He posed for all of the hands and figure gestures that appear in the mural. (His hands were expressive, by nature, artistically structural and adaptive to what I was trying to do.) I don't know what I would have done without him."[26]

Three dramatic moments were chosen to tell the *Amistad* story: panel one shows the mutiny in progress, panel two presents the trial, and panel three depicts the return of the Mende captives to West Africa. Each panel is accompanied by interpretive text in the form of poetic verses. Appearing in association with the first panel is:

> *The Schooner will be ours*
> *Ours to steer back, by the sun, to our shore*
> *To freedom.*
> *Our hands free.*
> *Our legs walking with a big stride*
> *And our faces upward to our Mountains.*

Panel two has the following lines:

> *Circuit Court,*
> *District Court,*
> *The Amistad case debated*

> *Men standing up for the slaves*
> *Men standing up for the Spaniards*
> *Men standing up for justice and truth*
> *Men standing up with fire in their voices*
> *For the honor of America and democracy.*
> *Circuit Court*
> *District Court*
> *Supreme Court*

The third panel bears the inscription:

> *Out of New York another ship goes, The*
> *Gentleman*
> *This time black freedom moves in her sides*
> *And the fighters for this freedom have sent*
> *the race*
> *To teach the heathens in the hunter's land*
> *The fire is lit*
> *The Smoke is rising……*
> > *rising.*

Woodruff approached the murals in a straightforward way. Each panel is organized around a single dramatic event, although related subthemes are generally present. The viewer is positioned as an observer with a window onto the scene. In panel one, the *Mutiny Aboard the Amistad*

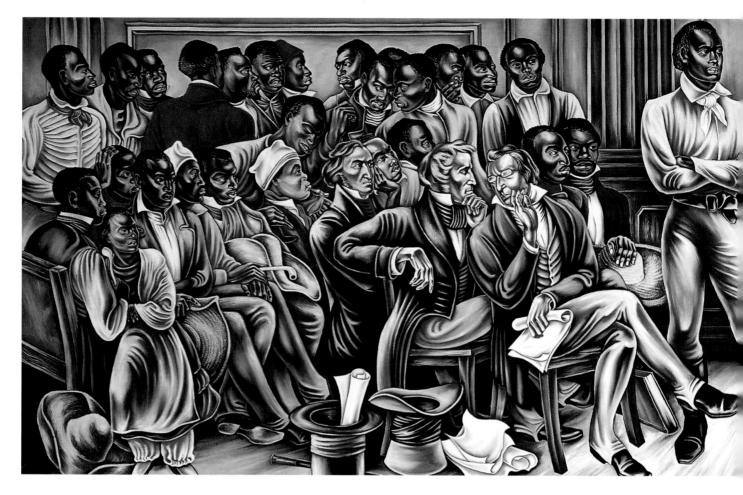

(fig. 81), four groups of combatants dominate the shallow space of the ship's deck. Space shortage is further emphasized by the foreclosing effect of the lower tip of the sail and the base of the mast. In the distance, an angry and agitated sea swells. In the group of combatants, the smooth musculature and dark skin of the Africans, clad only in loincloths, contrasts sharply with the generally light garments of the whites. Amid the rhetorical gestures of the fighting men, the machetes stand as emblems of revolutionary victory.

Cinque, the leader of the revolt and therefore its central figure, shares the spotlight with his lieutenants. But for his recognizable face, he might go unidentified. This fact underscores the collective nature of the mutiny. Captain Ferrer, in an attitude of prayful petition before a falling machete, likewise indicates that the "whites" were a collective force of oppression.

Figure 82. Hale Aspacio Woodruff. *The Amistad Mutiny, 1839*, 1939. Panel 2, *The Amistad Slaves on Trial at New Haven, Connecticut, 1840*. Savery Library, Talladega College, Alabama.

In the somewhat harsh light falling on the scene, subplots are clearly evident. To the left, colonists ponder escaping overboard into the sea. Near the mast, the slave who had come on board with the Cubans and is dressed like a Spaniard climbs the ropes. And in the far right corner, the revolt continues.

The wide center panel, *The Trial at New Haven* (fig. 82), set in shallow space inside the New Haven courtroom, is divided by the bar into a side for the defense and a side for the prosecution. On the defense's side, Cinque, arms folded, stands resolute and dignified. Behind him are the other Mendians, Roger Baldwin, Arthur Tappan, and Reverend Jocelyn. In the third row sits Kale, author of the letter to John Quincy Adams, wearing a green skull cap. At the end of the same row, a man holds Margue, a young girl captive. On the prosecution side are Montez, the ship owners, and their lawyer, and James Covey, the cabin boy turned interpreter. Behind them are Lewis Tappan, Josiah Gibbs of Yale Univesity, and the reverends Day, Whipple, and Bacon. Ruiz, standing and pointing to Cinque, whom he accuses of murder and piracy, dominates this side of

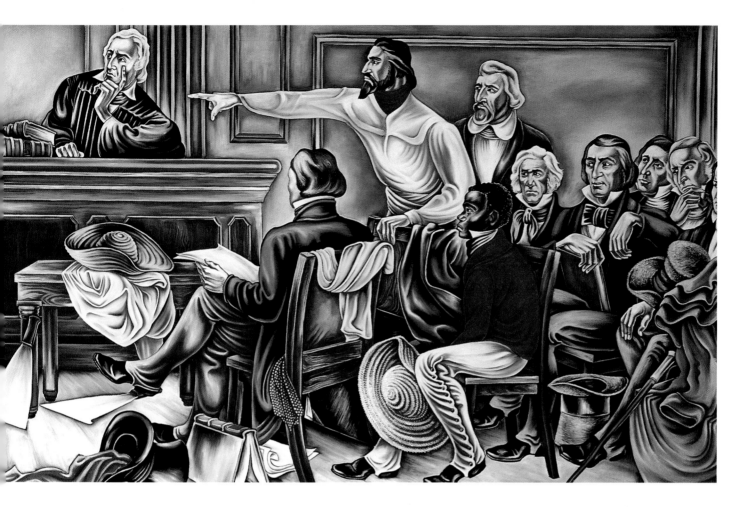

the panel. Justice Smith Thompson, though near the compositional center, is a mere backdrop to the charged encounter of accused and accuser.

The Return (fig. 83), like the *Trial,* is sharply divided. On the edge of the African coast, indicated by a palm frond, stands Cinque, transformed into Joseph Cinquez and accompanied by missionaries, teachers, and advisors, including James Steele and Henry Wilson. Close by is the young girl Margue as well as the returning party's books and school charter. On the opposite side, along with an additional white supporter, a grateful Mende offers a prayer for their safe return home on that January day in 1842. In the vista separating the figurative groups, jubilant returnees in a long boat are making their landfall.

The *Amistad* murals present Woodruff as a gifted visual storyteller capable of assimilating a vast amount of data and reworking it into a coherent statement. Relying on the hard edge and clear, bright color typical of midwestern regionalists and compositional ideas inspired by the Mexican tradition, Woodruff's *Amistad* murals are triumphant. Not even his weakness in achieving fully ef-

fective psychological integration in the compositions mitigated against their success. Of them, W. E. B. DuBois exclaimed: "Woodruff of Atlanta dropped his wet brushes, packed the rainbow in his knapsack and rode post-haste and Jim Crow into Alabama. There he dreamed upon the walls of Savery Library the thing of color and beauty portrayed on the opposite page: to keep the memory of Cinque, of the *Friendship* (*La Amistad*) and the day when he and his men, with their staunch white friends, struck a blow for the freedom of mankind."[27] To promote the mural, DuBois raised money and produced color prints of it, which were distributed as inserts accompanying a related article in Atlanta University's literary journal, *Phylon. Life* magazine sent Eliot Elisofon to photograph the murals for a feature; however, the German invasion of Poland preempted publication of the spread.[28]

Woodruff executed a second three-panel mural, similar in style and treatment, for the Savery Library at Talladega. In the *Founding of Talladega College*, the first panel depicts episodes associated with the underground railroad and the abolitionists who helped launch education in the

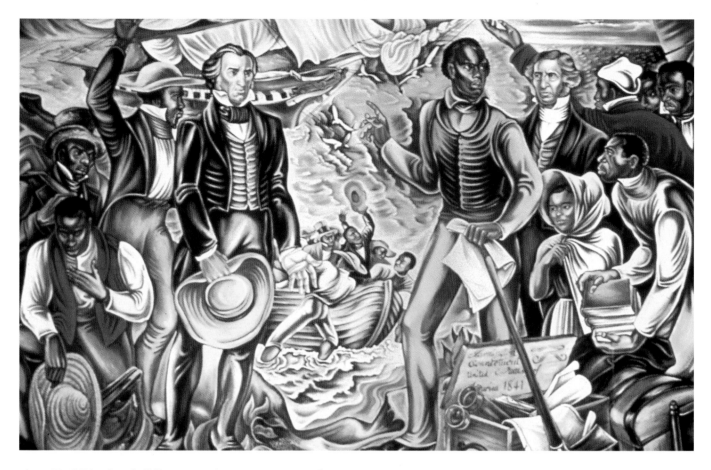

post-Civil War South.[29] Escaping slaves await a riverboat that will ferry them north toward freedom and perhaps even Canada. Sympathetic whites who assisted such departures would later form the American Missionary Association and prove great friends to southern black education. Panel two, well populated with students, teachers, and well-wishers, shows new students sitting before the school's registrar, who, with quill in hand, accepts fee payment in the form of farm produce and livestock. This arrangement, practiced until the mid-twentieth century, allowed the children of the rural poor to afford college even though they were still partly in a subsistence or share-cropping economy. Prominent in the scene is the pointing figure of William Savery and the white abolitionists/educators. Woodruff lightens the serious tone of the mural with minor distractions, such as the escaping chicken and the peering old man beyond the picket fence. The last panel, with its busy carpenters and masons and with the architect, Mr. Fletcher, observing, recalls the building of Savery Library.

On a plot that had formerly been a prep school for white young men, Talladega College was founded in 1867 as a college for African Americans. Transforming ex-slaves

who had been denied basic education into literate, capable people was a difficult task that might have been fatally discouraging except for the great importance the Freedmen attached to learning. Thus the mural honored the contribution of ex-slaves such as Thomas Tarrant and William Savery, both of whom sought and gained help from General Wager Swang of the Freedman's Bureau in securing AMA assistance for the fledgling endeavor. AMA's money helped underwrite the purchase of the college's first building, Swang Hall. AMA was also playing a leading role in the construction of Savery Library, named for the former slave.

The Talladega murals are Woodruff's most ambitious and successful undertaking in this format prior to the Second World War. The *Amistad* mural, which would become his best-known large-scale work, marked his place—even if not fully acknowledged—as a significant American painter of heroic sagas and narratives.

Figure 83. Hale Aspacio Woodruff. *The Amistad Mutiny, 1839*, 1939. Panel 3, *The Return to Africa, 1842*. Savery Library, Talladega College, Alabama.

The Contribution of the Negro to the Growth of California

Contrary to popular impressions, black businesses often aspired to play a major role in the cultural life of their communities. By so doing, they helped improve the neighborhood where they belonged while accepting "responsibility not only to support but to stimulate all aspects of community development. And what better way to encourage a people to greater accomplishments than through a constant reminder of their splendid heritage."[30] Additionally, they sought to compare their own values with "elements of vigor, social protest and group consciousness inherent in the paintings and sculpture...[that enhance] understanding of the life and thought of the American Negro people."[31]

Against this backdrop, the Golden State Mutual Life Insurance Company, founded in Los Angeles in 1925, commissioned murals for the lobby of its new home office, which opened in August 1949. Hale Woodruff and Charles Alston, who had earlier completed the Harlem Hospital murals, were each invited to paint one large, historical panel depicting some aspect of the contributions of blacks to the making of California. Paul R. Williams, architect of the building, worked closely with Woodruff to assure that their colors and stylistic approaches would be consistent and complementary and that their works would enhance the decorative design and architecture of the lobby.

The Contribution of the Negro to the Growth of California, as the mural complex was called, consisted of two parts, *Exploration and Colonization: 1527–1850*, executed by Alston, and *Settlement and Development: 1850–1949*, painted by Woodruff. Each panel was 9' 4" by 16' 5". Both were based on research by Miriam Matthews, a librarian and author of "The Negro in California from 1781–1910," and Titus Alexander, a historian and donor to the Golden State Art Collection.[32]

Woodruff approached the production of his mural in fundamentally the same way as the Talladega murals a decade earlier. Its language is that of the historic, figurative, realist painting. Yet *Settlement and Development* does present new challenges. More episodes, many widely separated in time and place, had to be accommodated and the resulting population of figures greatly increased. It became necessary to stack the events shown, thereby sacrificing single-point perspective. Text had to be introduced to help guide understanding of the overlapping story elements, and a certain sense of crowding ultimately became inescapable. Nevertheless, the mural reads clearly from left to the right.

In the distant upper left corner, gold miners with their oxen pause outside their mine shaft. The gold-mining industry developed many black specialists, such as Moses Rodgers, as well as mine owners such as Gabriel Simms, Abraham Freeman Holland, and James Cousins. These black miners sent more than a million dollars to the south to purchase or gain freedom for family and friends. Immediately to the right of the miners is Captain William Shorey, whose whaling ship appears on the ocean behind him. Shorey mastered whaling vessels in the Pacific waters in the late nineteenth century. Also in the rear but still further to the right, black workmen are busy constructing Boulder Dam. The San Francisco bridge, under construction by African-American workers, completes the right portion of the rear ground.

In the middle ground on the left, the office of *The Elevator*, a militant black newspaper of the 1860s, is evident. Its staff are at work beneath a marquee with the subtitle "A Weekly Journal of Progress." Though California joined the Union in 1850 as a free state, minorities were routinely discriminated against and subjected to racially motivated injustice. Against this background, the Convention of Colored Citizens of California was formed in 1855 in San Francisco and, along with the *The Elevator*, led the struggle for fairness and justice in the Golden State.

Immediately below *The Elevator* and along the foreground, soldiers protect the transcontinental railroad crews and cargo. Black regiments of the 9th and 10th cavalries and of the 24th and 25th infantry units of the United States Army provided necessary protection from Indians and bandits as the railroad moved west. Wearing a head scarf, Mammy Pleasant, a civil rights militant and contributor of $30,000 to finance anti-slavery initiatives, including John Brown's revolt at Harper's Ferry, stands with one of her beneficiaries. Behind them, John Brown, gun in hand, stands boldly. A little past the saloon along a street in the middle ground is the Pony Express office. A black rider carries his mail pouch over his arm. Over its brief life, a number of black horsemen served the Pony Express, including George Monroe.

Bridging both the middle and foregrounds, the next

passage of the mural celebrates the activist role played by the Convention of Colored Citizens of California. In front of its banner, protesters raise placards saying "Open Schools for Our Children" and "Justice Under the Law." Work on the Golden State Mutual building fills the remaining portion of the right side of the mural, where African Americans are evident in the architectural and construction teams.

The Art of the Negro

The Art of the Negro murals (figs. 84–89), completed in 1951, are Woodruff's finest and most aesthetically resolved. They bring together his interest in African art and his growing association with abstract expressionism or the New York School. These works merit far more attention than they have received. As Mary Schmidt Campbell accurately observes: "Although in 1952 there was nothing in black American art comparable to the Atlanta University murals in their effort to place African American art in a large cultural context, the murals have gone virtually ignored since they were installed. They have never been reproduced or discussed in any text on black American art, though they are certainly more innovative than the Talladega murals and more relevant to Woodruff's mature paintings."[33] Indeed, these murals, freed from strict historical narrative, allowed Woodruff to take a much broader, more metaphorical approach. We gain far more insight into Woodruff's personal idioms and ideas from *The Art of the Negro* than from any of the preceding large-scale works.

The circumstances that led to the commission to execute the murals for the Trevor Arnett Library reach back to 1931, when, at the invitation of President John Hope, Woodruff accepted a post at Atlanta University.[34] While teaching in Atlanta, and during the period of the completion of the Talladega murals, Woodruff recalls suggesting to Hope that such a large painting might be desirable at Atlanta University. His suggestion was not taken up at that time.[35] In 1945, however, Atlanta University president Rufus Clement offered Woodruff extra pay if he would undertake a mural project for Trevor Arnett Library, and though Woodruff was shortly to leave Atlanta for a post at New York University, he happily committed to executing the murals.

At the same time, Woodruff's artistic direction was

changing. He was abandoning realism for abstraction, and his longstanding interest in African art was finding formal expression in his work. He was also struggling to give his art a more personal cast and to free it of direct social commentary. *The Art of the Negro* murals become the *summa* of these converging concerns.

Woodruff was fascinated with form in African art, a facination not without a spiritual dimension, as suggested by his comment that "I look at the African artist...as one of my ancestors."[36] Indeed, this sentiment underlies the motivation for Woodruff's second series of library murals. In describing his intention, he said, "I wanted [the mural] to be an...inspiration to students who go to the library, to see something about the art of their ancestors."[37]

The Art of the Negro, as the series of six panels was called, sought to capture the interplay between African art and the other great cultural traditions of the world. In the tradition of Alain Locke and W. E. B. DuBois, Woodruff located Africa's art as existing in a dynamic relationship with both Western and non-Western artistic heritages. Though recognizing the brutalization of African culture and peoples in the colonial era and its aftermath, Woodruff nevertheless asserted that African rebirth and cultural resurgence are permeating forces in the art of Europe and the Americas. *The Art of the Negro* is thus not so much a history of the continental heritage of black peoples as it is a praise-song for its pervasive impact on form and iconography in the twentieth century.

The Art of the Negro, installed in the round-headed bays of the upper rotunda of the library, has the following individual panels: *Native Forms, Interchange, Dissipation, Parallels, Influences,* and *Artists*.[38]

New York's rich stock of museums, galleries, and book sources, as well as Woodruff's particular interest in Asante gold weights, inform the generally open iconographies in the murals. Institutions such as the American Museum of Natural History and the Metropolitan Museum of Art fed Woodruff's desire to see African art in a comparative way.

Native Forms (fig. 84) has the greatest concentration of African forms and references. Woodruff's intention in *Native Forms* was, I believe, to establish the primacy and global impact of African civilization under the bold and emphatic presence of the African muse. *Native Forms* is a visual poem about cultural origins. Presiding over it is a composite fetish (Shango-like double axe on head) hold-

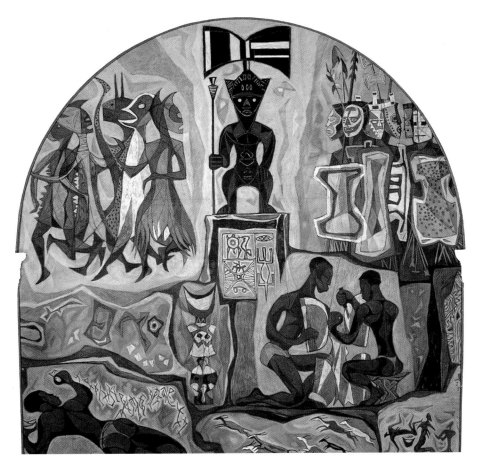

ing a staff and standing atop a base filled with African symbols, including the crocodile, bird, and turtle. To the left, hunters masquerading as animals dance. To the right, six warriors with masks, shields, and spears advance. Dogon inspiration in the masks seems apparent. Beneath the warriors are two sculptors at work. One sits on a traditional stool and carves with a short knifelike tool. Three closely related passages lie along the lower margin of the panel, all relating to African cave paintings. In one longhorn cattle or antelopes are running, and in another several figures, including a drummer, rotate along with a bird image. The opposite lower corner shows a cave artist painting. His image anticipates the art of moderns such as Henry Moore, an English sculptor drawing heavily on the notion of archetypal forms. A mask with superstructure and several abstract forms completes the panel.

Interchange (fig. 85) is organized around a series of conversations in which cultural representatives of African, Roman, Greek, and Egyptian traditions exchange cultural ideas. On the left, African and Greek musicians (griots and bards) converse. Across on the right, three African and Roman soldiers with spears and shields discuss soldiering. In the foreground next to the Egyptian friezes,

three ancient builders confer. Above them are sculptures, including a stylized horse. A passage of Egyptian/Nubian hieroglyphics supports architectural features, including Doric and Egyptian columns and a western Sudanic mosque tower. Recognition of the passage of time—that great container of all civilizations—is recalled in the Greco-Roman stele, or grave marker, at the right margin of the mural. *Interchange* forcefully posits the rich interplay between black and nonblack civilization in the ancient world.

Imperialism infuses the conflict evoked in *Dissipation* (fig. 86). Loosely inspired by the rape of Benin City in 1897, *Dissipation* offers a metaphor for the assault on African art and heritage represented by European colonialism. The Benin empire, its greatness extending back before the coming of the Portuguese to the West African shores in the 1480s and evidenced by its masterful bronzes and ivories, continued in a much weakened condition until the late nineteenth century. When a party headed by British vice-consul J. R. Phillips entered the empire at the time of the

Figure 84. Hale Aspacio Woodruff. *The Art of the Negro*, 1950–51. Panel 1, **Native Forms**. Trevor Arnett Library, Clark Atlanta University.

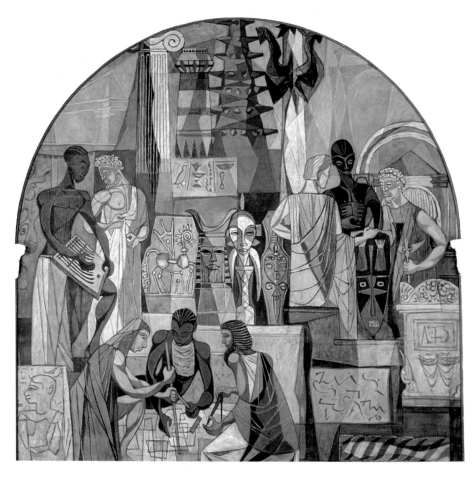

Igue ceremonies without the Oba's (king's) permission, all members were slain. Shortly thereafter, the British marched against Benin City and, following the flight of the court and royal family, occupied it. In the wake of the invasion, soldiers and others took thousands of works of art—indeed the Benin royal treasure—to Europe, thereby acquainting Europeans for the first time with the figurative bronzes and ivories of a traditional African kingdom. Woodruff, depicting the plundering of Benin, frames the action of the British solidiers destroying or stealing the sculptures within leaping, engulfing flames and falling city towers. Although the image of the Oba, with his ceremonial sword, is visible in front of the falling towers in the left mid-ground, the presence of Senufo and Basonge masks along with Asante combs and Dogon crocodiles confirms that Woodruff's comment is meant to apply to African heritage at large.

Parallels (fig. 87) makes a statement about comparative cultural vitality. In the upper central portion,

Woodruff has given prominence to several North American totemic sculptures, including one showing a stylized figure surmounting a drum. Flanking this totem are a mask with a superstructure and the elaborated sculpture resembling a ceremonial staff. Reminiscent of some ancient Nubian amulets, a Pre-Columbian Mexican figure fills the left corner of the panel. Adjacent to it and falling along the bottom of the picture is a painting showing an Amerindian ritual dancer. Just right of the center appears a Sepik River-inspired mask, perhaps symbolizing, more generally, cultural artifacts of the Pacific Islands. Interspersed throughout the remainder of the painting are irregular enclosures containing mythic forms, glyphs, and emblems suggesting the heritages of China, Japan, India, and other great civilizations of Asia. This mural underscores the common form in the vocabulary of cultures worldwide.

Influences (fig. 88), the fifth panel, develops the idea of cultural cross-fertilization. Several specific hybridizations are immediately evident. In the lower left corner a reclining female suggests the work of Henry Moore. Directly above is a series of Haitian *veves*, the sacred writing of *voudou* practice representing the names of the *Loas* or

Figure 85. Hale Aspacio Woodruff. *The Art of the Negro*, 1950–51. Panel 2, ***Interchange***. Trevor Arnett Library, Clark Atlanta University.

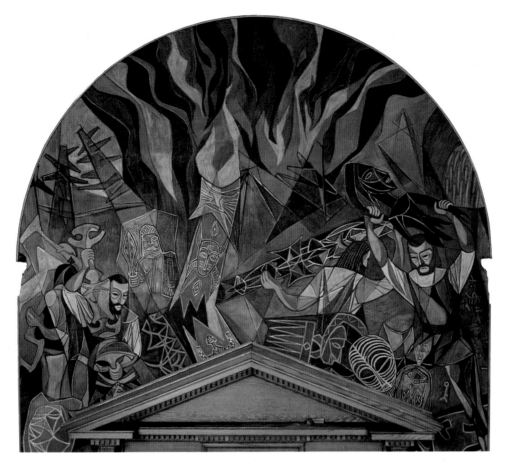

lieutenant spirits. These *veves* are executed with flour and earth and are related to traditional sand paintings. Near the center in a strongly vertical box appears a drawing of a female nude, suggesting the origins of cubism, the fundamental movement of modern art. This point is restated in an African sculpture of a female nude, at the right margin of the panel. In alternating boxes subdividing the picture plane appear paintings in modern abstract tradition and glyphs suggesting cave paintings or "tribal" notations. The panel asserts that cultural traditions are reciprocal, each giving and receiving new influences and growth through direct encounters. Modern art, in this respect, is a product of the fusion of African formal ideas and Western aesthetics and art practice. Its newness derives from a peculiar parentage rooted in the sustained, intimate cultural contacts generated by global colonialism, slavery, and capitalism.

Only the panel *Artists* (fig. 89) reminds us of Woodruff's earlier commitment to representationalism and figuration in his art. Here the concept, organization, and composition of the panel are immediately evident. In the upper register, the African and Western muses sit together. Symbolically, the Greco-Roman and the African cultural families are exchanging ideas on beauty, truth, etc. on an equal footing. Beneath them seventeen black American artists, heirs to both traditions, are assembled. These creative figures symbolize the cultural backgrounds from which artists of the world have come. On the rearmost rows from left to right are Joshua Johnston, the Baltimore limner; Henry O. Tanner, the most celebrated of nineteenth-century black artists; Jacob Lawrence, contemporary inventor of the serialized mural; Edward Mitchell Bannister, bronze medal winner at the 1876 Centennial Exhibition; Nada Kane, South African cave painter; Julien Hudson, nineteenth-century portraitist; Juan de Pareja, school of Velazquez; Patrick Reason, portraitist of the abolitionists; S. Gomez, school of Murillo; Antonio Franciso Lisboa, Aleijadihno (The Little Cripple), eighteenth-century sculptor; Iqueigha, thirteenth-century sculptor; Horace Pippin, self-taught master; Sargent Johnson, African-inspired twentieth-century sculptor; Charles Alston, muralist, painter, and sculptor; Hector Hypolite, mid-cen-

Figure 86. Hale Aspacio Woodruff. *The Art of the Negro*, 1950–51. Panel 3, ***Dissipation***. Trevor Arnett Library, Clark Atlanta University.

tury Haitian master painter; Robert S. Duncanson, nineteenth-century landscapist and first black American artist to achieve international recognition; and Richmond Barthe, sculptor. Together, this assembly is a tribute to the continuity and expansion of black contributions in the arts.

Romare Bearden said of Woodruff that "it was his love for African sculpture which...touched his most secret self and which accounts for the unity underlying his painting."[39] It is certainly this love which permeates *The Art of the Negro* at Atlanta University. Using what Campbell called "self-contained zones"—devices that first appeared in the 1950 painting *Carnival*—Woodruff frames African-inspired passages and constructs meaning in *The Art of the Negro*. Freed from the realistic and representational demands of history painting, he uses abstraction—which he attributes to the influence of African art—to unify each panel. The net effect is, as Campbell notes, "a wall covered with colorful hieroglyphics. With enough figurative elements performing descriptive actions to give the essential aspects of the history, they most effectively make their point in the way in which they visually relate the forms of African art to the modern idiom or to forms from other cultures."[40] *The Art of the Negro* murals were Woodruff's definitive integration of the myriad influences promoting modernism and abstraction with the desire to teach the lessons of black history and reclaim the credit due African ancestors.

Clearly, Woodruff's key murals are *The Amistad Mutiny*, *Settlement and Development*, and *The Art of the Negro*. On these works hang his critical place as an American muralist of accomplishment. The importance of *The Amistad Mutiny* derives from its early place as a heroic, historical mural celebrating a specifically black emancipation theme. It builds on earlier panoramic paintings, such as William E. Scott's *Lincoln at Springfield*, while departing from the more culturally based murals like *An Idyll of the Deep South* (1934) of Aaron Douglas, the much simpler murals like *Post Office* (1935) of Archibald Motley, and the bas-reliefs of Richmond Barthe. The *Amistad* murals, unlike Charles Alston's 1937 Harlem Hospital mural *Magic and Medicine*, do not rely heavily on the use of Africanized forms. Rather they are perhaps the earliest example of the complete assimilation of the influences of the Mexican muralists in African-American art. In this, however, Woodruff barely preceded Charles White, whose *Contri-*

bution of the Negro to American Democracy followed in 1943. *The Amistad Mutiny*, as a pioneering statement of black social realism, was, as DuBois noted "the most important work done by a black artist" when it was unveiled and dedicated on April 15, 1939.[41]

Perhaps one of the most salient observations about Woodruff's murals is that they all appear in traditionally black institutions. This fact underscores the vital role played in American art by historically black institutions and makes more urgent the need to move American art history toward a greater inclusiveness and truthfulness. Accomplishing this transformation remains work for present and future historians of American art.

■

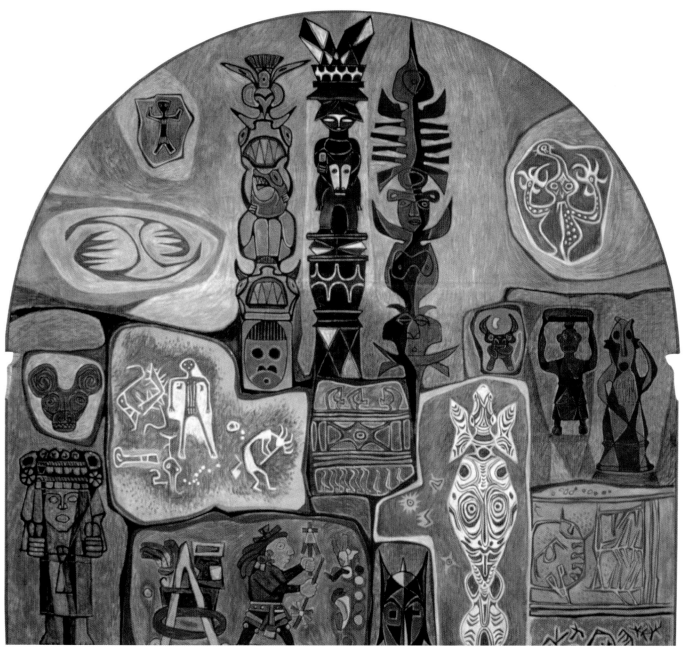

Figure 87.
Hale Aspacio Woodruff. *The Art of the Negro*, 1950–51. Panel 4, *Parallels*.
Trevor Arnett Library, Clark Atlanta University.

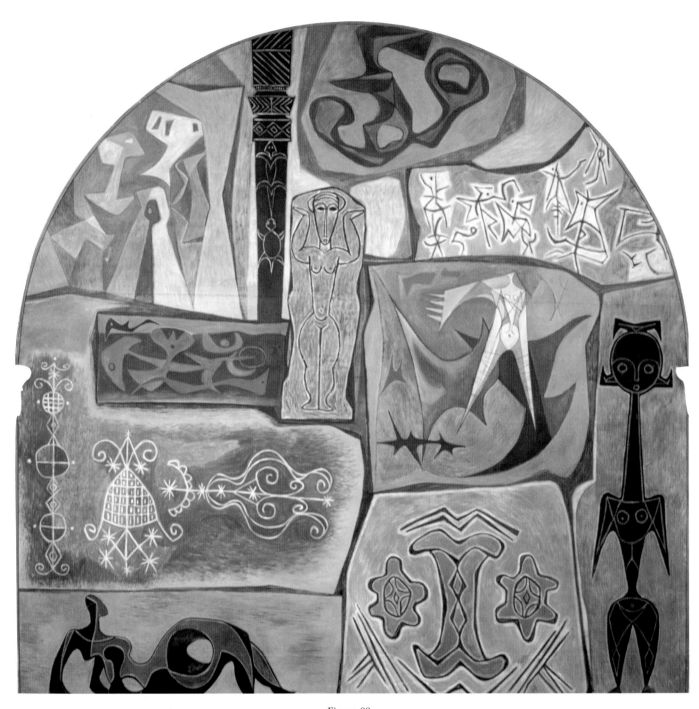

Figure 88.
Hale Aspacio Woodruff. *The Art of the Negro*, 1950–51. Panel 5, *Influences*.
Trevor Arnett Library, Clark Atlanta University.

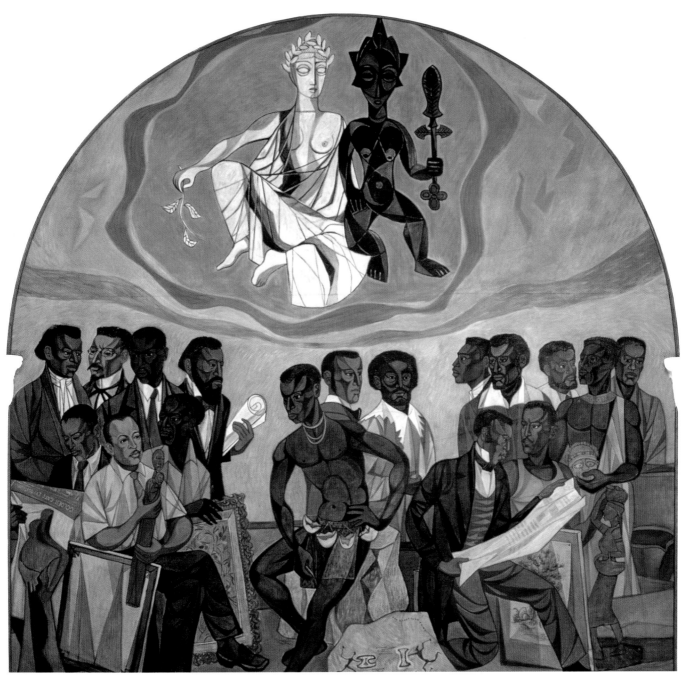

Figure 89.
Hale Aspacio Woodruff. *The Art of the Negro*, 1950–51. Panel 6, *Artists*.
Trevor Arnett Library, Clark Atlanta University.

Notes

1. See *Tanner-Harper-Scott: A Mentor and His Influence* (Washington, D.C.: Evans-Tibbs Collection, 1985).

2. Washington's hopes for Tanner in this regard are discussed in Dewey F. Mosby and Darrell Sewell, *Henry Ossawa Tanner: Catalogue* (Philadelphia: Philadelphia Museum of Art, New York: Rizzoli, 1991).

3. A list of murals appears in Peter J. Roberts, "William Edouard Scott: Some Aspects of His Life and Work," Master's Thesis, Emory University, 1985.

4. Jeff Favre, "Restored Glory," *The Chicago Tribune*, 8 June 1995, 1–2.

5. "The Art Student," Lane Technical High School, about 1909.

6. This painting was probably planned as a mural study. Additional research in this direction is currently going forward.

7. Lucille Morehouse, "Art: New Interest Develops in Work of William Edouard Scott," *The Indianapolis Star*, 2 May 1943, 19. This article provides considerable information about the competition. I have relied heavily on the data.

8. Ibid.

9. Ibid.

10. Ibid.

11. Edward B. Rowan, Letter to W. E. Scott, 5 April 1943.

12. Roberts, 60.

13. W. E. Scott, Letter to Edward B. Rowan, 26 June 1943.

14. "Decorates Burdsal City Hospital Wing," *The Indianapolis Star*, 31 October 1915.

15. Ibid.

16. Winifred Stoelting, Mary Schmidt Campbell, and Gylbert Coker, *Hale Woodruff: 50 Years of His Art* (New York: The Studio Museum in Harlem, 1979), 32.

17. Samella Lewis, *African American Art and Artists* (Los Angeles: University of California Press, 1990), 65.

18. *Hale Woodruff: 50 Years of His Art*, 60.

19. Ibid.

20. Ibid.

21. "Quarter" was a term used to refer to a dense cluster of houses associated with a plantation or specific family.

22. The date given for the completion of the mural *Founding of Talladega College* comes from a biographical chronology. Hale Woodruff papers. Amistad Research Center, New Orleans.

23. *Hale Woodruff: 50 Years of His Art*, 67.

24. This account relies heavily on Clifton H. Johnson, "The Amistad incident and the Formation of the American Missionary Association," *New Conversations*.

25. Data on Woodruff's research and working methods are taken from Winifred Louise Stoelting, "Hale Woodruff, Artist and Teacher: Through the Atlanta Years," PhD Dissertation, Emory University, 1978, 229–40.

26. Ibid., 229 ff. From a Woodruff letter to Winifred Stoelting, 2 August 1977.

27. *Hale Woodruff: 50 Years of his Art*, 33.

28. Ibid., 78. The article never appeared in *Life* magazine.

29. *Hale Woodruff, Artist and Teacher: Through the Atlanta Years*, 240, 308–9.

30. *Historical Murals* (Los Angeles: Golden State Mutual Life Insurance Company), 1965, 4.

31. *Selected Pieces from the Afro-American Collection* (Los Angeles: Golden State Mutual Life Insurance Company), 1965, unpaginated.

32. *Historical Murals*, 4.

33. *Hale Woodruff: 50 Years of His Art*, 36.

34. Ibid:, 16. Atlanta University merged with Clark College and is now known as Clark-Atlanta University.

35. Ibid., 26.

36. Ibid., 75.

37. Ibid.

38. The interpretation advanced is based largely on documents and diagrams from Hale Woodruff's papers in the Amistad Research Center, New Orleans. I am grateful to Paula Allen, Curator of Art, for her help.

39. *Hale Woodruff: 50 Years of His Art*, 7.

40. Ibid., 36.

41. Ibid., 33.

5

The Changing Same:
Spiral, the Sixties, and African-American Art

Floyd Coleman

The Changing Same: Spiral, the Sixties, and African-American Art

Floyd Coleman

The 1960s were shaped by shifting attitudes, rapid social changes, and competing ideologies and political persuasions of every stripe. The year 1963 in particular signified a dramatic sea change in American society and art. In the year marking the hundreth anniversary of the Emancipation Proclamation, it was becoming patently clear that African Americans would no longer allow their constitutional rights and demands for full citizenship to be denied. The lunch-counter sit-ins launched by black students in 1960 were spreading quickly to cities across the South. The charismatic civil rights leader Dr. Martin Luther King, Jr.—who had earlier led a successful bus boycott in Montgomery, Alabama—was leading aggressive desegregation demonstrations throughout the region and initiating plans for a massive Poor People's March on Washington, D.C. A countervailing force, the Black Muslims were preaching black pride, self-discipline, and self-sufficiency; yet their leader, Elijah Muhammad, and his chief minister, Malcolm X, were increasingly at odds over direction and ideology. Four little black girls were killed when a bomb planted in a church in Birmingham, Alabama, exploded during a choir rehearsal. Civil rights leader Medgar Evers was gunned down in front of his home in Jackson, Mississippi. Author James Baldwin published a collection of impassioned essays entitled *The Fire Next Time*. And on July 5, 1963, one of the most frequently mentioned but not extensively examined groups of African-American artists ever formed began meeting in New York City.

The group was called Spiral, and it was composed of sixteen artists of two generations whose work would significantly expand the canon of American art: Charles Alston (1907–77), Emma Amos (1938–), Romare Bearden (1912–88), Calvin Douglass (1931–), Perry Ferguson, Reginald Gammon (1921–), Felrath Hines (1913–93), Alvin Hollingsworth (1931–), Norman Lewis (1909–79), William Majors (1930–82), Richard Mayhew (1934–), Earl Miller (1930–), William Pritchard, Merton Simpson (1928–), Hale Woodruff (1900–80), and James Yeargens. The artists of

Spiral were a part of the World War II migration of artists that made New York the undisputed capital of the Western art world, once Paris relinquished that distinction because of the destruction it suffered during the war. While Lewis, Hollingsworth, and Yeargens were born in New York City, the other members of the group relocated to "the Big Apple" from the South, the Midwest, and the Northeast. Bearden and Alston were from Charlotte, North Carolina. Gammon was from Philadelphia. Amos was born in Atlanta and moved to New York via Antioch College in Yellow Springs, Ohio. Simpson was a native of Charleston, South Carolina. Mayhew grew up in Amityville, New York, some fifty miles from Manhattan. Douglas came to New York from Baltimore. Ferguson moved to New York, to study at the Art Students League. Miller, a denizen of Chicago, came to New York to study at the Pratt Institute and also at the Art Students League.

Significantly, three of the members of Spiral either hailed from Indiana or had very strong connections to it. Woodruff, the oldest member of the group, was born in Illinois but as a young man attended the John Herron School of Art in Indianapolis. He lived in the state from 1919 to 1927, going to Europe and later Atlanta to paint and study. He eventually moved to New York in 1947 to assume a teaching position in the art education department at New York University. Majors was a native of Indianapolis who moved to New York after studying at the Herron School of Art in Indianapolis and the Cleveland School of Art in Ohio. Hines, born in Indianapolis, relocated to New York City after having attended the School of the Art Institute of Chicago. Their works would loom large in the evolution of African-American art, and the Spiral exhibition of 1965 highlighted their importance.

In the foreword to the modest catalogue prepared for the group's first, and only, formal exhibition in 1965, they collectively proclaimed: "As a symbol for the group we chose spiral—a particular kind of spiral, the Archimedean one; because, from a starting point, it moves outward embracing all directions, yet constantly forward."[1] The

name would prove prophetic and uncannily appropriate for the group, for what it was and what it became, as well as for the influence it would have long after its birth and demise.

The artists of Spiral reflected the sociocultural spectrum of black America. Moreover, as modernists, they were ideologically and stylistically guided by formalist aesthetics and criticism. Fiercely individualistic and independent in thought and expression, they shared similar experiences with other people of African ancestry in America—a history of racial discrimination and social degradation, economic deprivation, and political repression, yet they did not want their efforts to be judged by the limitations of race. For two years these artists came together to share, without apology or explanation, their aspirations and hopes as artists. In so doing, they reconnected themselves to black history and experience in ways that gave them a broader perspective of the world and a better understanding of their place in it.

When Spiral held its first meeting in Romare Bearden's studio, few art historians and critics (whose black members numbered not even a handful), and certainly not the artists themselves, realized the importance of their gathering. Their coming together as a loosely federated group marked a historic moment in African-American art, not unlike the way the year 1950 had earlier marked a critical watershed for the abstract expressionists. Not since the opening of the Harlem Community Arts Center in 1937 had so many highly educated, technically prepared, and professionally committed seasoned and emerging artists of African descent formed a group in a northern city to explore social, artistic, intellectual, political, and ideological issues.[2] While the organization they created was short-lived, its members have had a profound influence on the development of African-American art over the past thirty years.

The Impetus for Spiral

Initially, the artists of Spiral came together to respond to black labor leader A. Phillip Randolph's call for broad participation in the march on Washington. Bearden, Lewis, Yeargens, and Woodruff had strong ties to the black community and its organizations; it was through these connections that they were called upon to participate actively in this civil rights initiative. They in turn asked other artists to join them. As a matter of course, the group they assembled began to discuss, as Mayhew later recalled, their "relationship to the oppression in our society, in terms of what was going on...the discrimination that was taking place. And certainly discrimination in the arts is no different than any other area."[3] As the discussion intensified, the idea of Spiral was born. Indeed, as Mayhew contends, "The name 'spiral' embodied this extending concept of evolving and unifying, bonding and constructively supportive relationships with one another, which was an art of Afro-American sensibility."[4]

When, at that meeting, Hale Woodruff posed the question, "Why are we here?" he raised the issue of identity for the group and for the individual participants as well. "How honest are you about what you are doing?" "Are you compromising your values as a creative person?" These were among the questions asked at the weekly Spiral meetings, first held in members' studios and later at the Christopher Street Gallery, which the group leased for meeting and exhibition space. In that modest Manhattan art space, these artists collectively sought "to affirm what was going on in terms of our creative development."[5] In many ways, their search paralleled that of African-American writers, playwrights, and composers of the day, many of whom were similarly compelled by the turbulent social climate to reexamine their creative processes in light of the European fine arts tradition.

In fact, the Spiralists were great admirers of the originality and inventiveness of African-American music, par-

Romare Bearden. Opening of Spiral
exhibition, New York, May 14, 1964.
Courtesy of James Rudin, Yellow Poui
Gallery, Grenada.

ticularly jazz. Several members of the group compared
their efforts to translate the essence of black life into the
medium of paint to those of jazz musicians. They were
not unaware that the authenticity and vitality of black
music connected it to black life. Relying on abstract rather
than explicit representations, however, they sought to
match the ability of the black jazz, gospel, or rhythm-and-
blues artist to, as Alain Locke maintained, intensify "the
emotional side of life by persecution and suffering, and
[concentrate] the group's life force at a point and in chan-
nels where the practical disabilities of social and economic
handicaps are relatively pointless and operative."[6]

The Spiralists were aware that it was not uncommon
for twentieth-century artists to come together, however
informally, to affirm their commitment to making art and
to create a sense of community. The cubists, futurists, and
surrealists provided for them earlier examples of mean-
ingful artistic collaboration and exploration. The abstract
expressionists—with whom Woodruff, Lewis, and
Bearden were closely associated—provided a more con-
temporary model. For the older men such as Lewis
(Spiral's first president), Woodruff, Alston, Yeargens, and
Bearden, the creation of such groups was quite a familiar
enterprise. They had actively participated in seminal ef-
forts by African-American artists to come together in sig-
nificant numbers. They recalled for the others the estab-
lishment, more than a quarter century earlier, of the
Harlem Artists' Guild and of the "306" group in 1935.[7]
They remembered as well the initiatives of the Harlem

Community Art Center, established in 1937. In each case,
they noted, the primary impetus was to bring together Af-
rican-American artists to discuss art, enhance their efforts
to exhibit, and identify support for their work. Thus, in
many ways, Spiral was an outgrowth of the ongoing real-
ization of this need to associate rather than to remain iso-
lated as artists.

Race, Identity, and Art

Jeanne Siegel ends "Why Spiral?"—the 1966 *Art News*
article that introduced the by-then defunct Spiral group
to the art world—with a bold statement by Romare
Bearden: "The Negro artist is unknown in America."[8] It
was precisely that recognition of the invisibility of the black
artist in the 1960s that gave impetus to the group's cre-
ation. When the Spiralists began meeting in 1963, few, if
any, had achieved real commercial success. Most were not
well known in the white-dominated art world, although
Bearden had been featured in major exhibitions at the
Koontz Gallery and Norman Lewis had a long associa-
tion with the Willard Gallery. Few black artists other than
those mentioned during Negro History Week (now Black
History Month) were known to the African-American com-
munity. The Spiralists, who abandoned representational
art for abstract forms of visual expression, virtually guar-
anteed their anonymity among the masses of their people,
who were often puzzled by and reacted adversely to art
that did not present a mirror image of the fictive "black
experience." Black modernist artists were frequently la-

Norman Lewis. Opening of Spiral exhibition, New York, May 14, 1964. Courtesy of James Rudin, Yellow Poui Gallery, Grenada.

beled elitists by other blacks, and their work was viewed as completely divorced from its racial and cultural origins. Without a following, these artists often had to be their own audience. With the publication of the *Art News* article, however, thousands of people interested in art across the United States and abroad became aware of this ingenious and eclectic band of African-American artists working within a modernist idiom.

As black Americans, the artists of Spiral were greatly influenced by both the civil rights and the Black Power movements as well as by the charismatic leaders and highly charged issues involved in those struggles. As stated in the group's 1965 exhibition catalogue, they "could not fail to be touched by the outrage of segregation, or fail to relate to the self-reliance, hope, and courage of those persons who were marching in the interest of man's dignity."[9] Yet the Spiral artists did not wish to create art whose raison d'être was protest. While individually committed to black progress and freedom, they wanted to be a part of the cultural and social reawakening of the era as artists, not as civil rights foot soldiers.

Although the Spiralists "sought to identify and define African-American artists' relationship to their people's struggles and the possibility of aesthetic goals and styles that would distinguish their cultural uniqueness,"[10] they did not wish to be seen as artists or individuals through a primarily racial lens. They did not want to be labeled "black artists" nor pushed to paint in the naively primitive way European Americans believed they should, or to

paint purely representational images relating specifically and explicitly to the African-American experience. They also wanted to be included within the art world not as tokens but as artists recognized solely for the merits of their work, and judged by the same standards that were used to assess the works of white artists. They came together because they believed that blacks had to define themselves as individual artists and determine their place as artists in the larger art world; to do anything less would be too limiting, reflecting an external view not unlike that of the oppressor.[11]

While the Spiralists acknowledged the biological fact of themselves as black, and individually either knew of or had actually experienced social discrimination and economic deprivation due to racism, none saw their identity as being defined primarily by race. Race to them was but a social construction, and it was only in that sense that it was important to their art, to art generally, and to their own and others' creative expression. The members of Spiral believed that the search for truth in art made race irrelevant. They believed that the most important challenge to black artists was not race or politics, but to make good art that addressed artistic and aesthetic concerns. The artists of Spiral sought to draw upon the experiences of black life to create works that were not limited to the tastes or experiences of one racial or ethnic group. Indeed, most of the Spiralists generally ascribed to the view put forth by member Alston: "I just consider myself to be an artist who happens to be black, who happens to have lived through

Richard Mayhew. Opening of Spiral exhibition, New York, May 14, 1964. Courtesy of James Rudin, Yellow Poui Gallery, Grenada.

black experience, and inevitably, that's got to have an influence on your work, but if it is anything at all, it is American."[12]

On the other hand, however, the artists of Spiral did not try to overtly distance themselves from their race or racial issues; rather, they were reacting to what they perceived to be the limitations of race consciousness. According to Bearden and Henderson, their discussions at Spiral meetings "helped members to clarify their identity as African-Americans and their goals as artists."[13] Though the Spiralists believed that aesthetics, not politics, should be the primary issue, social and racial concerns were ever-present in their minds. This is evident in their initial plans to center their inaugural exhibition on the theme "Mississippi, 1964," in recognition of the tumultuous civil rights struggle being waged in the South during "Freedom Summer." Instead, however, the group decided, at Bearden's suggestion, to present works whose palette was limited to only two colors: black and white. In this fashion, the Spiralists were able to reconcile their aesthetic and sociopolitical concerns. Indeed, their debut exhibition foreshadowed the issue-oriented art of the late 1960s. One can only surmise that the Spiralists were not unaware of how a palette of black and white would not be without ideological references to race. As Albert Boime has observed, "In the Caucasian-dominated culture of the West, color

symbolism served to reinforce the assumptions that whiteness connotes virtue and purity and blackness wickedness and impurity."[14] Though this experiment was short-lived, its value as a consciousness-raising device for the artists of this group cannot be underestimated.

The Ellisonian Influence

Like other modernist artists of the 1960s, the Spiralists believed that art should not be burdened with political and social concerns. Social realism was no longer relevant to their present existence as artists, and they strove to achieve an art that was neither ethnic nor racial but universal. All the artists of Spiral were ideologically modernistic in that they supported African-American novelist and critic Ralph Ellison's view that all creative expression must be guided by an assumption of the universality of human experience. They concurred further with Ellison's position that the best art by African Americans was "an affirmation of the irrelevance of the notion of race as a limiting force in the arts."[15]

It is not surprising that Ellison and the Spiralists were kindred spirits. Since his college days at Tuskegee Institute (now University), where he studied with artist Eva Hamlin (later Miller), Ellison had wanted to be a sculptor. It was Hamlin who provided the young Ellison with a letter of introduction to sculptor Augusta Savage when he

Charles Alston. Opening of Spiral exhibition, New York, May 14, 1964. Courtesy of James Rudin, Yellow Poui Gallery, Grenada.

left Tuskegee for New York City in 1936. However, Savage was unable to devote sufficient time to Ellison's apprenticeship because she was heavily involved in several Works Progress Administration (WPA) art projects. With an introduction from Howard University professor Alain Locke and poet Langston Hughes, Ellison was able to arrange to study with Richmond Barthe, a young African-American sculptor who had gained considerable recognition during the Harlem Renaissance.

Though he eventually abandoned hopes of a career as a visual artist for a life of letters, Ellison, like the Spiralists, was in every respect a modernist. In painting, modernist artists used line, color, and shape to create a nonobjective reality distinct from the natural world.[16] They were willing to take risks, to rely upon the power of the imagination to create compelling artistic works rich in structural complexity and cultural meanings. In writing *Invisible Man* (1952), with its self-referent articulations that called upon readers to become active participants in formulating meaning and its bold departure from the "well-made" novel, Ellison clearly distinguished himself as an exponent of modernist expression.

Even during the long, lean years of "apprenticeship" as a writer before *Invisible Man* was published, Ellison insisted that mastery of technique was essential in order to "discover and transfigure" the world of individual expe-

rience.[17] He saw art as "a fundamental and transcendent agency for confronting and revealing the world."[18] Thus, according to Ellison, the mission of the artist "is to bring a new visual order into the world, and through his art he seeks to reset society's clock by imposing upon it his own method of defining the times....The urge to do this determines the form and character of this social responsibility, it spurs his restless exploration for plastic possibilities, and it accounts to a large extent for his creative aggressiveness."[19] For Ellison, the artistic dimension, not the social or political, was primary. In his view, protest artists were "so fascinated by the power of their anachronistic social imbalance as to limit their efforts to describing its manifold dimensions and its apparent invincibility against change."[20] He continued:

Indeed, they take it as a major theme and focus for their attention; they allow it to dominate their thinking about themselves, their people, their country and their art. And while many are convinced that simply to recognize social imbalance is enough to put it to riot, few achieve anything like artistic mastery, and most fail miserably through a single-minded effort to 'tell it like it is.'[21]

The Spiralists, like Ellison, underscored the importance of the individual because they believed it was through individuality that the artist connects to the universal. In arguing for individual freedom, they and their

art countered the idea of an essentialist, monolithic racial identity. For these artists, a singular "Negro (or black) image" did not exist. Like Ellison, too, many of the Spiralists had difficulty with the term "black art." This was particularly true of the members who were of the older generation. They did not believe in mixing politics and art, in "storming the barricades" of the white-dominated art world. They generally ascribed to the Ellisonian view that the quality of black artistic culture "can by no means be conveyed by that term."[22] "Nor does it help," Ellison added, "to apply the designation 'black' (even more amorphous for conveying a sense of cultural complexity)… since such terms tell us little about the unique individuality of the artist or anyone else."[23]

The Spiralists' questioning of the validity and efficacy of the term "black art" and their insistence on separating the aesthetic from the political provided a distinct counterpoint to the more militantly race-conscious, cultural nationalists' views about art and society espoused by proponents of the Black Arts movement during the late 1960s and 1970s. While the artists and groups of this movement also acknowledged the uniqueness of the individual, they emphatically connected the personal with the political and deliberately sought to use art in the struggle for black liberation. The Spiralists, however, strove to paint figurative and abstract "nonracial" works and tried, as Alston contended, "to keep the universalities that make a painting a painting upper-

most."[24] Nonetheless, Spiral was to have a resonating impact on those younger African-American artists and cultural activists who were creatively coming of age during those years and who, in the words of historian Lerone Bennett, "made rebellion an art and art a rebellion."[25]

The Inaugural Exhibition

"Time, and judicious judgment, will determine the lasting merit of the work on exhibit. What is most important now, and what has great portent for the future, is that Negro artists, of divergent backgrounds and interests, have come together on terms of mutual respect. It is to their credit that they were able to fashion art works lit by beauty, and of such diversity."[26]

With those words the foreword to the catalogue of Spiral's inaugural exhibition marked the beginnings of a new era for African-American art. The formal Spiral exhibition reflected the diverse artistic concerns of the group. Hale Woodruff was represented by his *Africa and the Bull* (fig. 90), an abstract work that integrates landscape and figurative painting and African and European themes. Although his works were not illustrated in the catalogue, William Majors exhibited richly textured intaglio prints featuring a variety of biomorphic forms. Earl Miller chose *According Flyer* for the debut exhibition. Like Perry Ferguson's *Small Town*, which was also included, *According Flyer* was a mixed-media work. Yet, while Miller deftly

William Majors. Opening of Spiral exhibition, New York, May 14, 1964. Courtesy of James Rudin, Yellow Poui Gallery, Grenada.

reconciled collage techniques and painted abstract forms in his piece, Perry combined geometric abstraction and transparent overlays to create planes that deny specific reference to deep space.

Norman Lewis's contribution was a compelling piece entitled *Procession*, which symbolically alludes to the throngs of civil rights marchers across the South. Reggie Gammon likewise invoked the imagery of the civil rights struggle in the work he presented to the exhibition, entitled *Freedom Now*. *Untitled*, Merton Simpson's first Spiral offering, depicts a masklike head with bared teeth that dominate the picture space. In that work, only a section of a street sign provides a sense of place: 125th Street in Harlem. Alvin Hollingsworth was represented by his *Composition No. 2*, with its depiction of human images in an expressionistic, iconic style. Calvin Douglass offered an untitled collage, created by embedding small items into a polyester resin surface. Romare Bearden, who had suggested that the group work communally to create collages, exhibited his *Conjure Woman*, a small collage that would define his work for many years thereafter.

The Indiana Connection: Hale Woodruff and William Majors

Woodruff, who received much of his formative art education in Indiana, and Indiana native Majors personified the diversity of the Spiralists. Woodruff, however, represented the older generation and Majors the new. Woodruff sought to explore African-specific themes in his work, particularly his *Celestial Gate* series (figs. 57 and 58). Majors drew upon his deft delineation of forms from nature to create lyrical compositions that were symphonic in complexity and visual effect. To be sure, the two artists were committed to modernist, abstractionist forms; neither wished to limit his art to explicitly African-American themes. They were very much in concert with Norman Lewis, who intoned, "I am not interested in an illustrative statement that merely mirrors some of the social conditions, but in my work I am looking for something of deeper artistic and philosophical content."[27]

Hale Woodruff

Woodruff, much like Ellison, was able to draw upon a strong synthetic imagination. He was able to reconcile Cézanne's perspective of color with the plastic expressiveness of African sculpture. He abhorred the limitations of racial stereotypes, both personally and artistically, and stressed the primacy of the individual. Like Ellison he highly valued the improvisational, expressive energy of jazz and sought to convey much the same feeling in many of his works.

Woodruff had enjoyed a long and productive life as a teacher before the advent of Spiral in 1963. He had experimented with cubist aesthetics in the 1930s and 1940s and

Figure 90. Hale Aspacio Woodruff. *Africa and the Bull*, oil on canvas, 44 1/4 x 52 3/4 inches. Collection of The Studio Museum in Harlem. Gift of Mr. and Mrs. E. Thomas Williams, Jr., 87.5.3.

had investigated and experimented with African art forms prior to beginning his *Celestial Gate* series, perhaps his most important work other than his murals. While Woodruff was not as well known as the abstract expressionist Willem de Kooning or his New York University colleague sculptor Tony Smith, his influence on twentieth-century art over the long haul may be far greater. His teaching, his institution building, his ability to build bridges across racial and cultural lines, and his long investigation of modernist art expression through the lens of traditional African art distinguished him as one of the most significant of early African-American modernist artists.

William Majors

William Majors represented the younger generation of African-American artists who were drawn to Spiral. Unlike many of his contemporaries, he did not view his art as a political weapon. His primary emphasis, much like Ellison, was on the transcendency and universality of art. The Spiral years helped Majors to consolidate his aesthetic convictions and affirm and follow the artistic course he had set for himself.

When he began his association with Spiral, Majors's artistic vision was already quite mature. As a printmaker, he combined experimentation with mastery. He frequently explored patterns of growth seen in nature, and his use of biomorphic forms soon became his signature style. This fascination with nature, however, was mediated by a strong interest in artistic structure. His early pen-and-ink drawings reflect his skill as a draughtsman. Majors often divided his picture space into distinct vertically or horizontally oriented halves connected by a persistent overall pattern. He then modified the halves by line, pattern, or value to establish difference. Works such as *Harvest*, 1964, demonstrate this skill in using line to define form, create movement, and negotiate positive and negative space.

Genesis II, 1965 (fig. 91), serves as an example of Majors's ability to invoke and mediate a construct. Here Majors sets up the structural parameters by transforming the surface of the work through etched and engraved lines and aquatints. He establishes emphatic bipolarities, which are unified by layers of biomorphic shapes that invert expectations. Darks and lights are used to modify the pictorial space in bold, direct, but subtle ways. Despite the simple structure of many of his works, Majors creates a sense of mystery, a quiet elegance and control, in this piece.

Though Majors was often impatient with the discussions at Spiral meetings because of his strong commitment to making art rather than talking about it, his two years with the Spiral group were important to his development as an artist. He brought to the group an expertly honed voice that cut across the poetics of visual language. Truly a product of the Midwest, Majors reflected through his work the directness, honesty, and commitment to crafts-

Figure 91. William Majors. *Genesis II*, 1965, etching with aquatint, 22 ³/₈ x 24 inches. Collection of Susan Stedman Majors.

manship that made him one of the important young artists of the 1960s. Though not blessed with long life, Majors cut a decisive path across the art horizon of his day.

The Ongoing Spiral

When the Spiralists lost their lease to the Christopher Street Gallery and its doors closed in 1965, Spiral as a formal group ceased to be, but the influence of its members was only beginning.[28] Despite the ambiguities and criticisms that surrounded the group's ideological and aesthetic convictions, no discussion of African-American art of the 1960s can ignore its significance, which transcends both its limitations and its short duration. That the Spiralists did not embrace the Black Arts movement—indeed, that they often criticized and were criticized by advocates of this movement—led some to think they should have been left to the invisibility Bearden had lamented. By coming together, however, the artists of Spiral hoped to ensure their visibility. It is only now that the importance of their brief union is slowly being recognized.

Even though the group was virtually invisible to all but other African-American artists, art critics and historians, and a few others in the wider art world, Spiral did not go silently into that dark night. Its members continued to work, exhibit, teach, and support younger artists. They touched the lives of many and left a solid body of work. In their respective ways, the artists of Spiral drew upon their multiple identities and cultural heritages to create inventive and powerful art that would accord them a central place in the history of modern American art. The artists who banded together under the Archimedean symbol of all-encompassing change paved the way for those African-American artists who followed, if not in their footsteps, at least in the broad paths they cleared. Thus, the legacy of Spiral will expand and remain secure for generations to come.

Notes

1. "Foreword" to *Spiral*, Long Island University, 21 March–14 April 1965, n.p.

2. The National Conference of Artists (NCA) was founded a few years before Spiral (1959) on the occasion of the Annual Exhibition of Negro Artists, established by Hale Woodruff in 1942. At its 1963 spring meeting it issued a portfolio of prints, organized and edited by Margaret Goss Burroughs, commemorating the hundreth anniversary of the Emancipation Proclamation.

3. Tape-recorded interview with Richard Mayhew at the Studio Museum in Harlem, New York City, 11 February 1995.

4. Ibid.

5. Ibid.

6. Alain Locke, "The Negro's Contribution," in *On Being Black: Writings by Afro-Americans from Frederick Douglass to the Present*, ed. Charles T. Davis and Daniel Walden (Greenwich, CN: Fawcett Publications, Inc., 1970), 109.

7. Myron Schwartzman, *Romare Bearden: His Life and Art* (New York: Harry N. Abrams, Inc., 1990), 78–85.

8. Jeanne Siegel, "Why Spiral?" *ARTnews* 5:5 (September 1966): 48.

9. *Spiral*, 1965.

10. Romare Bearden and Harry Henderson, *A History of African-American Artists: From 1792 to the Present* (New York: Pantheon Books, 1993), 397.

11. For a contemporary discussion of identity that is similar to the views of the Spiralists, see Glenn Loury, "Free at Last? A Personal Perspective on Race and Identity in America," in *Lure and Loathing: Essays on Race, Identity and the Ambivalence of Assimilation*, ed. Gerald Earl (New York: Penguin Books, 1993), 1–12.

12. Bearden and Henderson, 269.

13. Ibid, 214.

14. Albert Boime, *The Art of Exclusion: Representing Blacks in the Nineteenth Century* (Washington, D.C.: Smithsonian Institution Press, 1990), 6.

15. Ralph Ellison. "The Art of Romare Bearden," in *Chant of Saints: A Gathering of Afro-American Literature, Art and Scholarship*, ed. Michael S. Harper and Robert B. Stepo (Urbana: University of Illinois Press, 1979), 165.

16. Mark Busby, *Ralph Ellison* (Boston: Tawyne Publishers, 1991), 60–64.

17. Ellison, 156.

18. Ibid.

19. Ibid., 160.

20. Ibid., 159.

21. Ibid.

22. Ibid., 158–59.

23. Ibid., 159.

24. Bearden and Henderson, 268.

25. Mary Schmidt Campbell, et al., *Tradition and Conflict: Images of a Turbulent Decade, 1963–1973* (New York: The Studio Museum in Harlem, 1985), 9.

26. "Foreword" to *Spiral*.

27. Siegel, 48.

28. Mayhew, taped interview.

6

Echoes of the Past: Artists' Biographies

William E. Taylor

Echoes of the Past: Artists' Biographies
William E. Taylor

William Edouard Scott, 1884–1964

During the early part of the twentieth century, William Edouard Scott was second only to Henry O. Tanner (1859–1937) as the most prolific black artist. His talent as a painter was noted by French newspapers during his years as a student abroad and in American journals after his return. Scott was a painter of impressionist landscapes as well as one of the first African-American artists to focus on black subject matter. He was among only a few black professional artists able to pursue their careers full time, as he achieved financial stability through numerous mural and portrait commissions. A painter who came out of the American realist tradition, Scott chose to devote most of his skill to expressing his racial pride and dignity. His success influenced and encouraged many other black artists in America and abroad.

Scott was born in Indianapolis on March 11, 1884, to Edward Miles Scott and Caroline Russell Scott.[1] He attended elementary and secondary school in Indianapolis and graduated in June 1903 from Emmerich Manual Training High School. Otto Stark, chairman of the high school's art department, took a special interest in Scott and advised him to seek enrollment in the School of the Art Institute of Chicago.

Scott spent the summer after graduation in Chicago, where he was hired to draw the plans for a flat to be built by a wealthy black woman. He returned to Indianapolis in fall 1903 and took a job at Manual High School, primarily stocking and keeping inventory of the art supplies for the department.[2] He also assisted Stark in teaching drawing to freshmen students. With this added responsibility, Scott became the first black person to teach in a public high school in Indianapolis. During this period he received additional drawing instruction from Stark and attended drawing classes at the John Herron School of Art, with which Stark was affiliated.[3]

With $65 in savings and his art portfolio, Scott left Indianapolis in 1904 to enroll at the School of the Art Institute of Chicago. He was fortunate to have his art come to the attention of John Vanderpoole, who taught the life drawing class. The nude life class was open to third-year students, but Scott's portfolio demonstrated such promise that he was allowed to enter the class on a trial basis when he enrolled at the Art Institute on September 26, 1904.[4] With little money left after paying his registration fee and tuition, Scott found a job waiting tables at a local restaurant in return for a meal plus fifty cents a day. After his first term, he added a job sweeping the classrooms. Scott also won illustration competitions and received scholarships, which helped to offset his expenses. Several of his illustrations were published in *Inland Printer*, *Outing*, *Redbook*, and *Voice* magazines.[5]

Scott was chosen for a commission to paint the first mural decoration in a Chicago public school. The subjects of his mural at Felsenthal School were the landing of the Norsemen, Penn's treaty with the Indians, and the landing of the pilgrims.[6] He went on to paint decorations for five public school buildings in Chicago, including the mural *Commerce* (fig. 92) for Lane Technical High School, as well as murals at schools in nearby Evanston and Highland Park. He also produced works for public schools in Washington, D.C.[7] These projects generated the revenue that enabled him to continue through five years of study at the Art Institute. He graduated on June 21, 1907, but continued studying at the school for another two years.

Although Scott was eager to embark for France, the young artist felt he needed more money than the $400 he had saved from scholarships and awards. Scott returned to Indianapolis for the summer of 1909 and again worked at the art department of Manual Training High School. He departed for France in August with plans to be away for two years and to divide his time between Paris, Holland, and Italy.

When Scott arrived in France he knew very little French. His attempts at ordering meals in restaurants sometimes resulted in a strange array of food on his plate. The artist opted for drawing on his sketch pad a picture of what he wanted. Despite his artistic ability, the waiter's

interpretation did not always match what Scott desired.

After several months in France, Scott's funds began to run low. His trip was saved by the expatriate artist Henry O. Tanner, who learned of his predicament and invited Scott to stay at his summer home in the artists' colony at Trepied-par-Etaples, about seventeen miles south of Boulogne.[8] The invitation led to one of Scott's most memorable European experiences, which he later characterized as "a source of great inspiration to me." In Tanner, Scott said, he found a man who "is painstaking, conscientious and a real genius."[9] Scott recognized as well the privilege bestowed on him, for although numerous artists met and talked to Tanner about art, only he and fellow Art Institute alumnus William Harper (1873–1910) spent extensive time with the master.[10]

In early 1911, when Scott's money ran so low he had only enough for boat fare, he returned to Chicago. Although he frequently visited his father and sister in Indianapolis and often exhibited and painted in that city, Scott considered Chicago his home. He soon arranged an exhibition in Chicago of the paintings he brought back from France, and then used the sales to finance a return trip to France that summer.

The second sojourn began well. An Indianapolis newspaper reported that Scott "exhibited three fine canvases at the summer salon at Paris-Plage, and has had high praise from the French papers."[11] In 1912 Scott followed Tanner's footsteps and enrolled as a student at the Académie Julian. Here students paid for the privilege of drawing and painting and received criticism once or twice a week from well-known academicians. A description of the school in 1911 tells of a rather bohemian existence:

The school was an enormous hangar, a cold, filthy, uninviting firetrap. The walls were plastered from floor to ceiling with the prize-winning academies, in oil and charcoal, of the past thirty or forty years. The atmosphere of the place had changed little since the days of Delacroix, Ingres or David. Three nude girls were posing downstairs. The acrid smell of their bodies and the smell of the students mingled with that of turpen-

William Edouard Scott. Reproduced from the collections of the Library of Congress.

tine and oil paint in the overheated, tobacco-laden air. The students grouped their stools and low easels close about the model's feet. While they worked there was pandemonium of songs, catcalls, whistling and recitations, of a highly salacious and bawdy nature.[12]

Scott found Paris an expensive place for an art student. He noted that among the expenses connected with study in Paris was the fee of five dollars paid to a celebrated artist for just a few words of private criticism. As Scott described Paris and student life: "The very least I ever paid in Paris for a room was two-dollars a week and then it was not heated. So I used to do as all the other students did—go to the cafes, buy a cup of coffee, then sit at the table for an hour or two, writing letters, listening to the orchestra or watching the dancing—yes, the tango, that is all the rage there."[13]

Figure 92. William Edouard Scott. *Commerce* (detail), about 1909, Lane Technical High School, Chicago.

He soon left the capitol for Trepied-par-Etaples, which had been a small but important fishing village and commercial port in the Middle Ages. Here he found that "the price of living is small" and was impressed that "the fisher folk of Etaples will pose for 20 cents each the half day."[14] More importantly, Scott did not have to rely again on Tanner's hospitality, because he found a bargain in a yearly rental of an entire furnished upper floor of a two-story building, where he lived and kept his studio.[15]

In spring 1912 Scott's painting *La Pauvre Voisine (The Poor Neighbor)* (fig. 1) was accepted at the Salon de la Société des Artistes Français in Paris. Scott was the second black American artist to have works admitted to this Salon: Tanner had exhibited in 1894. The work was well received by the French newspapers, which wrote about Scott's art and reproduced the painting. It was also reproduced in full color on postcards. The work came to the attention of government officials of the Argentine Republic, who purchased it. Scott recounted the event:

I had sent a picture to the Salon, and on the advice of a friend, Balfour Ker, a great American illustrator, put a price of $1000 on it. He said, "Scott, you are not going to [sell] it anyway, so make the price big." At the opening of the Salon I had about $10 in excess of my passage home. I had prepared to return to America when I received a letter from representatives of the Government of the Argentine Republic asking the lowest price I would accept for the picture. With as little money as I had I would have gratefully accepted $5, but, thinking the whole proposition a joke, I named a price of $600. Much to my surprise I received a check for that amount.[16]

He returned home in November 1912 with twenty-six paintings executed in a modified impressionist style. Exhibited in Indianapolis at Otto Stark's studio, the works were both an artistic and a financial success. A local newspaper reviewer observed that Scott did not belong to any particular school of art but chose what was best for him from several of them.[17] Two of Scott's canvases received special attention, *The Juggler* and *A Wet Night at Etaples*,[18] probably *Rainy Night, Etaples* (fig. 3), which a group of African-American citizens purchased and presented to the John Herron Art Institute, now the Indianapolis Museum of Art, where it remains in the permanent collection.[19]

In 1913, after painting three murals in Chicago, Scott was commissioned to paint murals for several public schools in Indianapolis. The school administrators were implementing a new concept, "the school beautiful," with the idea that pleasant surroundings are conducive to learning.[20] On February 7 exercises were held for the dedication of a mural painted by Scott in the first-grade room at Public School No. 26 on Martindale Avenue. A reporter for *The Indianapolis Star* wrote that Scott showed much originality in choice of theme and treatment of the subject. According to the journalist:

His subject is "The Old Woman Who Lived in a Shoe," and as the woman, he has chosen a typical old colored mammy busily engaged in looking after the affairs of her numerous brood, who, of all ages and degrees from babyhood up to long-legged youth, are frolicking gaily along the way. He apparently has under-

taken to indicate the happy, light-heartedness characteristic of childhood and of the colored race and has accomplished his purpose admirably. His taste in choosing to depict modern life and his own people instead of borrowing from classic models caused approving comment on the part of visitors present.[21]

The second mural was unveiled on March 7 at Public School No. 23. Scott had attended this school, and the mural was in his first classroom. The painting, entitled *Fountain of Knowledge*, was twenty-three feet long and forty inches high. A local reporter cited this mural as one of the most beautiful of its kind and gave recognition to Scott as "the young colored artist, whose work has attracted widespread attention." She wrote:

He calls it The Fountain of Knowledge, and has carried out the idea by representing the teacher and a group of children, whose toys and pastimes typify the different arts and trades of the world. A small boy with a hammer and toyhouse represents the carpentering trade, one child with a tiny boat typifies commerce, while two little girls represent music and dancing. The figures are all of colored children, and range in shade from the very light to the darkest seen in the race. Mr. Scott's idea was to portray the happy-go-lucky disposition of the colored child and the fact that the colored child more than that of any other race acquires his knowledge unconsciously. He is not studious by nature: he does not inherit any tendency to study. His life, even under stress of poverty and misfortune, is one happy frolic. And yet he unconsciously absorbs knowledge through no apparent application of his own, until, as the artist expressed it, "All at once he has acquired something." Certainly the picture is the embodiment of the life and gaiety of childhood.[22] Reviews such as these show the depth of public stereotyping of the black race. Although Scott hoped to bring about a change in such attitudes in his portrayals of black subjects, his work was often misinterpreted by critics of the day.

Scott went back to Paris that summer and enrolled at the Colarossi Academy. He submitted three paintings, *Soleil Gris*, *Après la Pluie*, and *La Misère* to the summer Salon de la Société Artistique de Picardie Le Touquet at Paris-Plage. One of the paintings, *La Misère* (*Poverty*) (fig. 4), was awarded the Tanqueray prize of 125 francs. The painting was reproduced, along with a picture of Scott, in the French catalogue. As Tanner also participated in the exhibition, it marked the first time two African-American artists had works in a major French exhibition.[23]

Scott returned to Chicago in early 1914 after almost a year's study, which included four months under Jean-Paul Laurens at Académie Julian and at Etaples with Tanner. He left behind two paintings that were to appear in European exhibitions: *Silver Sun at Boulogne* was admitted to the Royal Academy exhibition in London, and *Le Connoisseur* had been accepted for display at the Salon at La Loque, France.[24]

In May 1914 Scott exhibited thirty-one landscape paintings at the Senate Avenue YMCA in Indianapolis. The majority were executed abroad and gave local people an insight into Scott's life in France.[25] At the Indiana State Fair in Indianapolis in September, Scott won several honors, including first prize for the best painting. Prominent Indiana artist and John Herron Art Institute instructor William Forsyth came in second. Scott also took third place for a figure piece in oil, with Otto Stark taking first. For the best and most important entry, Stark won the first prize, with his student Scott earning the second award.[26] All of Scott's award-winning paintings were sold to a local art collector for his private collection.[27]

In January 1915 Scott went to Tuskegee, Alabama, where, as a guest of Booker T. Washington, he spent several months studying southern life among his people. A contemporary newspaper article noted that "Otto Stark and other artists who are interested in Mr. Scott have urged him to interpret colored life, not only because this field is untouched, but because the work he has done along this line shows an artistic expression beyond anything he has accomplished in other fields."[28]

As his work matured, Scott garnered numerous "firsts" among black artists. In October 1915 he was the only black among a group of artists who were commissioned to do a series of decorations for the new Burdsal Wing of Indianapolis City Hospital. For the hospital's lobby he depicted Christ being blessed by Simon, using as models members of the Stuart family, a prominent African-American black family whose relatives still reside in Indianapolis.[29] He decorated the women's medical ward

with a four seasons theme and chose biblical subject matter for the obstetrics ward. He treated the twenty-two panels in this ward, ranging in size from five to forty feet wide, with a silvery tone that enhanced the white walls. Three hundred figures were used. Unlike the other artists in the group, Scott did not trace his sketches onto the canvas, but instead used them only as a guide. It took him about five months to finish the work, which at the time he considered one of his best mural paintings.[30]

The demand for Scott's work grew steadily. In 1918 he created a cover for the November issue of *The Crisis*, the magazine of the NAACP, honoring America's black soldiers. During the 1920s he completed several murals in Indiana and Illinois, including historical paintings for the First National Bank of Fort Wayne, Indiana (1922), the First Presbyterian Church of Chicago (1923), and the Illinois National Bank in Edwardsville (1924). In 1925 he was commissioned to illustrate the cover of *Opportunity*, a monthly black publication.[31]

Scott was also the first black artist to participate in the Hoosier Salon exhibitions in Chicago, which were instituted in 1925 by the Daughters of Indiana to show how art had grown during the past twenty-five years in the state of Indiana. His painting *Lights on a Summer Night* was accepted in 1926. He had two works, *Mrs. Welling R. Chavis* and *The Witching Hour*, in the 1927 Salon and exhibited one painting, *Wrigley Reflections*, the following year.[32]

An awareness of the African-American artist on a national scale began in the 1920s with the advent of the Harlem Renaissance. The Harmon Foundation, formed in New York in 1922 under the guidance of philanthropist William E. Harmon with the purpose of "encouraging and stimulating individuals to self-help," played an important role during this period of the flowering of black culture. To administer the awards for Distinguished Achievement among Negroes, the only division of the foundation that included work by black fine artists, the Harmon group in 1926 selected Dr. George E. Haynes, a leader of the Commission on Race Relations of the Federal Council of the Churches of Christ in America. There were seven other areas in the division, including Business and Race Relations, an award that could be presented to a black or white

person. The first-prize gold medal in all fields came with an honorarium of $400 and the second-prize bronze medal with $100.[33]

In 1927 Scott submitted for consideration photographs of some of his murals. He was presented a special recognition by the Harmon Foundation and a gold medal for distinctive achievement in fine art, but without the monetary awards. A January 6, 1928, letter from the foundation stated:

It gives me great pleasure to inform you that the judges of the William E. Harmon Awards for Distinguished Achievement among Negroes voted you a special award in Fine Arts consisting of a gold medal. The judges stated that this was done because of the high character and excellence of your work. They regarded you as a finished artist who has had excellent training and years of practice, and so far matured in your work as to be beyond the purpose of the awards.[34]

Scott responded to the above letter:

Mr. Haynes, I have read and reread your letter a number of times and it is utterly impossible for me to understand the jury's point of view. You state that I was considered ineligible for the cash prizes. Of course, if I had known that I would not have competed. It is true that I have had training and experience, but I am as far from my ideal as the most modest exhibitor is from his. There is no such thing as a finished artist. If he is alive, his ideals are advanced and he slaves to progress and advance to make the world better for his having contributed towards its cultural development.

I hope that you will not consider me ungrateful, but I am truly at a loss to understand the point. If it is because I have apparently made money at mural painting, let me tell you, confidentially, the positive truth: I painted eleven portraits (30" x 40") for thirty-five dollars each last year and have been compelled to paint signs and campaign banners to keep body and soul together between mural decoration commissions. Then I read on your list, Mr. Anthony Overton as having received the first award in business. He is rated as a millionaire in Dun and Bradstreet and still he is not considered beyond the purpose of the award and receives cash prize also, a banker given four hundred dollars and an artist considered beyond the need of it.[35]

The committee did not change its mind, but possibly because of Scott's letter, it was the last time that an award was presented without the honorarium.

An important phase of Scott's career began when he was awarded a Julius Rosenwald Fellowship in 1931 for study in Haiti. He spent almost a year in this country and painted over 144 works depicting island life. In an exhibition of some of these works, twenty-seven paintings were sold, twelve of them to the president of Haiti. In 1936 the government honored Scott for his work by naming him a Haitian Officer in the National Order of "Honneur et Mérite," which is comparable to the French Legion of Honor.[36]

While in Haiti Scott painted peasants, workers, fishermen, the old, and the young. He was an important influence on the island's young artists, as exhibits of his paintings demonstrated to them that there was an abundance of subject matter in their own environment. It was too expensive for Haitians to study abroad, so a number of young people interested in art took correspondence courses from France and worked in a style that reflected the French academic tradition. Scott held classes for prospective artists in which he gave instruction in painting as well as demonstrations of his own techniques. Petion Savain, who became one of the leaders of the Haitian school of art, was fascinated with the black American artist. According to one historian, "He followed Scott around, observing with rapt attention the artist's technique and picking up what principles of oil painting he could."[37] Girodani Michelet was another Haitian artist who was inspired to paint after watching Scott work.[38]

Scott had married Esther Elaine Fulks of Charleston, West Virginia, in 1918 and over the years had made frequent visits to the area. In fall 1938 I. J. K. Wells, State Supervisor of Negro Schools in West Virginia, invited Scott to be an artist in residence and to tour the high schools under the auspices of the Wells's Motivational and Inspirational Program. During one of his presentations, at Garnet High School Auditorium in Charleston, Scott was described as a "tall (about six foot), handsome mulatto gentleman who presented a spectacle unlike anything or anyone ever seen in the area. A dark beret, topping rather long almost completely straight hair, a goatee in the form of a 'van dyke,' and an artist's smock with full long sleeves, completed the unusual attire."[39] Here, as at other assemblies, Scott discussed his art and his painting techniques

with the student body. As an artist in residence, he also painted in northern West Virginia, Bluefield, at Harpers Ferry, and John Brown's Fort.

For the *American Negro Exposition: Celebrating 75 Years of Negro Achievement* in Chicago from July 4 to September 7, 1940, Scott was responsible for the murals around the walls of the exhibition hall, named the Tanner Art Gallery, in the Chicago Coliseum. Working sixteen-hour days, Scott executed twenty-four murals during a three-month period. They depicted important events involving African Americans during the past seventy-five years, including the Fisk University Jubilee Singers performing before Queen Victoria, Marion Anderson singing the "Star Spangled Banner" at the Lincoln Memorial, and the Frederick Douglass and Stephen Douglas debate, which never materialized because the latter failed to appear.[40]

In 1943 the section of fine arts in Washington, D.C., using WPA money, announced a competition for seven mural paintings depicting the Negro's contribution to life in America. The murals were to carry a total award of $5,600 and would decorate the public lobby and library of the Recorder of Deeds building in Washington. Each of the seven murals was to illustrate a heroic act or deed performed by a Negro during the past two hundred years. The competition was open to all American artists, and designs submitted could cover one or all of the murals. The awards for winning designs varied from $650 to $1200 per mural. Paintings were judged anonymously by a jury composed of artists. The competition received 360 entries, some of them from the country's leading black artists, including Charles H. Alston, Aaron Douglas, Louis Mailou Jones, James A. Porter, and Hale Woodruff.[41] The jury, however, had no way of knowing the race of the artist; and of the seven winners, the only black selected was Scott. His mural, based on descriptive information provided during the competition, depicted Frederick Douglass appealing to President Lincoln and his cabinet to enlist Negro soldiers in the Civil War. It hangs in the lobby of the Recorder of Deeds building. Scott received a $650 award for this work.[42]

Scott's mural was so well received that he was commissioned to do an easel painting depicting the dedication ceremony for the same building, for which he was

paid $500.[43] The completed work shows President Roosevelt and his cabinet, whom Scott composed from photographs of each individual plus information about their heights.[44]

In 1948 Scott painted six religious murals for the opening of the Stuart Mortuary in Indianapolis. Dr. William Weir Stuart had been one of Scott's patrons throughout his years as a student, and their relationship continued after Scott settled in Chicago. When visiting Indianapolis, Scott often made his first stop Dr. Stuart's dental office. The Stuarts were well aware of Scott's reputation as a mural artist and were more than happy to give their friend the commission to decorate the new mortuary. Scott painted the murals, using Stuart family members as models for some of the figures, in his Chicago studio, framed them, secured them to the top of his automobile, and drove them to Indianapolis for installation.[45]

During the 1950s Scott concentrated mainly on portraiture. In 1955 the artist traveled to Mexico to paint. There he became ill and learned he had diabetes. His illness led to the amputation of one of his legs in 1957, when he was seventy-three. The operation did not stop him from producing art, and he continued to lecture. The disease progressed, and a few years later his other leg was amputated. Scott died on May 16, 1964, at the age of eighty.

Although Scott's career began in Indianapolis and flourished in Chicago, his French training and his mentor Tanner set him on a path that would leave an indelible mark on future artists. His southern genre scenes are among the first images of the black experience painted by an African-American artist, and his more than twenty-seven murals depicting the achievements of Negroes in America are some of the earliest examples of public art to include black subject matter. "With his skills," asserts one critic, "he could have been absorbed into the mainstream and might have built a personal reputation; he chose, however, to commit himself to the establishment of pride, dignity and self-realization for all Negroes."[46]

■

John Wesley Hardrick, 1891–1968

John Wesley Hardrick felt the black artist was an essential part of the population in general and the black community in particular and could play a significant role in the betterment of race relations. He expressed his self-worth through his art, using it to record his environment and his people.

Hardrick's grandfather, Shephard Hardrick, was a farm owner in Kentucky after the Civil War. Some members of the white population resented African Americans who owned property and expressed their resentment by riding around the black-owned farms and harassing the inhabitants. In 1871 the Hardrick family became the brunt of these protests, when the Knight Riders (later called the Ku Klux Klan) gave them twenty-four hours to leave their farm. The family packed their belongings and traveled by springboard wagon to Indianapolis, where they settled on the outskirts of the city on the southeast side. When their son Shephard, Jr., married Georgia Etta West on October 10, 1888, the newlyweds moved a short distance from the family home to 3309 Prospect Street. John Wesley Hardrick was born at the Prospect Street address in 1891.[47]

When young Hardrick was six years old his talent for drawing became apparent. At the age of eight, without the benefit of instruction, he began to work in watercolor. His sister Georgia recalled that when her brother was not in class or busy with other activities, he was sketching with a pencil and paper.[48] In 1904 Hardrick had his first exhibition, at the convention of the Negro Business League in Indianapolis.[49]

In summer 1906, while visiting his aunt at Lake Okabosier, a resort outside Des Moines, Hardrick made sketches of a monument erected in memory of the white families killed by Indians during the early settlement of the area. People were so fascinated by these sketches that Hardrick sold them for twenty-five cents as fast as they were produced.[50]

A teacher who had observed Hardrick drawing while he was a student at Harriet Beecher Stowe School asked to see some of his finished work. She was so impressed with the budding artist's drawings that she arranged for Herman Lieber, owner of the H. Lieber Company, an art supply store in Indianapolis, to look at them. After Hardrick finished elementary school in June 1905, Lieber was instrumental in convincing the boy's parents to enroll him in the children's class at the John Herron School of Art in October 1906.[51]

Hardrick attended Emmerich Manual Training High School, where he learned to draw in crayon under Otto Stark. He taught himself to work in oil and became adept in the medium. He also attended the Saturday morning sessions at Herron in 1908. While in high school, he entered his artwork in the Indiana State Fair and won several awards. At nineteen Hardrick competed at the State Fair for the fourth time. He contributed fifty-three oil paintings and charcoal and mechanical drawings, eight of which won awards, including several first prizes.[52]

In October 1910 Hardrick enrolled in regular sessions at Herron and on his first day started classes in drawing and painting under William Forsyth and Clifton Wheeler. He attended the school for eight years and received a scholarship for the year 1913–14.[53] To earn money, Hardrick worked at night at the Indianapolis Stove Foundry and sold newspapers, which had also helped him through high school. Money became an even greater concern after he married Georgia Anna Howard in 1914.

While still a student at Herron, Hardrick had his first major exhibition at Allen Chapel, the family church. The January 1914 exhibition consisted of forty-three oil paintings, eight watercolors, and six drawings in pastel, charcoal, and pencil, priced from $5 to $200.[54] In 1916 the artist painted portraits of Abraham Lincoln and Frederick Douglass for a celebration honoring the two leaders held under the auspices of the Indiana Association of Colored Men at Tomlinson Hall in Indianapolis. After the ceremony the paintings were sent to the Simpson Chapel, M.E. Church, where at a second event Joseph H. Douglass, grandson of Frederick Douglass, gave a violin recital. The portraits were then given to the city's black YMCA.[55] In a

John Wesley Hardrick. Reproduced from the collections of the Library of Congress.

letter to the Indiana Association of Colored Men, the secretary of the YMCA stated, "We appreciate this [the portraits] for the spirit in which they were given and also because they are the work of our own artist, Mr. John Hardrick and I am sure that these pictures will be a source of inspiration to the men and boys who come in and out of our building to the extent that their lives will be broadened in the field of usefulness."[56]

Hardrick received critical acclaim when he exhibited with William Edouard Scott at the *Tenth Annual Exhibition of Works by Indiana Artists* held at John Herron Art Institute from March 9 to April 8, 1917. In a newspaper review of the exhibit, special notice was given to Hardrick's entries: "John Hardrick has a portrait of the colored artist, Will E. Scott, that is a good likeness, but better still is his self portrait, which is an excellent likeness, good in perception of coloring and interesting in technique."[57] By 1924 Hardrick had a studio at 541 1/2 Indiana Avenue, where, as a local journalist noted, "beneath him the Gem laundry fumes and frets, but within the barred walls of the studio is Art-Life itself, caught in passing and transfixed on a gleaming canvas."[58] Hardrick and Indianapolis artist Hale

Woodruff shared this studio for several years prior to Woodruff's trip to Paris in 1927. That year, before Woodruff began his journey, Hardrick executed a work showing himself at his easel painting a portrait of his friend and colleague.

Hardrick's financial situation had deteriorated to such an extent that in 1925, to support his wife and three daughters, he began concentrating less on his art and joined the family trucking company. He also established his own carpet cleaning business. In 1927 a review of an exhibition at the Pettis Gallery, located in the Pettis Dry Goods Co. in the downtown Indianapolis New York Store, noted that turning to labor "gave [Hardrick] time in which to grow and develop unconsciously."[59]

Despite the demands of business, Hardrick continued to have success as an artist. In November 1927 he and Woodruff displayed their work at the Art Institute of Chicago along with such important African-American artists as Henry O. Tanner, William Harper, and the sculptors Meta Warwick Fuller and Edmonia Lewis.[60] That year Hardrick was also under consideration for a William E. Harmon Award for distinguished achievement in the field of fine arts. A letter from the Harmon Foundation requesting information on the artist was sent to two prominent Indianapolis residents, Evans Woollen and Faburn E. De Frantz. In response to the question about why Hardrick should receive the award, Woollen wrote that the artist "has shown courage and perseverance in the face of serious discouragements." De Frantz gave a similar reply: "His long fight to do work worthwhile, which I believe he is doing now, should be rewarded."[61]

Hardrick was awarded the second-place bronze medal. His prize included an honorarium of $100, which was presented to the artist by Indianapolis mayor L. Ert Slack during a ceremony honoring the achievements made

by African Americans that was part of the sixth annual observance of Inter-racial Sunday.[62] To acknowledge Hardrick's accomplishments, a number of black churches, clubs, lodges, sororities, and fraternities in Indianapolis decided to raise money for the Hardrick Picture Fund.[63] A newspaper reviewer commented, "Because of what he has done for racial advancement, all classes of our people are his debtors, and the response which they make to this fund will show just how deeply they feel the obligation."[64] The funds raised by these organizations were used to purchase *Little Brown Girl* (fig. 31), one of the five paintings for which Hardrick received the Harmon Award and one of his most widely exhibited works. An article in the *Indianapolis Recorder* describes the work:

It will be sufficient to say that "The Little Brown Girl" is a superb expression of thousands of pretty little colored girls, who, through the proper care and training will in the future be a pride of American womanhood.... Why have the colored people of Indianapolis chosen to select the "Little Brown Girl" as a permanent painting for the John Herron Art Institute? This picture radiates a moral beauty that should be preserved eternally.[65]

In a March 25, 1929, ceremony the painting was officially accepted by the board of directors of the Art Association of Indianapolis, sponsor and founder of the John Herron Art Institute.[66]

Although Hardrick was best known for his portraits and landscapes, he also painted other subjects. In 1928 he was creating a painting for the new Allen Chapel of the A. M. E. Church in Indianapolis, but the canvas was stolen from his studio before it could be installed. He repainted the work in the church, making it large enough to discourage any other potential thieves. The finished mural, *Christ and the Samaritan Woman at the Well*, was framed and attached to the wall at the balcony level so it could not be easily removed.[67] It took the artist between thirty and forty hours to complete. After working all day in the family trucking business, Hardrick spent five to eight hours a night on the mural. No models or preliminary sketches were used in the composition; instead, the artist relied on his imagination to paint the figures.[68]

In 1929 Indianapolis-born artist William E. Scott was asked by the Inter-racial Committee of San Diego to assist in selecting artists for the *Second Annual Exhibition of Contemporary Negro Art*, whose purpose was "to create wider interest in the work of the Negro artist as a contribution to American culture; to stimulate him to aim for the highest standards of achievement."[69] Hardrick was invited to participate and exhibited *Jean*, *A Landscape*, *Jesus of Nazareth*, and *Self Portrait*. Among the other twenty-one artists were Scott, Woodruff, and Tanner.

Hardrick had developed a formidable reputation as an artist. The high regard in which he was held is obvious in this response to a 1930 Harmon Foundation questionnaire:

In spite of his acute poverty this young man has the faculty of discerning beauty in everything, being able to face all of his adversity with a smile that conceals the feeling within, at the same time he possesses a personality which strangely draws people to him.

This young man and his wife find great joy in exhibiting his paintings and the purchasers of these paintings are made to feel their great appreciation. However, his pride is touched when purchasers impress upon him the fact that they are only making the purchase to help him along, his joy comes in the knowledge that the painting is purchased because of its value.[70]

Despite the problems that the Depression created, Hardrick continued to paint and exhibit. The Hoosier Salon, held in the Marshall Field Art Gallery of Chicago, was one of a number of exhibitions outside Indianapolis in which Hardrick exhibited. An art critic from Paris who viewed the 1929 Salon "was fascinated by the uniqueness and individuality shown by the drawings exhibited there by Mr. Hardrick."[71] Hardrick also participated in the 1931 and 1934 Hoosier Salons. When Hallie Beacham, who had worked as a librarian at the Indianapolis Public Library, relocated to Atlanta, she arranged to have an exhibit of works by Hardrick and Woodruff in May 1931 at the Atlanta University Laboratory School. The exhibit was well

received, with six hundred people attending the opening. Four of Hardrick's small landscapes were sold at the exhibition.[72]

Hardrick's difficult financial state became very clear in July 1932, when the Harmon Foundation sent one of his paintings back to him via Railway Express. Hardrick wrote to Evelyn Brown at the Foundation explaining that he was unable to pay the express cost of $4.47 for the painting.[73] An April 1933 communication from Brown expressed surprise that the painting, *Lady X*, had not been retrieved by Hardrick after nine months. Since few people at this time were buying art and the storage charges by the express company had risen to $13.47, Brown asked Hardrick about his financial condition. The Harmon Foundation offered to pay the fee and retain the painting in New York until the artist was able to reimburse them. This would keep the express company from selling the work to retrieve their charges.[74] There is no record of Hardrick's response to this inquiry, and the painting has not been located.

Under the Civil Works Administration (CWA) established in 1933, the Public Works of Art Project (PWAP) was authorized. Artists interested in being hired for the PWAP came to the Herron Art Institute on the morning of December 18, 1933, to sign applications. Hardrick was first in line and became one of four artists selected for the project planning committee. Some proposed projects were panels for school corridors, auditoriums, and classrooms.[75] It was during the 1933–34 PWAP period that Hardrick was hired to paint murals for the spaces on each side of the Crispus Attucks High School auditorium. The subject of the murals was laborers in a foundry. Hardrick's daughter Rowena recalled: "He did a forge, all of this fire, you know, you could almost see the fire and these blacks standing and working and these muscles, marvelous muscles seem to be rippling and sweat pouring off. The principal didn't approve of that kind of painting. He wanted doctors and lawyers and professions like that. So they [the murals] disappeared down into the basement and were never found."[76]

A major activity for blacks under the Federal Arts Project (FAP) took place in Chicago with the July 4, 1940,

opening of the *American Negro Exposition: Celebrating 75 Years of Negro Achievement*. Part of the exposition included an exhibition, *The Art Of The American Negro (1851 to 1940)*, which included works by Scott and Woodruff as well as one of Hardrick's portraits. Committee chairman Alain Locke called the exhibit "the most comprehensive and representative collection of the Negro's art that has ever been presented to public view."[77]

During this period Hardrick's health prevented him from working in the family hauling business, and he turned to taxi driving.[78] This profession offered him the opportunity to sell his paintings, which he carried in the trunk of his car, as well as to find subjects for his compositions. Sometimes, while driving down the street, Hardrick saw someone he wanted to paint. He then stopped his car, got out and introduced himself, and asked permission to paint the man or woman. If the person agreed, the artist would take him or her to his studio and complete the portrait in a few hours.

After his wife Georgia's death in January 1941, Hardrick moved with his three children—Raphael, Georgia, and Rachel—to his parents' house on Prospect Street. He set up a studio in their attic but left in 1943 after his daughters married. In 1946 Hardrick accepted an offer from his friends Rufus and Emily Wharton to set up a studio and residence in their basement. He continued to paint until later in life, when he developed Parkinson's disease and was unable to work.

When he died on October 18, 1968, he had become nationally recognized for his artistic endeavors, even though he remained in Indianapolis. A prolific portrait painter and landscape artist, Hardrick left a legacy displaying the strength of a determined man and the creations of a gifted artist.

Hale Aspacio Woodruff, 1900–1980

The public is anxious to see a black image," asserted Hale Woodruff. "But whenever you label an artist or categorize what he is doing, you are in trouble. The totality of a culture makes an art form. You must be careful not to say, 'This is black art and this is unique.'"[79] Woodruff was opposed to recognizing the black artist solely because of his color. He felt talent and quality should be the most important criteria in judging an artist and his work. A teacher as well as an artist, Woodruff tried to train his students to recognize "the essential art quality that must be most important."[80]

Born in Cairo, Illinois, in 1900, Woodruff was raised in Nashville, Tennessee, by his widowed mother.[81] At age twelve he helped his mother financially by working at a downtown café, where he earned three dollars a week. It was here that Woodruff's artistic talents were displayed, in hand-drawn menus that were prominently exhibited in the restaurant's window. He also drew cartoons for his high school newspaper, *The Pearl Voice*. Through the school library's copies of *The Crisis*, the magazine of the NAACP, Woodruff learned about Henry O. Tanner, whose success was an encouragement for the young artist. After graduating from high school in summer 1918, Woodruff left Nashville with his friend George Gore to visit the latter's father, a minister in Franklin, Indiana. In search of work, the two traveled to Indianapolis, where they saw a student art show at the John Herron Art Institute. This event was the catalyst for Woodruff's determination to enter the art school.[82]

Woodruff worked for two years to save money to attend the Herron School of Art. He and Gore were houseboys at the Claypool Hotel in Indianapolis, where they scrubbed carpets. The two friends also took jobs shoveling coal and ashes at the Indianapolis Athletic Club, washing dishes at the Stegemeier Restaurant, and mopping floors at the Senate Avenue YMCA, where they lived.

On the strength of the cartoons he drew for his high school newspaper, Woodruff obtained a job as editorial cartoonist on the *Indianapolis Freeman*. This black newspaper was founded in 1888 and remained in operation until 1926. It was one of the few illustrated African-American journals in the United States.[83] Woodruff was paid five dollars for each published cartoon. His cartoons focused on racial issues, such as the slow pace of the government in implementing civil rights legislation, the government's role in eliminating segregation, and how prejudice was holding back progress on racial issues.

Woodruff entered day classes at Herron on October 4, 1920. His principal teacher was William Forsyth, one of Indiana's leading impressionist artists.[84] Indiana artists such as Forsyth and Otto Stark were the primary teachers training black art students in Indianapolis at this time. Among their students was William E. Scott, the first "real live Negro artist" with whom Woodruff had contact. As he recalled: "At that time [Scott] had just come back from Europe and frequently talked about his having met and worked with H. O. Tanner. This was a great thrill for me. Scott and I used to talk a lot about painting…people like Scott and Tanner thrilled me a great deal."[85]

An inability to pay his tuition forced Woodruff to discontinue his studies at Herron in 1924. He applied for a summer course in an eastern art school but was not accepted. Woodruff felt he had been rejected because of his color and remembered that "this was pretty hard for a young fellow and I felt like giving up."[86] Although he was discouraged, Woodruff explained why he decided to continue pursuing an art career: "Many of my people are earnestly working to make what some call 'the new Negro race.' It is like laying the foundation for a great building. Workers are carrying stones we may call music, art, science, literature, etc. I, too, want to add something. All of us together will help the colored man. We will help America."[87]

He persevered despite a full work schedule, as Woodruff was membership secretary at the Senate Avenue YMCA in Indianapolis from 1923 to 1927. In fall 1925, for example, he entered seven works in the Spingarn contest in literature and art held in New York and sponsored by *The Crisis* magazine. He was awarded third prize.[88]

On January 4, 1926, Woodruff and Elsie L. Mitchell were married in Greenfield, Indiana.[89] Just eight months later, on September 9, the marriage was cut short by

Elsie's untimely death from tuberculosis.[90]

Woodruff had not given up his desire to study abroad, but financial difficulties compounded by his wife's illness and death made it impossible for him to make the trip.[91] A chance to supplement his income came in 1926 when the Harmon Foundation initiated an award in fine arts for minority individuals. Faburn E. De Frantz, secretary of the Senate Avenue YMCA; William Forsyth, art instructor at Herron; and Miss Edna Mann Shover, principal of John Herron School of Art, recommended Woodruff for the competition. He won second prize for a group of five paintings, including three landscapes, a portrait of two women, and a landscape with figure.[92]

Indiana governor Ed Jackson presented the second-place bronze medal to Woodruff during a ceremony at the Senate Avenue YMCA in early 1927. In his speech the governor noted, "Hale Woodruff has competed with other worthy artists, and his success is especially pleasing when we realize that he is only a few years removed from the period when his grandparents labored under the greatest handicap a people can have."[93]

In a letter sent to George E. Evans of the Harmon Foundation, Woodruff expressed appreciation and gratitude for his award, "As a recipient of an award, already one can see the influence it has on the members of the younger group and a number of them are taking a renewed interest in their educational welfare and feel inspired to bigger and better things."[94]

The Harmon Foundation award had given Woodruff a boost, but he was anxious to obtain enough money to study in France. Help came from the Florentine Club of Lebanon, Indiana, a women's group, at their February 1927 meeting. The program for the month was "The Negro in Music, Art and Literature." Woodruff was invited to be a special guest because he had won the Harmon prize. He brought four of his paintings to the meeting. In his discussion of the progress made by the modern Negro artist, Woodruff told of his own dream of pursuing his study abroad and his goal to eventually portray the life of his people. To help the artist achieve his goals, the club presented Woodruff with $200.[95]

Hale Woodruff. Reproduced from the collections of the Amistad Research Center, New Orleans.

With new-found enthusiasm, Woodruff entered the 1927 Hoosier Salon in Chicago, which accepted three of his paintings, including one of his wife prior to their marriage.[96] This second Hoosier Salon held in Chicago contained 387 works by 168 artists.

When Woodruff left Indianapolis for Europe via New York in 1927, his finances had been bolstered by sales of his prize-winning Harmon paintings through an exhibit at Lieber's Art Emporium in Indianapolis. Herman Lieber, the owner of the art store and gallery, promised to sell at least one painting a month to sustain the artist. Walter White, then assistant executive secretary of the National Association for the Advancement of Colored People, solicited Otto H. Kahn, a banker and patron of the arts, to contribute funds to help Woodruff. Kahn supported the artist by giving him a small sum for each of two years.[97] While Woodruff was waiting in New York for his ship to sail, a local newspaper journalist asked him to speak about his work. Since he felt himself to be chiefly an imaginative painter, the artist classified himself as an "ultra impressionist." Woodruff explained that he did not paint

images with photographic accuracy and often blended figure and landscape together with an emphasis on design rather than realistic representation.[98]

Woodruff set sail for Europe on September 3, 1927. He planned to stay for two years and spend time in Paris, Italy, and Spain working independently while studying the different schools of art. He also hoped to contact Henry Tanner.[99] Soon after his arrival, Woodruff sent a postcard to his mother in Los Angeles: "Arrived Sat. Sept. 10 noon. Good trip. Pretty city. Have met artist friend from U.S.A. Will send letter soon. Hope all is well with you. All I worry about is that I can't talk the language. Write me at 26 Rue Rousselet. Love-Hale."[100]

In a letter to his mother dated October 11, 1927, Woodruff said he was beginning to feel like a Frenchman but still had trouble making himself understood, although reading the language was easier. He wrote:

The rain is taking a rest and the weather has turned cold. The landlady told me that there would be an extra charge for heat. Nov. first. That took me off my feet. Not the extra charge but that I've got to freeze until Nov. 1st. Too bad, I say. There isn't much for me to do now as I am not situated so I can paint. I may get a studio in 2 or 3 months. Its [sic] too cold for outside painting now.[101]

He noted the living expenses were about the same as in the States but the art supplies were less expensive.

Soon after he arrived in Paris, Woodruff visited the Académie Julian, where Tanner had studied. He found the teachers sometimes never met their students and the school's reputation had declined. Woodruff chose to attend two smaller schools that were attracting artists from the modern movements, the Académie Scandinave and the Académie Moderne.[102]

During Woodruff's European sojourn *The Indianapolis Star* paid him ten dollars for articles discussing his views of modern Paris, which appeared in their Sunday edition from January 6, 1928, to February 17, 1929, often accompanied by an illustration. In an article published March 18, 1928, Woodruff expressed his feelings about the many forms of modernism thriving in the French capital: "Although most of the modernists fail to impress me, I would not be justified in condemning any of them. I feel it is every artist's privilege to create whatever he desires in the manner that pleases him most."[103]

In an October 26, 1928, letter to Mary Beattie Brady, director of the Harmon Foundation, Woodruff requested a loan of $200 from the foundation. He said, "As you may know, my support while studying in France was to have come from the sale of paintings in America. This has proved to be quite unsuccessful for during my first year here, even, so little did I receive from sales that I had to continue under the most unfavorable conditions. Not only was I often unable to work but at times my health was placed in jeopardy."[104] A reply from the foundation dated November 22, 1928, indicated they did not have a policy for loaning money and were trying to find a fund to which he might apply. At this time, the only advice they could give the artist was to make plans to return home.[105]

Woodruff managed to stay in France by taking various jobs. In late winter he traveled to Etaples, a small town in Normandy, to meet with Tanner. Luckily for Woodruff, who had been unable to contact the master, he found the sixty-eight-year-old Tanner at home. Woodruff's art folio, which he brought with him, was comprised mostly of landscapes, with only four figural works. The young artist explained that he preferred landscapes because of the "openness and expansiveness they suggest." Tanner scrutinized the pieces and emphasized the importance of the human form. He advised Woodruff to bring his figures to completion on the level of his landscapes. Tanner asked Woodruff what impressed him at the Paris museums, and who was his "real artist-god." Woodruff responded by expressing his admiration for Monet's lily ponds and his enthusiasm for Cézanne.[106] The artist's devotion to Cézanne is reflected in his most important European painting, *Card Players* (fig. 41), originally painted in 1929.

In March 1929 Faburn De Frantz announced at a meeting of art patrons and philanthropists in Indianapolis that Mrs. John D. Rockefeller had bought one of Woodruff's watercolors for her private art collection and was considering the purchase of other examples of work by the young Indianapolis artist. The painting, a watercolor of a Paris scene, was purchased at the Downtown Gallery in New York City, where Woodruff had other paintings for sale.[107]

Woodruff entered his work in the 1929 Harmon Awards exhibition, but because of a problem with the French transportation system, his paintings did not arrive at the foundation office by the December 1 deadline and were not evaluated for the top awards. They were, however, placed in the exhibition and received an honorable mention. By the time the exhibit ended two of Woodruff's paintings had sold.[108] Two more of Woodruff's paintings sold for $135 in February 1929 at the *Fine Art Productions by Negroes* exhibition in New York. Mary Brady sent Woodruff the full amount without taking a commission fee, because the Harmon Foundation understood his need of funds.[109]

Woodruff had been sharing a small house with three friends in Malakoff-sur-Seine, a suburb of Paris. When his friends left, the artist was unable to pay the rent. With the money he received from the sales of his paintings, Woodruff paid his bills and left Paris for Cagnes-sur-Mer in the south of France. He chose this area because it had been the home of three artists he admired: Chaim Soutine, Auguste Renoir, and William H. Johnson, an African-American artist who had recently worked in the region. Woodruff felt it was time to leave Paris and explore another part of France, one that he hoped would be less expensive. During his stay in Cagnes-sur-Mer Woodruff painted frescoes in a restaurant near his home.[110]

In March 1931 Woodruff had a one-man exhibition at the Galerie de la Muette in Paris.[111] The exhibition was not a monetary success, as indicated by his letter of May 5, 1931, to Mary Brady asking the Harmon Foundation to suggest potential lenders who might advance him $400 for the return trip to the United States.[112]

That summer John Hope, president of Atlanta University, offered Woodruff, whom he had met in Indianapolis and again in France, a position as an art instructor. The artist accepted Hope's offer and returned to Indianapolis in early September. Shortly after his arrival, a reception was held for Woodruff at the Phyllis Wheatley YWCA. The following week, Woodruff gave a talk on art in the sculpture court of the Herron Art Institute, which coincided with the Harmon awards exhibition.[113]

That fall Woodruff began teaching in the Atlanta University system, which consisted of Atlanta University, Spelman and Morehouse colleges, and the elementary and high school laboratory classes. At first he primarily taught at the laboratory school, as neither Atlanta University nor Morehouse had an art department. When enough students from the school system became interested in Woodruff's studio classes, he began holding them in the Spelman art department and eventually taught the majority of his classes there.

When time permitted Woodruff taught art history once a week at Talladega College in Alabama.[114] He had not planned to teach when he was a student at Herron and had avoided education courses. Woodruff took the position in Atlanta mainly because jobs were hard to find during the Depression and he needed to support himself.[115] After he began teaching at Spelman, and possibly because he had no art education training, Woodruff took every opportunity to broaden his art knowledge.

In summer 1933, with a grant from the American Institute of Architects, Woodruff attended classes at the Fogg Art Museum of Harvard University to study eighteenth- and nineteenth-century French painting from a historical point of view. The course consisted of a series of lectures and tours to neighboring galleries and museums, but no actual painting classes or creative activities were conducted.[116]

On June 14, 1934, Woodruff married Theresa Baker in her hometown of Topeka, Kansas.[117] He had been introduced to her in 1927 by De Frantz and corresponded with her while he was in Europe. After their marriage, she became a teacher at the Atlanta University Laboratory School.

Woodruff's first entry into an important art arena in New York City took place in February 1935, when his work appeared in a major exhibition, *An Art Commentary on Lynching*, at the Arthur U. Newton Galleries. The exhibition, protesting the persistence of lynching in the United States, made an important statement about the treatment of blacks in America. It contained the work of thirty-seven artists, including Thomas Hart Benton, Reginald Marsh, and Paul Cadmus. Woodruff entered two woodcuts, *Giddap* (fig. 45) and *By Parties Unknown* (fig. 46).

Hale Woodruff. Courtesy of Corrine Jennings, Kenkeleba House, New York.

In December Woodruff presented a major exhibition of his work at the Atlanta University library, including twenty-five oil paintings and ten watercolors. An article in the *Atlanta Constitution* hailed the artist as a modern master and compared his use of colors to that of Vincent van Gogh.[118] Woodruff received a General Education Board Scholarship in 1936 to study in Mexico. There he worked as an assistant for Diego Rivera. About his decision to go to Mexico, he said: "[It] was really inspired by my desire to get into the mural swing. I wanted to paint great significant murals in fresco and I went down there to work with Rivera to learn his technique."[119]

The Texas Centennial held in Dallas from June to November 1936 included an art exhibit, *Exhibition of Fine Art Productions by American Negroes*, in the Hall of Negro Life. Woodruff exhibited fourteen pieces, four oils and ten woodblock prints. Among the other participants were Scott, Laura Wheeler Waring, Palmer Hayden, James Porter, Lois Mailou Jones, Archibald Motley, and Richmond Barthe.[120]

In 1938 Woodruff's *Little Boy* was chosen for display at the 1939 New York World's Fair. Only six Georgia artists, who entered the preview exhibition of contemporary American art held in Richmond, Virginia, were selected to represent the state at the fair.[121] This achievement helped bring Woodruff international recognition.

Although he lived and worked in Atlanta, Woodruff continuously sent work to the Indiana State Fair. In 1935, 1937, and 1939 his paintings won numerous awards.[122] His 1939 first-prize entry was *Old Mining Town*, completed during the summer of 1939 at Idaho Springs in the mountains of Colorado.[123]

By 1939 the government's support of mural art had given African-American artists an opportunity to bring the history and culture of blacks in America to public attention. After his training under Diego Rivera, Woodruff was prepared to make his contribution. On April 15, 1939, during the formal dedication of the William Savery Library at Talladega College in Alabama, one of Woodruff's most important projects, *The Amistad Murals*, was unveiled. The murals comprised three panels measuring 6 1/2 by 80 feet and had been completed in the artist's Spelman studio in Atlanta. They represent the story of the 1839 mutiny on the slave ship *Amistad*, the subsequent trial of the black mutineers in New Haven, Connecticut, and the return of the ship's slaves to Africa.[124] In 1940 Woodruff produced a set of murals of similar size documenting the history of Talladega College from its founding in 1867 through its rise to importance as a black school in the South.[125]

One of Woodruff's major accomplishments was convincing John Hope that Atlanta University should be the birthplace of the first national exhibition by black artists. Woodruff was primarily interested in giving these artists a place to exhibit, but he also wanted to open cultural avenues previously closed to African Americans and offer the black artist a means to earn money.[126] The *Atlanta University Bulletin* of July 1942 described the beginning of what would become an annual event. The works of sixty-two artists were on view at the first exhibition, held at the Atlanta University library from April 19 to May 10, 1942.

One hundred seven oil paintings and watercolors were shown, and cash awards totaled $500. All the winning entries became part of the permanent collection of Atlanta University, inaugurating a collection that would become one of the major holdings of black art in the United States.[127]

In 1943 Woodruff received a two-year Julius Rosenwald Fellowship to paint in New York. He and his wife moved there and lived in a mid-Manhattan studio from 1943 to fall 1945.[128] Shortly after their return to Atlanta University, Woodruff was offered a position as a faculty member in art education at New York University, which he accepted. His salary was partially paid through special grants, education funds, and a grant from the Julius Rosenwald Fund which, as a policy, supplied white college presidents with lists of available black scholars.[129]

Over the years Woodruff had spent most of his summers visiting his mother at her home in Los Angeles. In the late 1940s Woodruff was approached in New York by George Beavers, chairman of the board of the Golden State Mutual Life Insurance Company of Los Angeles, whom he had met while visiting his mother. Golden State was planning a new building, designed by the black Los Angeles architect Paul Williams, and Beavers wanted Woodruff to paint a mural to celebrate the California centennial. Woodruff accepted the commission but asked that Charles Alston join him in the project. Woodruff and Alston had become close friends when the latter occupied a studio in an old library building at Atlanta University. Alston was a New York painter, sculptor, and teacher who went to Atlanta to paint rural and urban life in the South.[130] The mural commission offered the two painters an opportunity to study California history and to research the role of blacks in the settlement and development of the state. They traveled over three thousand miles in less than three months and visited more than twenty major missions from San Diego to San Francisco. The murals trace the little-known story of the black man's contribution to California history over a span of four centuries. The two finished panels each measure 9 1/2 by 16 feet and were unveiled in August 1949.[131]

A year after finishing the California mural, Woodruff received a long-awaited commission from Atlanta University. He had always wanted to paint something that would be a source of pride for Atlanta's black community. In 1951 he realized his desire with the completion of six murals, *The Art of the Negro* (figs. 84–89), which were installed in the university's Trevor Arnett Library. The panels depict the ancient and modern art worlds and their relationship to black artists.[132]

To recognize his accomplishments as an artist and a teacher, New York University promoted Woodruff to professor of education in 1957.[133] In 1966 the university's Alumni Association chose him as Great Teacher,[134] and the university honored him again in May 1967 with his first retrospective exhibition, which included twenty-five paintings, fourteen drawings, and two woodcuts covering the artist's work from 1927 to 1967.[135]

The civil rights march on Washington in 1963 prompted Woodruff, Romare Bearden, Charles Alston, and Norman Lewis to found Spiral to explore their common cultural experiences as black artists. Woodruff, who proposed the name Spiral to suggest the group's continuous reaching out into broader circles, wanted to accept white artists into the group.[136] Although everyone initially agreed, members decided they should first resolve questions about their own purpose and identity. This association of sixteen artists held meetings to try to determine the path black art or black artists should take to relate to their people and the civil rights movement.[137] Although no definitive agreements were reached, it was an important organized attempt by black artists to address the issues facing their community.[138]

In 1965 the Department of State's Bureau of Education and Cultural Affairs asked Woodruff to be a member of the United States delegation to the First World's Festival of Negro Art in Dakar, Senegal, April 1–24, 1966. An editorial in *African Forum* hailed the festival: "The Dakar Festival will demonstrate to the world the Negro's contribution to world culture, not only in Africa but also wherever he has gone.... It is therefore fitting that Brazil, the United States, Haiti, Jamaica and Trinidad-Tobago are represented in the festivities."[139] The Department of State also invited the artist to spend a month visiting Nigeria, Ghana, Sierra Leone, and Liberia.[140]

Woodruff, who retired from New York University in 1968 and was named Professor Emeritus, received many honors during his long career as an artist and a teacher. Yet despite the accolades, he knew how difficult an art career could be for a black artist. In a July 1969 lecture at the Detroit Institute of Arts, Woodruff responded to a question about the ability of black artists to make a living. He noted that top collectors are investors and, at that time, nobody was investing in black art.[141] Compounding this problem was the public's tendency to have predetermined ideas of what African-American artists should create.[142] He indicated he would not have been able to live on the sale of his art alone.

In 1977 the Indianapolis Museum of Art held an exhibition of three major black artists who studied in Indianapolis: Woodruff, Scott, and Hardrick. This was Woodruff's first Indianapolis showing since 1933. Interviewed at the time of the show, he seemed dismayed that the museum in the city where he received his start had none of his works in its collection.[143] At the request of the museum, he sent eight slides of his paintings for purchase consideration, and in response the museum purchased one of the artist's paintings for its permanent collection.[144] Woodruff stated in a letter to the museum that besides feeling honored to be included in the collection, he knew that his "painting will hold its own among the other work there and...the painting itself will stand as ample testimony to the fine teaching I received at the John Herron Art School 50 odd years ago."[145] On May 10, 1978, an honorary Doctor of Fine Arts degree was bestowed upon Woodruff at the commencement exercises at Indiana University-Purdue University, Indianapolis.[146]

Woodruff was in ill health when New York art collectors John and Vivian Hewitt approached him in November 1977 about a private showing of his work. The artist had cancer, and his deteriorating condition left him with little energy. Woodruff had slowed his production of art and felt he did not have enough paintings on hand for a representative exhibit. Encouraged by the Hewitts that even twelve works would be sufficient, the artist once again began to work in earnest. When the exhibit opened at the Hewitts's New York residence on May 21, 1978, Woodruff had twenty-seven paintings, including his third version of *The Card Players*. Only black professionals and collectors were invited to this Sunday afternoon exhibit, at which twenty of the paintings were sold. Many of the new owners were so captivated by the works that they took their paintings with them rather than waiting to have them delivered the following week. Woodruff observed that it was the first time he was able to "ask five figures for my paintings and get it."[147]

In spring 1979 the Studio Museum, in Harlem, honored Woodruff with a retrospective covering fifty years of his art. Asked about his artistic development by a reviewer, Woodruff said:

My style has varied over the years. I think abstractly because I think that abstraction is another kind of reality. And although you may see a realistic subject..., you have to transpose or transform that into a picture, and my whole feeling is that to get the spectator involved it has to extend his vision...and his way of seeing, so that there is a wider experience open up to him.[148]

This was Woodruff's last major exhibition during his lifetime. He died on September 6, 1980, in New York Hospital-Cornell Center and was buried on September 10 in Mt. Hope Cemetery in Topeka, Kansas, the home of his wife.[149]

Woodruff felt that no matter how an artist's work changed over the years, there was always a common thread running through all of it, something that tied the works together.[150] For Woodruff that common thread was a concern for his people. He expressed strong feelings regarding the purpose of art and its relationship to humanity:

Artistic structure makes tangible the intangibility of the spirit of the man, the artist—For the artist is, or should be, one of the spirit.

—And if that spirit of the artist is concerned with man—Then so much greater the significance of his work.

It is through the Arts—All arts—that the spirit of man is best realized—transmitted to others.[151]

■

William Majors, 1930–1982

William Majors was born in Indianapolis on July 21, 1930. His father, William Majors, Sr., died in 1931, leaving his wife Fannie to raise her son and daughter, Patricia, who was born shortly after his death.[152] The family, which was very close, continued living in Indianapolis. In the late 1930s and during the war, they resided in the newly constructed Lockefield housing project. Majors dropped out of school in 1944 when he was only thirteen and worked at odd jobs. In 1946 he was diagnosed with spinal tuberculosis and became a patient at Marion County's Sunnyside Sanitarium.[153]

At Sunnyside, where he underwent a succession of operations and treatments, Majors met Helen Mowrey, an art teacher and member of the hospital's social services staff. Mrs. Mowrey recognized the young man's artistic potential and gave him instruction and art supplies. She also urged Majors to continue his education. While he was a patient, he earned his high school diploma from Indianapolis's Crispus Attucks High School. During this time he also received his first artistic assignments from the medical staff at the sanitarium, who engaged him to do anatomy and pathology drawings.[154] After almost seven years at Sunnyside, Majors was able to leave the institution at the age of twenty-three. With the assistance of Mowrey he obtained a scholarship to John Herron School of Art, where he enrolled in fall 1953.[155]

During the 1953–54 semester Majors's instructors included Edmund Brucker, life drawing; Garo Antreasian, fundamentals of design; Joe Messing, perspective; and Gardner Fiscus, commercial art.[156] His first recognition for outstanding work came in 1954 when he won the Katharine Ayres Smitheram Memorial Award for general excellence.[157]

In 1955 Majors married Janet Burt, and the following year their son Joseph was born. He continued to study at Herron, pursuing personal ideas and feelings through his art. Although Majors was not formally religious, his work was spiritually inspired. His mother had raised her children in the Shiloh Baptist Church, located at West and Walnut streets in Indianapolis. Later, during treatment at Sunnyside Sanitarium, Majors converted to Roman Catholicism. He subsequently withdrew from worship in the church and maintained that position throughout most of his adult life. Nevertheless, Majors credited his early religious experiences as primary sources of inspiration for the Old Testament themes he would later use in his art. This spirituality first appeared in paintings and drawings created at Herron and evolved ten years later into one of his most significant artistic statements, *Etchings from Ecclesiastes* (figs. 66–68).

Majors perceived he was working in a prejudicial atmosphere in Indianapolis. Although he was recognized with awards and respected in the Herron art community, he believed that less-qualified white students were receiving more support than their black colleagues. Compounding these feelings was Majors's awareness that the black community, in general, did not rally to support him, and, in many instances, even seemed to question what he was attempting to do with his art.[158] In addition, he was pulled in different directions by family responsibilities and his personal creative aspirations. His supporters counseled him that to find an environment where he could pursue his art, it might be necessary to leave Indianapolis.[159]

In an attempt to broaden his contacts and to expand his learning experience, Majors attended the Cleveland School of Art from 1956 to 1958; his main concentration was in painting. While attending the school he worked at various jobs, including welding shocks at the Gabriel factory. He also participated in many of the activities offered by Karamu House, a multicultural arts center where he interacted with other African-American artists, writers, and musicians.[160]

In fall 1958 Majors returned to his family and continued his studies at Herron. In 1959 and 1960 he taught children's classes at Herron and was a substitute teacher in the Indianapolis public school system.[161] In Spring 1959 his drawing *The Prophet* won the George W. Roper Tidewater Purchase Prize in the *17th Annual American Draw-*

ing Exhibition at Norfolk, Virginia. The drawing was also chosen for reproduction on the cover of the catalogue.[162] When Majors received his Bachelor of Fine Arts degree from Herron in June 1960, he had already been notified that he was a recipient of the John Hay Whitney Foundation fellowship to continue independent studies in Florence, Italy.[163]

While in Italy Majors met the African-American artist Richard Mayhew, who was also studying in Florence on a Whitney fellowship. The two artists lived at the Pensione Bartolini on the Arno River. From his first meeting with Majors, Mayhew considered him an impressive, friendly individual, very proud, involved with his art, and secure in his goals. Majors at this time was trying to discover himself as an artist, his relationship with European art, and how that art might be involved and integrated with his ethnic background.[164]

Majors returned to Indianapolis in 1961 and attempted to continue his career. His second child, daughter Kelley, was born that year. After the cosmopolitan life of Europe, cultural activity in Indianapolis seemed sparse, to say the least. The respect Majors received in foreign cities was in direct contrast to the lack of recognition in his own community. This lack of support, coupled with his perception that racial prejudice within the community was keeping him from achieving his potential, made Majors realize that if he was to grow as an artist, it would not be in this city. His wife, Janet, also recognized his difficulty, and the two agreed to separate and were eventually divorced. In 1962 Majors left Indianapolis for New York.[165]

Upon arriving in New York and being unable to find a place to stay, Majors contacted Richard Mayhew, who had a studio on 22nd Street between Fifth and Sixth avenues. Mayhew offered to share his studio until Majors was able to find a residence of his own.[166] At this time Majors's artistic endeavors centered on painting and drawing figures, landscapes, and still lifes executed with an emphasis on line and abstract forms rather than on realistic representation. By 1963 Majors began to concentrate

William Majors. Dartmouth College, New Hampshire, Artist-in-Residence, 1977. Courtesy of Susan Stedman Majors.

more on etchings and collages and developed abstract forms derived from nature and the human figure. He painted steadily while also extensively creating drawings, etchings, and collages throughout the 1960s.[167]

Initially, Majors found work selling art supplies and designing patterns for a lace manufacturer. In 1963 he became a security guard for the Museum of Modern Art. When he had saved enough money, he rented a small flat at 200 Mott Street, which served as his residence and studio, and enrolled in one printmaking course taught by John Ross at the New School for Social Research.[168] His job at the museum offered Majors an opportunity to study the collections as well as meet many other New York artists. Between work shifts, while on night duty, Majors would work on the etching plates he had brought with him.[169] When he worked the day shift, he taught adults painting and printmaking at the museum's Institute of Modern Art. As soon as he arrived home after these classes, he would begin painting or working on his prints. At seven in the morning he stopped, slept for three or four hours, and returned then to work.[170]

In 1963 Mayhew introduced Majors to the Spiral group, which had just been formed. The members, includ-

ing Majors, met every Wednesday to discuss their work. After Spiral gave up its gallery and meeting place in 1965, many of the artists continued to get together at Majors's Seventh Avenue studio,[171] where they could meet as well as share advice and information. Majors freely helped anyone in attendance learn the techniques and materials of printmaking. Mayhew observed that when Majors was in Florence, his work involved a kind of mystical, lyrical illustration and interpretation. In New York, Mayhew noticed the artist's continued involvement with interpretation based on Eastern philosophies and other kinds of ideology.[172] It was during this period that Majors made many lasting friendships with fellow artists such as Jacob Lawrence, Norman Lewis, Mel Edwards, Romare Bearden, and Benny Andrews.

In 1964 Majors began a collaboration with Susan Stedman on a series of prints based on the Old Testament.[173] That same year a fire destroyed most of his work, but he resumed the series. The next summer, after a second fire in his flat, Majors moved to a loft building on Seventh Avenue.[174] The eighteen-etching portfolio *Etchings from Ecclesiastes*, commissioned and published by the Museum of Modern Art, was printed there on his new press in a limited edition of ninety.

In New York in 1965, as in numerous other American cities, few galleries or museums offered black artists an opportunity to exhibit their work.[175] In his introduction to the *Ecclesiastes* portfolio, Fritz Eichenberg, professor of art history and printmaking at Pratt Institute, observed:

Try to visualize a negro seeking peace and solace in a white man's church, being asked by an indignant fellow worshiper at the altar rail: "What are you doing here?" You either go mad— or you find yourself rewarded by some insight which gives you the strength to surmount your personal problems and to see them in the light of the greater contexts and verities. This William Majors has done with the help of Ecclesiastes, the royal preacher, who saw that all is vanity several thousand years ago.[176]

For *Etchings from Ecclesiastes*, Majors received the grand prize in graphic arts at the First World Festival of Negro Arts in Dakar, Senegal, in 1966.[177] He was the only visual artist to win an award. Majors did not attend the festival, nor did he accept the prize from Senegal's presi-

dent, Leopold Senghor, when he came to New York to present the award to the artist and those musicians, writers, and dancers who had been recognized at the festival.[178] Ten artists—Majors, Bearden, Alston, Lewis, Mayhew, Lawrence, Richard Reid, Charles White, Raymond Saunders, and Woodruff—had withdrawn their work from the exhibition to protest the United States Commission's management and funding cuts. The projected budget for the festival had been drastically curtailed, and the $7,500 originally set aside for awards and honorariums in the fine arts was withdrawn.[179]

In 1965 Majors joined the faculty at Orange County Community College in Middletown, New York, where he taught painting, drawing, design, and art history until 1969. During his last two years at Orange County, he served as chairman of the art department. Majors continued to live in New York, teaching concurrently at the New School for Social Research and an art center in New Jersey.

By 1968 Majors had become one of the few African-American artists to have work purchased by the Metropolitan Museum of Art and the Museum of Modern Art. That year his work was included in an exhibition by the Minneapolis Institute of Arts called *30 Contemporary Black Artists*. In a *New York Times* article published a few years later, Majors expressed his frustration about being included only in exhibitions of black artists: "No one is really interested in what the black artist paints about. We have something to say. We say it quite beautifully. but [*sic*] No one's interested in our esthetic. They're interested in our blackness."[180] Majors declined to participate in many comparable exhibitions during the 1960s and 1970s, but at the same time his work continued to be shown nationally as well as in Switzerland, Scandinavia, and Chile.[181] Majors also received several prestigious awards during this time, including the Louis Comfort Tiffany Award.

William Majors and Susan Stedman were married in 1969, when they moved to San Francisco so that he could begin teaching at California State University at Hayward that fall. Jacob Lawrence moved from New York to teach at Hayward at the same time, giving the two artists the chance to share a close association.[182] During this time

Majors's work was widely exhibited, and in 1970 it was included in the United States Pavilion exhibition at the 35th Venice Biennale.

Majors's teaching career spanned more than twenty-three years. During the 1970s he also taught at the California College of Arts and Crafts, University of New Hampshire, and the Rhode Island School of Design, and was an artist in residence at Dartmouth College. After returning to New York from California in 1971 Majors and his wife moved to Portsmouth, New Hampshire, where they bought a home and studio. A John Simon Guggenheim Foundation fellowship in graphic arts was awarded Majors in 1974, enabling him to purchase a new etching press and to travel with his wife in Italy, Denmark, and the Netherlands. His last faculty position was at the University of Connecticut, Storrs, where he taught graphic arts from 1979 until 1981, when illness forced him to resign.[183]

After several years of illness and frequent hospitalizations, Majors died in Portsmouth on August 29, 1982, at the age of 52.[184] Susan Stedman Majors said of her husband and his art: "Bill was not formally religious but he was a believer. He used Old Testament themes translated into abstract terms to relate them, he would state, to the sanctity of life in all its forms."[185] Majors's spirituality was crucial not only to his art, but also to his teaching and his life. He believed that true creativity comes from deep within a person, and understanding oneself is the key to an artist's development:

I believe in the universality of the Christian concept. This statement carries the teachings of parents, of blacks and whites, after whom I've tried to fashion my life. My teaching in the classroom is very simple. Below any foundation there exists a line where lies the true spirit of man. I attack and appeal below the surface and urge young and old alike to deal foremost with themselves in developing their concepts and perception, their own values and determinants.[186]

Notes

1. "Artist of Indian and Negro Extraction Attracts Attention with His Pictures," *The Indianapolis Star*, 17 November 1912, 8. This article states that Scott's paternal great-grandparents were of Native American heritage.

2. "Worked As Laborer to Get Education in Art," *The Indianapolis News,* 12 September 1903, 16.

3. Rena Tucker Kohlmann, "William Scott's Exhibition," *The Indianapolis News*, 2 May 1914, n.p.

4. Francis C. Holbrook, "William Edouard Scott, Painter," *The Southern Workman* 52 (February 1924): 2.

5. "Artist of Indian and Negro Extraction," 8.

6. Florence Webster Long, "Wall Decoration Used in School," *The Indianapolis Star*, 9 March 1913, 10.

7. "'Commerce,' Painting by Young Negro Artist, Who Leaves Chicago for Paris," *The Chicago Record-Herald*, 26 July 1909, n.p.

8. Lucille E. Morehouse, "New Interest Develops in Work of William Edouard Scott," *The Indianapolis Sunday Star*, 2 May 1943, 19.

9. Men of the Month," *The Crisis* (March 1913): 224.

10. *Henry O. Tanner, William A. Harper, William E. Scott: A Mentor and His Influence* (Washington, D.C.: Evans-Tibbs Collection, 18 January–30 March 1985), 6.

11. "Indianapolis Artist of Mixed Negro and Indian Blood Winning Success in Paris," *The Indianapolis News*, 9 December 1911, 2.

12. Marcia M. Matthews, *Henry Ossawa Tanner: American Artist* (Chicago: The University of Chicago Press, 1969), 58.

13. Lucille E. Morehouse, "Colored Artist Home from Study in France," *The Indianapolis News*, 16 April 1914, 14.

14. Lucille E. Morehouse, "Colored Artist Home from Study in Paris," *The Indianapolis Star*, 14 November 1912, 13.

15. Morehouse, *The Indianapolis, News* , 16 April 1914, 14.

16. Holbrook, 74. Scott was actually paid in francs not in dollars.

17. "Artist of Indian and Negro Extraction Attracts Attention With His Pictures," *The Indianapolis Star,* 17 November 1912, 8.

18. Morehouse, *The Indianapolis Star*, 14 November 1912, 13.

19. *Art Association of Indianapolis, Indiana, John Herron Art Institute Annual Report 1913* (Indianapolis: The Hollenbeck Press, 1913). Archives, Indiana University-Purdue University, Indianapolis.

20. Long, "Wall Decoration," 10.

21. "Mural Painting Dedicated," *The Indianapolis Star*, 8 February 1913, 7.

22. Long, "Wall Decoration," 10.

23. *Société Artistique de Picardie Le Touquet*, Paris-Plage, 1913.

24. Morehouse, *The Indianapolis News*, 16 April 1914, 14; and Holbrook, 74.

25. Holbrook, 74.

26. "State Fair Fine Art Awards Show High Standard of Indiana Exhibits," *The Indianapolis Star*, 12 September 1914, 3.

27. "Local Artist Sells Prize Pictures," *Indianapolis Recorder*, 19 September 1914, 2.

28. "Colored Artist to Study Negro," *The Indianapolis News*, 16 January 1915, 2.

29. "Decorates Burdsal City Hospital Wing," *The Indianapolis Star*, 31 October 1915, n.p.

30. Lloyd H. Wilkins, "Little Known Murals in City Among Finest Art Works in State," *The Indianapolis Sunday Star*, 7 January 1940, 1 (Part 5).

31. Peter J. Roberts, "William Edouard Scott: Some Aspects of his Life and Work," Master's Thesis, Emory University, 1985, 25–27.

32. Judith Vale Newton and Carol Weiss, *A Grand Tradition: The Art and Artists of the Hoosier Salon 1925–1990* (Indianapolis: Salon Patrons Association, 1993), 293.

33. Gary A. Reynolds and Beryl J. Wright, *Against the Odds: African-American Artists and the Harmon Foundation* (Newark: The Newark Museum, 1989), 27-29.

34. George E. Haynes, Letter to William Edouard Scott, 6 January 1928. Collections of the Manuscript Division, Library of Congress.

35. William Edouard Scott, Letter to Dr. George E. Haynes, 17 January 1928. Collections of the Manuscript Division, Library of Congress.

36. *Afro-American Painting and Prints from the Collection of Judge Irvin C. Mollison* (Atlanta: Waddell Gallery, Atlanta University, 1985), n.p.

37. Eleanor Ingalls Christensen, *The Art of Haiti* (Cranbury, NJ: A. S. Barnes and Co., Inc., 1975), 40, 66, 67, 72.

38. Interview with John Hewitt, December 1994.

39. Della Brown Hardman, "William Edouard Scott Remembered: Lessons from a Remarkable Life." Ph.D. dissertation, Kent State University, 1994.

40. Paul Healy, "Negro Exhibit Coming to Life in Oil, Colors," *Chicago Sunday Tribune*, 23 June 1940, n.p.

41. Recorder of Deeds List of Competitors, reproduced at the National Archives, Washington, D.C.

42. Morehouse, "New Interest," 19.

43. Edward B. Rowan, Letter to William Edouard Scott, 26 May 1943. National Archives, Washington, D.C.

44. William Edouard Scott, Letter to Edward B. Rowan, 1944. National Archives, Washington, D.C.

45. Interview with Mary Kathalyn Stuart Mance, February 1994.

46. *William Edouard Scott: An Artist of the Negro Renaissance* (Beloit, WI: Theodore Lyman Wright Art Center, Beloit College, 1970), n.p.

47. "Freetown Realities: Remembering the Hardricks," *The Freetown Villager* 2:3 (Summer 1986): 7.

48. Interview with Georgia Stewart, April 1982.

49. "Colored Boy's Work as Artist Astonishes," *The Indianapolis News*, 26 September 1908, 14.

50. Interview with Georgia Stewart , April 1982.

51. John Herron Art Institute Class Rosters, October 1906–May 1907 and October 1907–May 1908. Archives, Indiana University-Purdue University, Indianapolis.

52. "A Promising Young Artist," unknown Indianapolis newspaper, about 1912, n.p.

53. Transcript, Herron Archives, Indiana University-Purdue University, Indianapolis.

54. "John Hardrick's Art Exhibit," Allen Chapel, Indianapolis, January 9 and 10, 1914.

55. "Honors The Memory of Lincoln and Douglass," *The Indianapolis Ledger*, 25 February 1916, n.p.

56. Letter to N. D. Brascher, Executive Secretary, Indiana Association of Colored Men from (?) Taylor, Secretary of the Colored Men's Branch of the Indianapolis YMCA, 14 March 1916.

57. "Annual Display at John Herron Institute," unknown Indianapolis newspaper, March 1917, n.p.

58. "In the Circle's Shade: The Artist," unknown Indianapolis newspaper, 23 February 1924, n.p.

59. Lucille E. Morehouse, "In the World Of Art: Encouragement of Talent Among Negro Artists Urged," *The Indianapolis Star*, 31 July 1927, 5.

60. "Two Indianapolis Painters," unknown Indianapolis newspaper, 13 November 1927, n.p.

61. George E. Haynes, Letters to Evans Woolen [*sic*] and F. E. De Frantz, 23 August 1937. Library of Congress, Washington, D. C.

62. "Inter-racial Sunday Observance Planned," unknown Indianapolis newspaper, February 1928, n.p.

63. "Hale Woodruff Water Color Painting Bought by Mrs. John D. Rockefeller, Jr.," *The Indianapolis Star*, 26 March 1929, n.p.

64. Mrs. Ida Lewis, "Make Last Appeal for Picture Fund," *Indianapolis Recorder*, April 1929, n.p.

65. F. W. Donahue, "John Hardrick and His Art," *Indianapolis Recorder*, 13 April 1929, n.p.

66. "Painting is Accepted by Herron Directors," *The Indianapolis News*, 17 April 1929, 1.

67. Interview with Hardrick's daughters Rowena Tucker, Georgia Rhea, Ruth Reed, and Rachel Buckner, 20 August 1991.

68. Lucille E. Morehouse, "John Hardrick, Harmon Art Winner, Is Completing Big Religious Mural," *The Indianapolis Star*, 15 January 1928, 34.

69. *Second Annual Exhibition of Contemporary Negro Art* (San Diego: Fine Arts Gallery, Balboa Park, October 17–November 15, 1929).

70. John Patton, Questionnaire requesting information about John W. Hardrick for Field of Fine Arts, Harmon Foundation, 18 November 1930. Collections of the Manuscript Division, Library of Congress.

71. Donahue, n.p.

72. "John W. Hardrick to Paint Portrait of Dr. Winders in Public Exhibit," *The Indianapolis Star*, 9 June 1931, n.p.

73. J. W. Hardrick, Letter to Miss Brown, 14 September 1932. Collections of the Manuscript Division, Library of Congress.

74. Evelyn S. Brown, Letter to Mr. John W. Hardrick, 29 April 1933. Collections of the Manuscript Division, Library of Congress.

75. Lucille E. Morehouse, "18 Artists File for Public Works Project; Definite Plans Due Today," *The Indianapolis Star*, 19 December 1933, n.p.

76. Interview with Rowena Hardrick Tucker, 18 June 1988.

77. *The Art Of The American Negro (1851 to 1940)* (Chicago: American Negro Exposition, Chicago 4 July–2 September 1940. Hale Woodruff files, box 6, folder 13, Amistad Research Center, New Orleans.

78. Interview with Rowena Tucker, 1988.

79. Joy Hakanson, "Painter sees pitfalls in black label," *The Detroit News*, 3 August 1969, n.p.

80. Ibid.

81. According to Roy Woodruff, the artist's son, his grandmother, Augusta Woods, was working as a domestic in California for an English family named Hale when she became pregnant by their son. The family sent her to Cairo, Illinois, where Hale Woodruff was born. Woodruff's mother received some financial support from the Hale family. Interview with Roy Woodruff, August 1988.

82. Winifred Stoelting, "Hale Woodruff, Artist and Teacher: Through the Atlanta Years," Ph.D. Dissertation, Emory University, 1978, 2+.

83. Information on the *Indianapolis Freeman* is from *The Encyclopedia of Indianapolis*, ed. David J. Bodenhamer and Robert G. Barrows (Bloomington: Indiana University Press, 1994), 781.

84. *Art School Register 1920–21—1921–22.* Archives, Indiana University-Purdue University, Indianapolis.

85. Interview with Hale Woodruff by Al Murray, 18 November 1968, 1. Archives of American Art, New York.

86. "Artist Youth Surmounts Obstacles to Achievement," *The Indianapolis Star*, 31 December 1926, n.p.

87. Ibid.

88. "Local Artist Gets Prize in N.Y. Contest," *Indianapolis Recorder*, 5 September 1925, n.p.

89. "January Bride," *Indianapolis Recorder*, 13 February 1926, 1.

90. "Young Teacher Dies," *Indianapolis Recorder*, 18 September 1926, 1.

91. Walter White, Letter to George E. Haynes, 17 September 1928. Collections of the Manuscript Division, Library of Congress.

92. William E. Harmon Award for Distinguished Achievement, 30 July 1926. Collections of the Manuscript Division, Library of Congress.

93. "Jackson Lauds Student Artist at Harmon Medal Presentation," *The Indianapolis Star*, 2 January 1927, n.p.

94. Hale Woodruff, Letter to George E. Haynes, 13 December 1926. Collections of the Manuscript Division, Library of Congress.

95. "Florentine Club Meeting," unknown newspaper, 19 February 1927, n.p. Woodruff Papers, Amistad Research Center Archives, New Orleans.

96. Judith Vale Newton and Carol Weiss, *A Grand Tradition: The Art and Artists of the Hoosier Salon 1925-1990* (Indianapolis: Hoosier Salon Patrons Association, 1993), 332.

97. Stoelting, 12. *Time* (September 21, 1942, p. 74) reported Woodruff received from Otto Kahn $750 over the four-year period.

98. "Harmon Prize Winner Sails," *New York Sun,* 3 September 1927, 4.

99. Lucille E. Morehouse, "Hale Woodruff, Artist, Will Study in Europe," *The Indianapolis Star*, 28 August 1927, n.p.

100. Hale Woodruff, Postcard to Mrs. Gussie Woodruff, 10 September 1927. Woodruff Papers, Amistad Research Center Archives, New Orleans.

101. Hale Woodruff, Letter to Mrs. Gussie Woodruff, 11 October 1927. Woodruff Papers, Amistad Research Center Archives, New Orleans.

102. Stoelting, 14.

103. "Local Negro Artist Finds Painters Hard To Classify," *The Indianapolis Star*, 18 March 1928, 31.

104. Hale Woodruff, Letter to Mary Beaty [sic] Brady, Harmon Foundation, 26 October 1928. Collections of the Manuscript Division, Library of Congress.

105. Harmon Foundation, Letter to Hale Woodruff, 22 November 1928. Collections of the Manuscript Division, Library of Congress.

106. Hale Woodruff, "My Meeting With Henry O. Tanner," *The Crisis* (January 1970): 77.

107. "Hale Woodruff Water Color Painting Bought by Mrs. John D. Rockefeller Jr.," *The Indianapolis Star*, 26 March 1929, n.p.

108. Hale Woodruff, Letter to George Haynes, 3 March 1929. Collections of the Manuscript Division, Library of Congress.

109. Mary Beattie Brady, Letter to Hale Woodruff, 14 February 1929. Collections of the Manuscript Division, Library of Congress.

110. Hale Woodruff, Letter to Mary Brady, 5 May 1931. Collections of the Manuscript Division, Library of Congress.

111. "Local Artist Goes to Atlanta Duties," *The Indianapolis Star*, 22 September 1931, 21 C. 7.

112. Hale Woodruff, Letter to Mary Brady, 5 May 1931. Collections of the Manuscript Division, Library of Congress.

113. "Local Artist Goes to Atlanta Duties," *The Indianapolis Star*, 21 C. 7.

114. Interview with Jenelsie Walden Halloway, 23 June 1994.

115. C. Gerald Fraser, "Hale Woodruff Looks Back on Lifetime of Painting," *New York Times*, 6 May 1979, n.p.

116. *Questionnaire for Negro Artists*, Harmon Foundation, Inc., April 1934. Collections of the Manuscript Division, Library of Congress.

117. Wedding invitation, 14 June 1934, Saint John's Church, Topeka, Kansas.

118. Ralph McGill, "Quiet, Modest Negro Hailed as One of Modern Masters," *Atlanta Constitution*, 18 December 1935, n.p.

119. Stoelting, 215.

120. *Exhibition of Fine Art Productions by American Negroes*, Hall of Negro Life, Texas Centennial, Dallas, 19 June–November 1936. Amistad Research Center Archives, New Orleans.

121. "Hale Woodruff Among Georgia Artists to Exhibit Work at New York's World Fair," *The Atlanta University Bulletin* (December 1939): 8. Amistad Research Center Archives, New Orleans.

122. Photocopies of award ribbons. Indiana State Library.

123. "Hale Woodruff Wins First Prize for Landscape in Oil at Indiana Fair," *The Atlanta University Bulletin* (December 1939): 11. Amistad Research Center Archives, New Orleans.

124. "Murals by Hale Woodruff," *Spelman Messenger* 55: 3 (May 1939).

125. "Black Beaux-Arts," *Time*, 21 September 1942, 74.

126. Jim Walker, "Hale Woodruff Has Paid His Dues," *Black Creation* (Spring 1972): 45.

127. "First National Art Exhibit," *The Atlanta University Bulletin* (July 1942): 24.

128. Lillian Scott, "Woodruff, Painter-Teacher, Feels Education is Key to Creative Art," *Chicago Defender*, 7 June 1947, n.p.

129. "New York Has Most Colored Teachers," *Ebony* (October 1947): 15.

130. Romare Bearden and Harry Henderson, *A History of African-American Artists: From 1792 to the Present* (New York: Pantheon Books, 1993), 264.

131. Hale Woodruff, "Facts about California Residence." Hale Woodruff Papers, Amistad Research Center Archives, New Orleans, n.d.

132. "The Art of the Negro murals by Hale Aspacio Woodruff." Trevor Arnett Library, The Atlanta University. Woodruff Papers, Amistad Research Center, New Orleans, n.d.

133. Hale Woodruff, Letter to Dr. Harold Voorhis, 14 May 1957. Woodruff Papers, Amistad Research Center, New Orleans.

134. "1966 NYU Great Teachers Named," unknown newspaper, 3 May 1966.

135. *Hale Woodruff: An Exhibition of Selected Paintings and Drawings, 1927–1967*, New York University, 15 May–8 June, 1967.

136. Bearden and Henderson, 400.

137. Jeanne Siegel, "Why Spiral," *Art News* 65: 5 (September 1966): 48+.

138. See Chapter 5 in this book.

139. J.A.D., "Editorial," *African Forum* 1:4 (Spring 1966): 4.

140. Bela Zempleny, Department of State, Letter to Hale Woodruff, 4 November 1965. Woodruff Papers, Amistad Research Center, New Orleans.

141. "No Premium Paid for Black Art, Artist Says," *Detroit Free Press*, 27 July 1969, n.p.

142. Hakanson, "Painter sees pitfalls," n.p.

143. Jane Allison, "Prominent Indiana Black Artist Shows Works 'Where It All Began,'" *Muncie Indiana Star*, 6 February 1977, n.p.

144. The painting purchased by the Indianapolis Museum of Art was *Landscape with Constellations*.

145. Hale Woodruff, Letter to Diane Lazarus, 10 December 1976. Indianapolis Museum of Art, Historical File, 77. 178.

146. "Commencement 78," 10 May 1978. Library Archives, Indiana University-Purdue University, Indianapolis.

147. Interview with John and Vivian Hewitt, New York, August 1989.

148. Fraser, "Hale Woodruff Looks Back," n.p

149. *The Call*, Kansas City, Missouri, 12 September 1980, n.p.

150. Interview with Hale Woodruff conducted by Professor Melvin L. Alexenburg, Dowling College, Oakdale, Long Island, 24 March 1969. Hale Woodruff Papers, Archives of American Art, New York.

151. Hale Woodruff Papers, Archives of American Art, New York, Roll 70-60.

152. Anthony Panzera with Susan Stedman Majors, "Conversation With Susan Stedman Majors" in *William Majors, Distinctions: Approaches To Drawing* (New York: The Bertha and Karl Leubsdorf Art Gallery, Hunter College of the City University of New York, 11 February–26 March 1993), 5.

153. Jane Allison, Hoosier in Manhattan, "Battle with T.B. Launches Artist," *The Indianapolis Star*, 1965, n.p.

154. Panzera and Majors, 5.

155. Interview with Susan Stedman Majors, February 1993.

156. Class rosters, Fall 1953–54. Archives, Indiana University Purdue University, Indianapolis.

157. Mary H. Finke, ed., *The Chronicle*, John Herron Art School, 17:2 (June 1954): 1.

158. Interview with anonymous Indiana patron, 2 December 1994.

159. Ibid.

160. Conversation between Susan Stedman Majors and Harriet Warkel, 3 June 1995.

161. Panzera and Majors, 12.

162. Mary H. Finke, ed., *The Chronicle*, John Herron Art School, 22:2 (June 1959).

163. Mary H. Finke, ed., *The Chronicle*, John Herron Art School, 23:2 (June 1960): 1.

164. Interview with Richard Mayhew, 22 February 1995.

165. Interview with the artist's niece, Clara Martin, 26 November 1994.

166. Panzera and Majors, 12.

167. Ibid., 7.

168. Ibid., 12.

169. Interview with Susan Stedman Majors, 1990.

170. Allison, "Battle with T.B.," n.p.

171. Majors moved into his Seventh Avenue studio in 1965.

172. Interview with Richard Mayhew, 22 February 1995.

173. Panzera and Majors, 12.

174. Jane Allison, "Etchings Display Marks Victory for Former Sunnyside Patient," *The Indianapolis News*, 19 February 1966, n.p.

175. Interview with Mel Edwards, 11 July 1994.

176. Christine Temin, "Majors' Posthumous Show Is an Affirmation of Life," *The Boston Globe* 231:22 (January 1987): 1.

177. The portfolio had been loaned by the Museum of Modern Art.

178. Interview with Susan Stedman, 1990.

179. Richard F. Shepard. "10 Painters Quit Negro Festival in Dispute with U.S. Committee," *New York Times*, 10 March 1966, n.p.

180. Grace Glueck, *The New York Times*, 27 February 1969, 34.

181. In his career as a teacher Majors also reacted to conditions he found to be biased and discriminatory. In one instance he pursued legal action, filing a claim against the University of New Hampshire in 1973–74 through the Federal Equal Employment Opportunity Commission. (Telephone conversation between Susan Stedman Majors and Harriet G. Warkel, 9 June 1995.)

182. Ellen Harkins Wheat, *Jacob Lawrence: American Painter* (Seattle: University of Washington Press, 1986), 143, fig. 62.

183. Panzera and Majors, 13.

184. Ibid.

185. Ibid., 10.

186. Statement by William Majors, sent in a letter to his sister, dated 23 May 1973, read by Patricia Hurd in a telephone interview, 26 November 1994.

Exhibition Checklist

Exhibition Checklist

William Edouard Scott (1884–1964)

1. **Rainy Night, Etaples**, 1912
oil on canvas
25 $^1/_2$ x 31 inches
Indianapolis Museum of Art, Gift of a group of African-American citizens of Indianapolis, 13.219

2. **La Misère**, 1913
oil on canvas
58 x 45 $^1/_4$ inches
From the Collection of the Indiana State Museum and Historic Sites

3. **Night Turtle Fishing in Haiti**, 1931
oil on canvas
39 $^1/_2$ x 29 $^1/_2$ inches
Clark Atlanta University Collection of African American Art, Gift of Judge Irvin C. Mollison

4. **Turkey Vendor**
oil on canvas
37 $^1/_2$ x 36 $^1/_4$ inches
DuSable Museum of African American History, Chicago

5. **Blind Sister Mary**, about 1931
oil on canvas
29 $^3/_4$ x 24 inches
Schomburg Center for Research in Black Culture, Art and Artifacts Division, The New York Public Library, Astor, Lenox and Tilden Foundation

6. **Kenskoff, Haiti**, about 1931
oil on board
about 1931
22 x 18 inches
Schomburg Center for Research in Black Culture, Art and Artifacts Division, The New York Public Library, Astor, Lenox and Tilden Foundation

7. **The Citadel, Haiti**
oil on canvas
18 $^1/_2$ x 22 $^1/_2$ inches
Collection of James T. Parker

8. **Cockfight**
oil on wood panel
22 x 18 inches
Collection of Byron and Frances Minor

9. **Haitian Market**, 1950
oil on canvas
30 x 48 inches
Collection of Fisk University, Nashville, Tennessee

10. **Booker T. Washington and George Washington Carver in Carver's Laboratory**
oil on canvas
62 x 42 inches
DuSable Museum of African American History, Chicago

11. **Traveling (Lead Kindly Light)**, 1918
oil on canvas
18 x 22 inches
Collection of Mrs. Virginia Van Zandt

12. **Toussaint L'Ouverture**
oil on canvas
30 x 20 inches
Amistad Research Center, New Orleans, AFAC Collection

13. **Pope Pius XII and Two Bishops**, about 1953
oil on canvas
40 x 33 inches
Collection of Lester and Nancy McKeever

14. **Frederick Douglass**
oil on canvas
40 x 30 inches
Collection of Dr. Margaret Burroughs

15. **Breton Smithy**, about 1913
oil on canvas
25 $^1/_2$ x 32 inches
From the collection of the Indiana State Museum and Historic Sites

16. **The Maker of Goblins (High-powered Salesman, Hallowe'en)**
oil on canvas
32 x 25 inches
Collection of Mr. and Mrs. Richard C. Norton

17. **Mother and Child**
oil on canvas
13 x 17 inches
Collection of Dr. Joan Scott Wallace

18. **It's Going to Come**, 1916
oil on canvas
18 x 21 $^7/_8$ inches
Collection of Mary Louise Clampitt

John Wesley Hardrick (1891–1968)

19. **Bus in a Snowstorm**
oil on board
20 x 24 inches
Collection of George and Terry Gray

20. **Little Brown Girl**, 1927
(dated March 25, 1929)
oil on canvas
22 x 30 inches
Indianapolis Museum of Art, Gift of a group of African-American citizens of Indianapolis, April 16, 1929, 29.40

21. **Summer Landscape**
oil on board
28 x 34 inches
Jack D. Finley Collection

22. **Woman in a Fur Coat**
oil on canvas
26 $^1/_4$ x 21 inches
Collection of Dr. Stephen N. Butler

23. **Thou Good and Faithful Servant**, 1930
oil on board
46 x 34 inches
Collection of Dr. Stephen N. Butler

24. **Dolly and Rach**, about 1930
oil on board
38 x 33 inches
Collection of Georgia A. Hardrick Rhea

25. **Street in Indianapolis**
oil on board
12 x 10 inches
Indiana Historical Society

26. **Springtime (Portrait of Ella Mae Moore)**, 1933
oil on board
48 x 32 inches
Private Collection

27. **Xenia Goodloe**, 1930
oil on board
36 x 20 inches
Collection of Derrick Joshua Beard

28. **Untitled Landscape**
oil on board
29 $^{13}/_{16}$ x 23 $^1/_2$ inches
Indianapolis Museum of Art, Jacob Metzger Memorial Fund, 82.159

29. **Winter Landscape**, 1945
oil on board
22 $^3/_4$ x 28 $^3/_4$ inches
Indianapolis Museum of Art, Gift of the Indianapolis Chapter of Links, 1984.397

30. **Lady in Red (Before the Party)**, about 1931
oil on board
30 x 28 inches
Private Collection

31. **National Malleable Company**, 1941
oil on canvas
30 x 40 inches
Collection of Richard and Elizabeth Kramer

32. **Portrait of a Woman**, 1932
oil on board
30 x 24 inches
Hampton University Museum, Hampton, Virginia

Hale Aspacio Woodruff (1900–1980)

33. **Cigarette Smoker**
oil on canvas
18 $^1/_4$ x 15 $^1/_4$ inches
Hampton University Museum, Hampton, Virginia

34. **Southland**, about 1936
oil on canvas
30 x 40 inches
Amistad Research Center, New Orleans, AFAC Collection

35. **The Card Players**, about 1978
oil on canvas
36 x 42 inches
Collection of John H. and Vivian D. Hewitt

36. **Poor Man's Cotton**, 1944
watercolor and gouache on paper
30 $^1/_2$ x 22 $^1/_4$ inches
Collection of The Newark Museum, Purchase 1944, Sophronia Anderson Fund, 44.122

37. **Georgia Landscape**, 1934-35
oil on canvas
21 $^1/_8$ x 25 $^5/_8$ inches
National Museum of American Art, Gift of Alfred T. Morris, Jr., 1986.82.2

38. **Sharecropper Boy**, 1938
oil on canvas
20 x 15 inches
The Harmon and Harriet Kelley Collection

39. **Giddap**, 1933–35
woodcut
13 x 10 inches
Museum of the National Center of Afro-American Artists, Boston

40. **By Parties Unknown**, 1933–35
woodcut
13 x 10 inches
Museum of the National Center of Afro-American Artists, Boston

41. **Afro-Emblems**, 1950
oil on canvas
18 x 22 inches
National Museum of American Art, Washington, D.C., Gift of Alfred T. Morris, Jr., 1984.149.2

42. **Ancestral Memory**
oil on canvas
60 $^1/_8$ x 52 $^1/_8$ inches
The Detroit Institute of Arts, Founders Society Purchase, African Art Gallery Committee Fund, 78.87

43. **Landscape with Constellations**, 1973
oil on canvas
40 x 50 inches
Indianapolis Museum of Art, Mr. and Mrs. Julius F. Pratt Fund, 77.178

44. **Central Park Rocks (Rocks in Central Park)**
about 1947
watercolor
13 x 20 $^1/_4$ inches
The Harmon and Harriet Kelley Collection

45. **African Memory**, about 1967–68
oil on canvas
52 x 27 inches
Collection of Mary H. Jennings

46. Untitled (Celestial Gate Series)
oil on canvas
56 x 43 inches
Kenkeleba House, New York

47. Carnival, 1950
oil on canvas
42 x 33 $^1/_2$ inches
Wadsworth Atheneum, Hartford, Connecticut
The Ella Gallup Sumner and Mary Catlin Sumner
Collection Fund

48. Sentinel Gate, 1977
oil on canvas
40 x 30 inches
Collection of John H. and Vivian D. Hewitt

William Majors (1930–1982)

49. In the Studio, 1966
oil on canvas
49 $^1/_2$ x 60 inches
Collection of David and Carol O'Connor

50. #3, 1958-1959
oil on canvas
50 x 36 inches
Collection of Kelley Majors

51. Burning Bush, 1961
oil on canvas
62 x 48 inches
Collection of Dr. Daisy Riley Lloyd

52. Untitled Abstraction, about 1958–60
oil on board
30 x 24 inches
Collection of Betty Joan Owsley

53. Crucifixion, 1958–59
oil on canvas
41 x 30 inches
Collection of Wendell L. Parker

54. Untitled, 1975
collage on linen, mounted on paper, mounted on Masonite
18 x 24 inches
Collection of Susan Stedman Majors

55. Gestation, 1975
collage with mixed media on gessoed paper, mounted on
gessoed board
17 $^{15}/_{16}$ x 23 $^7/_8$ inches
Collection of Susan Stedman Majors

56. Untitled (Tondo) from Allegory Series, 1976
collage with mixed media on gessoed Masonite, mounted
on cardboard panel
16 $^{11}/_{16}$ tondo diameter inches
Collection of Susan Stedman Majors

57. Ghetto on 7th Avenue and 30th Street, N.Y.C.
1975–77
collage with mixed media mounted on gessoed Masonite
19 $^7/_8$ x 30 inches
Collection of Susan Stedman Majors

58. Untitled, 1970
pencil on paper
29 $^1/_2$ x 21 $^5/_8$ inches
Collection of Susan Stedman Majors

59. Study VIII for Paintings—The Blues, 1976
colored pencil on paper
22 $^1/_8$ x 29 $^7/_8$ inches
Collection of Susan Stedman Majors

60. Allegory to Love, 1973
pencil (colored and graphite), gold leaf on gessoed board
24 x 30 x 1 inches
Collection of Susan Stedman Majors

61. Genesis II, 1965
$^3/_4$ Estate Proof 1985
etching with aquatint
22 $^3/_8$ x 24 inches
Collection of Susan Stedman Majors

62. **Figure**, 1967
$^1/_5$ Estate Proof 1985
etching with aquatint
29 $^7/_8$ x 22 $^1/_4$ inches
Collection of Susan Stedman Majors

63. **Allegory to Love**, 1974
etching (silver roll with black ink)
22 $^3/_4$ x 28 $^1/_4$ inches
Collection of Susan Stedman Majors

64. **River Niger**, 1973
etching (silver roll with black ink on sheet music), mounted
on Kozo paper
16 $^1/_2$ x 23 $^1/_4$ inches
Collection of Susan Stedman Majors

65. **Etchings from Ecclesiastes**, 1965
18 etchings, aquatint, and intaglio on Rives BFK paper
13 $^7/_8$ x 16 $^3/_4$ inches
Indianapolis Museum of Art, Gift of the Art School
Committee, Herron School of Art, 66.13A-R

Index

A

Abstract Composition (Woodruff), 66, 79
Académie Julian, 18, 161
Académie Moderne, 173
Académie Scandinave, 173
According Flyer (Miller), 154
Adams, John Quincy, 132
Africa and the Bull (Woodruff), 88, 90, 154, *156*
African Memory (Woodruff), 94, *95*
Afro Emblems (Woodruff), 81, *83*, 84
Aleijadihno, 141
Alexander, Titus, 137
Allegory to Love (drawing) (Majors), 111, *116*
Allegory to Love (etching) (Majors), *117*
Allen Chapel, Indianapolis, 56, 167, 169
Alston, Charles, 137, 141, 142, 148, 150, 151, 153, 176
American Church Federation, 50
American Institute of Architects, 174
American Missionary Association (AMA), 132, 136
American Museum of Natural History, 138
American Negro Exposition: Celebrating 75 Years of Negro Achievement, 165, 170
La Amistad (Friendship) (Woodruff), 132, 135
Amistad Murals (Woodruff), 14, 135, 175
The Amistad Mutiny (Woodruff), 131, 132, 133, 134-35, *136*, 142
The Amistad Slaves on Trial at New Haven, Connecticut (Woodruff), *134-35*
Amos, Emma, 148
Ancestral Memory (Woodruff), 88, *89*, 90
Anderson, Marion, 165
Annunciation to Mary (Scott), 129
Antreasian, Garo, 178
Aprés la Pluie (Scott), 163
An Art Commentary on Lynching exhibition, 174
Art Institute of Chicago, 13, 60, 126, 160, 168
Art News, 150, 151
The Art of The American Negro (1851 to 1940), 170
The Art of the Negro (Woodruff), 80, 81, 131, 138, 139-42, *143*, 144, *145*, 176
Arthur U. Newton Galleries, 64, 174
Artists (Woodruff), 138, 141, *145*
Atlanta Constitution, 131, 175
Atlanta University, 63, 79, 138, 174, 175, 176
 art exhibitions, 14, 60
 School of Social Work, 131
Atlanta University Laboratory School, 169, 170, 174

B

Baker, Josephine, 78
Baker, Theresa, 174
Baldwin, James, 148
Baldwin, Roger, 134
The Banjo Lesson (Tanner), 124
Bannister, Edward Mitchell, 42, 141
Barbizon School, 42
Barthe, Richmond, 142, 153
Beacham, Hallie, 169
Bearden, Romare, 142, 148, 149, 150, 152, 155

Beavers, George, 176
Before the Party (Lady in Red) (Hardrick), 47, *53*
Bénézit, E., 56
Benton, Thomas Hart, 14, 63, 64, 124
Bernard, Catherine, 78
Biggers, John, 124
Billings, Henry, 128
Binga State Bank of Chicago, 125
black art, 154
black musicians, 11
black population of Indianapolis, 11
Blind Sister Mary (Scott), 35
Boime, Albert, 152
Bontemps, Arna, 79
Booker T. Washington and George Washington Carver in Carver's Laboratory (Scott), 22, *23*
The Boy Christ (Scott), 129
Brady, Mary, 174
Braque, Georges, 66, 79, 105
Breton Smithy (Scott), 18, *19*
Brown, John, 137
Brown County, Indiana, 41, 42
Brucker, Edmund, 178
Buckingham, Mrs., 126
Burning Bush (Majors), 100, *102*
Bus in a Snowstorm (Hardrick), *12* (detail), 50, *58*
By Parties Unknown (Woodruff), 64, *71*, 174

C

Cadmus, Paul, 64
Cagnes-sur-Mer, 63, 79
California State University at Hayward, 180
Campbell, E. Simms, 64
Campbell, Mary Schmidt, 138, 142
Card Players (Woodruff), 63, 75n.58, 79, 173
The Card Players (Woodruff), 63, *65*, 75n.58, *177*
Carnival (Woodruff), 81, *82*, 142
Carver, George Washington, 13, 22
Castle of Villeneuve (Woodruff), *63*, 78
Celestial Gate Series (Woodruff), *92*, 155-56
Celestial Gate (Woodruff), 90, *91*, 93, 94
Central Park Rocks (Rocks in Central Park) (Woodruff), 66, *74*, 80
Centre d'Art in Port-au-Prince, 13
Cézanne, Paul, 60, 63, 85, 88, 173
Chase, William Merritt, 50
Chicago Public School Art Society, 126
Chicago's Davis Square Field House, 130
Christ and the Samaritan Woman at the Well (Hardrick), 169
Christ Appearing to Mary after the Resurrection (Scott), 129
Christ as Carpenter (Scott), 129
Christ before Pilate (Scott), 129
Christ in the Temple with the Elders (Scott), 129
Christ with Simeon (Scott), 129
Christopher Street Gallery, 149, 157
The Chronicle (Majors), 100
Cigarette Smoker (Woodruff), 60, *62*
Cinque, 132, 134
Citadel, 29
The Citadel, Haiti (Scott), 29, *31*

civil rights movement and Spiralists, 151
Civil Works Administration (CWA), 170
Clement, Rufus, 138
Cleveland School of Art, 178
Cockfight (Scott), 29, *30*
Colarossi Academy, 163
Commerce (Scott), 125, 126, 127, 129, 131, 160, 162
Composition No. 2 (Hollingsworth), 155
Conjure Woman (Bearden), 155
Le Connoisseur (Scott), 163
Conroy, Jack, 79
Constructive Recreation: A Vital Force in Character Building (Scott), 130, 131
Contribution of the Negro to American Democracy (White), 142
The Contribution of the Negro to the Growth of California, 137
Convention of Colored Citizens of California, 137, 138
Conversations with Ogotemmeli, 94
Cook County Juvenile Court, 35, 37
Countee Cullen (Woodruff), 60
Country Church (Woodruff), 132
Cousins, James, 137
Covey, James, 134
The Crisis, 22, 164, 171
The Crisis Advertiser, 27
Crispus Attucks High School, 10, 11, 56, 170, 178
Cristophe, Henry, 29
Crite, Allan Rohan, 131
Crucifixion (Majors), 100, *101*
Cullen, Countee, 60, 63, 78
Curry, John Steuart, 124

D

David T. Howard School in Atlanta, 131
De Frantz, Faburn E., 168, 172, 173
de Kooning, Willem, 156
de la Muette, Galerie, 174
de Pareja, Juan, 141
Dedication of the Recorder of Deeds Building (Scott), 128
Degas, Edgar, 41
Delacroix, Eugène, 35, 39
Les Demoiselles d'Avignon (Picasso), 63
Desert Rocks (Woodruff), 80
Dictionnaire critique et documentaire des peintres, sculpteurs, dessinateurs and graveurs (Bénézit), 56
Dissipation (Woodruff), 81, 90, 138, 139-40, *141*
Dolly and Rach (Hardrick), 50, *55*
Douglas, Aaron, 124, 142
Douglas, Stephen, 165
Douglass, Calvin, 148, 155
Douglass, Frederick, 13, 27, 127, 128, 131, 165, 167
Douglass, Joseph H., 167
DuBois, William E. B., 22, 27, 78, 135, 138, 142
Duncanson, Robert S., 42, 142
Duvall, John, 11

E

Eakins, Thomas, 39
Eichenberg, Fritz, 105, 180
The Elevator, 137
Elisofon, Eliot, 135
Ellison, Ralph and Spiralists, 152-54
Equinox (Woodruff), 85, *86*
Etchings from Ecclesiastes (Majors), 14, 105, 178, 180
Etchings from Ecclesiastes (III-3) (Majors), *107*
Etchings from Ecclesiastes (V-15) (Majors), *108*
Etchings from Ecclesiastes (VI-12) (Majors), *109*
Europa and the Bull (Woodruff), 88
Evans, George E., 172
Evers, Medgar, 148
Exhibition of Fine Art Productions by American Negroes, 174-75
Exploration and Colonization: 1527-1850 (Alston), 137
Expulsion from the Garden of Eden (Scott), 129

F

Federal Arts Project (FAP), 14, 170
Ferguson, Perry, 148, 154-55
Ferrer, Ramon, 132
Figure (Majors), 105, *110*
First Communion, Port-au-Prince, Haiti (Scott), 27, 29
First National Bank of Fort Wayne, 164
First Presbyterian Church of Chicago, 164
First World Festival of Negro Arts, Dakar, Senegal, 14-15, 88, 176, 180
Fiscus, Gardner, 178
Fisk University, 125, 165
Flight into Egypt (Scott), 129
Florence, Italy, 100
Florentine Club, 172
Fogg Art Museum, Harvard University, 174
Forsyth, William, 41, 60, 163, 167, 171, 172
Founding of Talladega College (Woodruff), 131, 135
Fountain of Knowledge (Scott), 163
Four Scenes from the Life of Christ (Scott), 129
Frazer, James George, 85
Frederick Douglass (Scott), *28*
Frederick Douglass Appealing to President Lincoln and His Cabinet to Enlist Negroes (Scott), 37, 128
Freedom Now (Gammon), 155
Fulks, Esther Elaine, 165
Fuller, Meta Warwick, 168

G

Gammon, Reginald, 148, 155
Gauguin, Paul, 41
Genesis II (Majors), 105, *106*, 156, *157*
George W. Roper Tidewater Purchase Prize, 178
Georgia Landscape (Woodruff), 63, *67*
Gestation (Majors), 111, *119*
Ghetto on 7th Avenue and 30th Street, N.Y.C. (Majors), 111, *120*
Gibbs, Josiah, 134

Gibson, Ann, 81
Giddap (Woodruff), 64, *70*, 174
Girls Skipping (Woodruff), 79, 80
gold weights, 84
The Golden Bough (Frazer), 85
Golden State Mutual Life Insurance Company, 80, 137, 176
Gomez, S., 141
Goodloe, Xenia, 47, 50
Gore, George, 171
Gorky, Arshile, 105
Gottlieb, Adolph, 80
Graves, Robert, 85
Griaule, Marcel, 94
Grigsby, Eugene, 80
Gris, Juan, 105
The Gulf Stream (Homer), 35, *37*

H

H. Lieber Company, 167
Haiti, 29, 165
Haitian Market (Scott), 29, *33*
Hamlin, Eva, 152
Hardrick, Georgia, 50
Hardrick, John Wesley, 10, 11, 13, 41-59, 60, 167-70. *See also specific works*
 at Art Institute of Chicago, 168
 Harmon Award, 168-69
 landscapes by, 41-42
 at Manual Training High School, 167
 marriage to Georgia Howard, 167
 portraits by, 42, 47, 50, 56
 and Scott, 168, 169
 and Woodruff, 168, 169
Hardrick, Rachel, 50
Hardrick, Shephard, 167
Hardrick Picture Fund, 169
Harlem Artists' Guild, 150
Harlem Renaissance, 10, 39, 60, 78, 153, 164
Harlem YMCA, 125
Harmon, William E., 164
Harmon Awards, 47, 164, 168, 174
Harmon Foundation, 11, 60, 164, 170, 172, 173, 174
Harper, William, 161, 168
Harriet Beecher Stowe School, 167
Harvard University, Fogg Art Museum, 174
Harvest (Majors), 156
Hayden, Palmer, 63, 78
Haynes, George E., 164
He Who Is without Sin (Scott), 129
Herndon Homes, 64
Herring, James V., 128
Hewin, A., 132
Hewitt, John, 177
Hewitt, Vivian, 177
High-powered Salesman, Hallowe'en (The Maker of Goblins) (Scott), 22, *25*
Hines, Felrath, 148
Holland, Abraham Freeman, 137
Hollingsworth, Alvin, 148, 155
Homer, Winslow, 35, 37, 39
Hoosier Group, 41
Hoosier Salon, 164, 169, 172

Hope, John, 63, 78, 79, 138, 174, 175
Howard, Georgia Anna, 167
Hudson, Julien, 141
Hudson River School, 42
Hughes, Langston, 93, 153
Hurston, Zora Neale, 93
Hypolite, Hector, 141

I

An Idyll of the Deep South (Douglas), 142
Illinois National Bank, Edwardsville, 164
In the Studio (Majors), 111, *112*
Indiana State Fair, 11, 163, 167, 175
Indiana University-Purdue University, Indianapolis, 177
Indianapolis City Hospital, 129, 163
Indianapolis Freeman, 171
Indianapolis Museum of Art, 11, 162, 177
Indianapolis Recorder, 169
The Indianapolis Star, 41, 129, 162, 173
Indianapolis Stove Foundry, 56, 167
Influences (Woodruff), 138, 140-41, *144*
Interchange (Woodruff), 85, 138, 139, *140*
International Print Society, 79
Inter-racial Committee of San Diego, 169
Invisible Man (Ellison), 153
Iqueigha, 141
It's Going to Come (Scott), 22, *24*

J

Jackson, Ed, 11, 172
jazz musicians and Spiralists, 150
Jean (Hardrick), 169
Jennings, Wilmer, 64, 131
Jesus of Nazareth (Hardrick), 169
Jocelyn, Simeon S., 132, 134
John Hay Whitney Foundation Fellowship, 14
John Herron Art Institute, 11, 168
John Herron School of Art, 13, 14, 41, 60, 100, 160, 167, 171, 178
John Simon Guggenheim Foundation, 181
Johnson, Mordecai, 78
Johnson, Sargent, 141
Johnson, William H., 174
Johnston, Joshua, 141
The Juggler, 162
Julius Rosenwald Fellowship, 13, 27, 66, 79, 165, 176
Junior Council of the Museum of Modern Art, 15, 105

K

Kahn, Otto H., 172
Kane, Nada, 141
Karamu House, 178
Katharine Ayres Smitheram Memorial Award, 178
Kenskoff, Haiti (Scott), 35
Ker, Balfour, 162
King, Martin Luther, Jr., 148
Koontz Gallery, 150
Krasner, Lee, 80
Ku Klux Klan, 11

L

Lady in Red (Before the Party) (Hardrick), 47, 53
Lady X (Hardrick), 170
A Landscape (Hardrick), 169
Landscape with Constellations (Woodruff), 85, 87, 88
Lane Technical High School, 125, 126, 160
Laurens, Jean-Paul, 163
Lawrence, Jacob, 141
Lead Kindly Light (Traveling) (Scott), 22, 26, 27
Leavitt, Joshua, 132
Leda and the Swan (Woodruff), 88
Lewis, Edmonia, 168
Lewis, Norman, 148, 149, 150, 151, 155
Lewis, Samella, 10
Liberation (Majors), 111, *113*
Liberty Leading the People, July 18, 1830 (Delacroix), 35, *39*
Lieber, Herman, 13, 167, 172
Life magazine, 135
Lights on a Summer Night (Scott), 164
Lincoln, Abraham, 35, 127, 128, 167
Lincoln at Springfield (Scott), 127, 142
Lisboa, Antonio Franciso, 141
Little Boy (Woodruff), 79, 175
Little Brown Girl (Hardrick), 11, 47, *52*, 169
Locke, Alain, 10, 18, 39, 63, 78, 79, 138, 150, 153, 170
L'Ouverture, Toussaint, 13, 35

M

Magic and Medicine (Alston), 142
Majors, William, 10, 11, 14, 100-121, 148, 154, 178-81. *See also specific works*
 death, 181
 at Herron School of Art, 100, 178
 in Italy, 100, 179
 marriage to Stedman, 180
 in New York, 100, 105, 111, 179-80
 religious experiences of, 178
 as Spiralist, 155, 156-57, 179-80
The Maker of Goblins (High-powered Salesman, Hallowe'en) (Scott), 22, *25*
Malcolm X, 148
Manual Training High School, 160, 167
Marsh, Reginald, 64
Marshall Field Art Gallery of Chicago, 169
The Massacre (Hewin), 132
Matisse, Henri, 111
Matthews, Miriam, 137
Mayhew, Richard, 148, 149, 152, 179
McGill, Ralph, 131
McKay, Claude, 78
McLeary, Kindred, 128
Medieval Chartres (Woodruff), 80, 93
Mende Committee, 132
Messing, Joe, 178
Metropolitan Museum of Art, 138, 180
Michelet, Girodani, 165
Miller, Earl, 148, 154
Minneapolis Institute of Arts, 180
La Misère (Scott), 18, *21*, 163

Mitchell, Elsie L., 171-72
modernist artists, 153
Monroe, George, 137
Montez, Don Pedro, 132
Moor, John T., 56
Moore, Henry, 139, 140
Mother and Child (Scott), 29, *34*
"Mother to Son" (Hughes), 93
Motherwell, Robert, 111
Motley, Archibald, 142
Mowrey, Helen, 178
Mrs. Welling R. Chavis (Scott), 164
Mudhill Row (Woodruff), 131
Muhammad, Elijah, 148
"mural complexes," 129
murals, 124-45
 of Scott, 124-31, 162
 of Woodruff, 81, 85, 88, 131-45, 175
Murray, Albert, 81
Museum of African American Art in Los Angeles, 90
Museum of Modern Art, 179, 180
Mutiny Aboard the Amistad (Woodruff), 133

N

National Association for the Advancement of Colored People (NAACP), 22, 171
National Malleable Company (Hardrick), 56, *59*
Native Forms (Woodruff), 81, 85, 138-39
The Nativity (Scott), 129
Neal, Robert, 133
Negro Business League, 167
"Negro Colony," 78
Negro History Week, 150
The Negro in Modern American Life: Agriculture and Rural Life (Woodruff), 131
New Negro movement, 10
New York University, 14, 80, 176, 177
Night Turtle Fishing in Haiti (Scott), 35, *36*
1939 World's Fair, 79
#3 (Majors), 100, *103*

O

Old Mining Town (Woodruff), 175
Orozco, Jose Clemente, 131

P

Parallels (Woodruff), 81, 138, 140, *143*
Paris Salon, 18, 22
Paris-Plage, 161
La Pauvre Voisine (The Poor Neighbor) (Scott), 18, 162
The Pearl Voice, 171
Pettis Gallery, 11, 168
Phillips, J.R., 139
Phyllis Wheatley YWCA, 50
Phylon, 135
Picasso, Pablo, 63, 66
Pickens, William, 78
Pilgrim Baptist Church, Chicago, 125, 129
Pippin, Horace, 141

Pleasant, Mammy, 137
Pont Neuf (Woodruff), 93
Poor Man's Cotton (Woodruff), 64, *72*, 79, 80
The Poor Neighbor (La Pauvre Voisine) (Scott), 18, 162
Pope Pius XII, 37
Pope Pius XII and Two Bishops (Scott), 37, *40*
Port-au-Prince, Haiti, 13, 27
Portrait of a Woman (Hardrick), *46*, 47
Portrait of Cinque (Jocelyn), 132
Portrait of Countee Cullen (Woodruff), *61*
Portrait of Ella Mae Moore (Springtime) (Hardrick), 47, *51*
Post Office (Motley), 142
printmaking, 105
Pritchard, William, 148
Procession (Lewis), 155
The Prophet, 178
Public School No. 23, 163
Public Works of Art Project (PWAP), 170

R

race and Spiralists, 151-52
Rainy Night, Etaples (Scott), 11, 18, *20, 162
Randolph, A. Phillip, 149
Reason, Patrick, 141
Recorder of Deeds building, Washington, D.C., 37, 128, 165
Renoir, Auguste, 41, 174
Results of Good Housing (Woodruff), 64, 66, *73*, 80
Results of Poor Housing (Woodruff), 64, 66, *73*
The Return to Africa (Woodruff), 135, *136*
River Niger (Majors), 111, *115*
Rivera, Diego, 14, 64, 79, 131, 175
Robbins, Warren, 84
Rockefeller, John D., 173
Rocks in Central Park (Central Park Rocks) (Woodruff), 66, *74*, 80
Rodgers, Moses, 137
Roman Catholic Church, 37
Roosevelt, Franklin D., 37, 124
Rosenwald, Julius, 37
Rowan, Edward B., 37, 128
Royal Academy, London, 22, 163
Ruiz, Don Jose, 132

S

St. Paul's A.M.E. Church, 37
Salon del la Société des Artistes Français, 162
Savage, Augusta, 78, 152-53
Savain, Petion, 165
Savery, William, 136
Savery Library at Talladega, 135
School Arts, 88
Scott, Caroline Russell, 160
Scott, Edward Miles, 160
Scott, William Edouard, 10, 11, 18-40, 56, 78, 142, 160-66, 169, 170. *See also specific works.*
 in France, 160-62
 and Hardrick, 168, 169
 illness and death, 166
 marriage to Esther Fulks, 165

murals by, 13, 124-31, 162
 and Tanner, 18, 29, 160, 161, 162, 163
 and Woodruff, 169, 171
Second Annual Exhibition of Contemporary Negro Art, 169
Self Portrait (Hardrick), 169
Senate Avenue YMCA, Indianapolis, 78, 163
Senghor, Leopold, 180
Sentinel Gate (Woodruff), 94, *96, 97*
separate but equal doctrine, 10
Sermon on the Mount (Scott), 129
Settlement and Development (Woodruff), 131, 137, 142
17th Annual American Drawing Exhibition, 178-79
Shantytown (Woodruff), 131
Sharecropper Boy (Woodruff), 64, *69*
Shiloh Baptist Church, Indianapolis, 178
Shorey, William, 137
Siegel, Jeanne, 150
Silver Sun at Boulogne (Scott), 163
Simms, Gabriel, 137
Simpson, Merton, 148, 155
Slack, L. Ert, 11, 168
Small Town (Ferguson), 154
Smith, Tony, 156
Soleil Gris (Scott), 163
The Souls of Black Folk (DuBois), 78
Southland (Woodruff), 63, *68*
Soutine, Chaim, 63, 174
Spelman College, 14, 63, 93, 174
Spiralists, 148-57, 176
 and civil rights movement, 151
 demise of, 157
 Ellison influence, 152-54
 exhibition of, 154-55
 impetus for, 149-50
 and jazz musicians, 150
 Majors as, 148, 155, 156-57, 179-80
 and race, 151-52
 Woodruff as, 148, 149 155-56
Springtime (Portrait of Ella Mae Moore) (Hardrick), 47, *51*
Stark, Otto, 13, 42, 160, 163, 167
Stedman, Susan, 105, 115, 180
Stephenson, D. C., 11
Stoelting, Winifred, 131
Story, Joseph, 132
Street in Indianapolis (Hardrick), 50, *57*
Stuart, William Weir, 129, 166
Stuart Mortuary, Indianapolis, 129, 166
Studio Museum, Harlem, 88, 177
Study VIII for Paintings - The Blues (Majors), *121*
Suffer the Little Children to Come unto Me (Scott), 129
Summer Landscape (Hardrick), *45*
Sunnyside Sanitarium, 100, 178
Suzetta (Woodruff), 79
Swang, Wager, 136

T

Talladega College, 14, 85, 174
Talladega murals, 132-36

Tanner, Henry Ossawa, 10, 13, 14, 18, 56, 60, 85, 88, 124, 129, 131, 141, 168, 169
 and Scott, 18, 29, 160, 161, 162, 163
 and Woodruff, 171, 173
Tanqueray prize, 163
Tappan, Arthur, 134
Tappan, Lewis, 132, 134
Tarrant, Thomas, 136
Tenth Annual Exhibition of Works by Indiana Artists, 168
Texas Centennial, 175
The Thankful Poor (Tanner), 18
"The Negro in California from 1781-1910" (Matthews), 137
They Seek a City (Bontemps and Conroy), 79
30 Contemporary Black Artists, 180
Thompkins, William J., 128
Thompson, Smith, 135
Thou Good and Faithful Servant (Hardrick), 47, *48*
The Three Magi and the Star in the East (Scott), 129, *130*
Three Tiered Gate (Woodruff), 90
Time magazine, 66
Tomlin, Bradley Walker, 80
Totem (Woodruff), 88
Toussaint L'Ouverture (Scott), *38*
Traveling (Lead Kindly Light) (Scott), 22, *26, 27*
Trepied-par-Etaples, 161, 162
Trevor Arnett Library, 81, 138
The Triumphant Entrance into Jerusalem (Scott), 129
Trumbull, John, 124
Tucker, Rowena, 56
La Tumulte noire, 60
Turkey Vendor (Scott), 29, *32*
The Turtle Pound (Homer), 35
Tuskegee, Alabama, 22, 163
Tuskegee Institute, 22, 152
Twachtman, John H., 42
Two Card Players (Cézanne), 63
"Two Worlds: African-American Abstraction in New York at Mid-Century" (Gibson), 81

U

The Underground Railroad (Woodruff), 85
University of Connecticut, 181
Untitled, Celestial Gate Series (Woodruff), *92, 93, 94*
Untitled (1970) (Majors), 111, *114*
Untitled (1975) (Majors), 111, *118*
Untitled (1976) (Majors), *121*
Untitled (1958) (Woodruff), 90
Untitled Abstraction (Majors), 100, *104*
Untitled Landscape (Hardrick), 42, *43*
Untitled (Simpson), 155

V

van Gogh, Vincent, 41, 60
Vanderpoole, John, 160
Vincent, Stanio, 37

W

Wabash Avenue YMCA, Indianapolis, 125
Walrond, Eric, 78
Washington, Booker T., 13, 22, 124, 163
Watson, Nan, 128
Wells, I. J. K., 165
West, Georgia Etta, 167
A Wet Night at Etaples (Scott), 162
Wharton, Charles, 41
Wharton, Emily, 170
Wharton, Rufus, 170
Wheeler, Clifton, 167
White, Charles, 124, 142
White, Walter, 78, 172
"Why Spiral?" (Siegel), 150
Willard Gallery, 150
Williams, Paul R., 137
Wilson, Judith, 79, 93
Winders, C. H., 50
Winter Landscape (Hardrick), 42, *44*
The Witching Hour (Scott), 164
Woman in a Fur Coat (Hardrick), 47, *49*
Wood, Grant, 14, 124
Woodruff, Hale Aspacio, 10, 11, 13-14, 60-74, 78-97, 124, 148, 149, 150, 154, 169, 170, 171-77. *See also specific works*
 in Europe, 60, 173
 and Hardrick, 168
 at Herron School, 171
 marriage to Elsie Mitchell, 171
 marriage to Theresa Baker, 174
 murals by, 131-45, 175
 and Scott, 169, 171
 as Spiralist, 154, 155-56
 and Tanner, 169, 171, 173
Woollen, Evans, 168
Works Progress Administration (WPA), 56, 64, 124, 131, 153
World's Fair, New York, 175
Wrigley Reflections (Scott), 164

X

Xenia Goodloe (Hardrick), 47, 50, *54*

Y

Yeargens, James, 148, 149, 150
YMCA, 167
The Young Sabot Maker (Tanner), 18

Z

Zacharias in the Tree (Scott), 129

Photo Credits

Amistad Research Center pp. 38, 61, 68, 172

Bass Photo Company Collection,
 Indiana Historical Society Library p. 15

Mark Bondarenko pp. 134-135

Dawood Bey p. 156

Hilton Braithwaite p. 29

The Detroit Institute of Arts p. 89

Giraudon/Art Resource p. 39

High Museum of Art p. 73

Courtesy Dr. and Mrs. Harmon Kelley pp. 69, 74

Kenkeleba House p. 175

Stephen Kovacik p. 84

Library of Congress pp. 161, 168

Michael McKelvey p. 91

The Metropolitan Museum of Art p. 37

National Museum of American Art pp. 67, 83

The Newark Museum p. 72

James Rudin pp. 150-155

Savery Library, Talladega College pp. 133, 136

Schomberg Center for Research in Black Culture p. 35

Clark Atlanta University Collection of
 African American Art pp, 139-141, 143-145

Michael Tropea pp. 23, 32, 126-127, 162

Wadsworth Atheneum p. 82

Robert Wallace p. 63

Karen L. Willis p. 65, 96

M. Wysocki p. 179

The design of this catalogue was produced entirely with
PageMaker 5.0 software on a Macintosh Quadra computer at
David Alcorn Museum Publications, Blairsden, California, and
output on Linotronic's L300 at a Dai Nippon Printing Company
facility in Hong Kong.

The family of type used for headlines, body text, and captions
throughout this catalogue is Palatino in its roman, italic, bold, and
bold italic forms.

The catalogue was printed on a Komori Lithrone press and Smyth
sewn by Dai Nippon Printing Co., Ltd., Tokyo, Japan, at a facility
in Hong Kong.